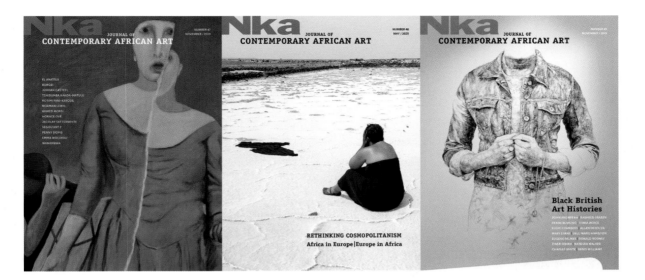

Nka

JOURNAL OF
CONTEMPORARY AFRICAN ART

Salah M. Hassan and
Chika Okeke-Agulu,
editors

N*ka* contributes to the intellectual
dialogue on world art by publishing
critical work in the developing field
of contemporary African and African Diaspora
art. The journal features scholarly articles,
reviews of exhibitions, book and film reviews,
and roundtables.

SUBSCRIBE TODAY. *Two issues annually*

Individuals: $50 Students: $35 Single issues: $27

dukeupress.edu/nka

DUKE
UNIVERSITY
PRESS

Nka

JOURNAL OF CONTEMPORARY AFRICAN ART

FOUNDED 1994

FOUNDING PUBLISHER
Okwui Enwezor
(1963–2019)

EDITORS
Salah M. Hassan
Chika Okeke-Agulu

ASSOCIATE EDITORS
Sarah Adams • Carl Hazelwood • Nancy Hynes
Derek Conrad Murray • Sunanda Sanyal

CONSULTING EDITORS
Rory Bester • Isolde Brielmaier • Coco Fusco
Kendell Geers • Michael Godby • Elizabeth Harney
Thomas Mulcaire • O. Donald Odita • Gilane Tawadros
Frank Ugiomoh

MANAGING EDITOR
Clare Ulrich

GRAPHIC DESIGN
Mo Viele

ADVISORY BOARD
Norbert Aas • Florence Alexis • Rashid Diab
Manthia Diawara • Elsabet Giorgis • Freida High
dele jegede • Kellie Jones • Sandra Klopper
Bongi Dhlomo Mautloa • Gerardo Mosquera
Helen Evans Ramsaran • Ibrahim El Salahi
Janet Stanley • Obiora Udechukwu
Gavin Younge • Octavio Zaya

Cover: **Mikhael Subotzky and Gideon Mendel**, *Three Portraits for Okwui (composited)*, 2013/2020.
Ink on paper, 42.4 x 33.9 cm. each. Courtesy and © the artists

Nka wishes to acknowledge support for the publication of the journal
through generous grants from the Andy Warhol Foundation for the
Visual Arts, the Prince Claus Fund for Culture and Development,
The Hague, Netherlands, and David Hammons.

 C Fonds Andy Warhol Foundation

***Nka* is published by Duke University Press
on behalf of Nka Publications.**

CONTENTS

NUMBER 48, 2021

From the Editors

When we announced, in issue no. 44 of this journal, the March 15, 2019, death of our dearest friend, brother, and colleague Okwui Enwezor, we promised to find an appropriate way, beyond mourning, to commemorate him and celebrate his work and legacy. Two years have passed and we are still working, in collaboration with various institutions on different continents, on some long-term initiatives to conserve his library and archive and to collect his published and unpublished writings in dedicated volumes. These are challenging tasks, but we are fully committed to their realization in the coming years.

The decision to devote an entire issue of *Nka* to Okwui was one of the initial plans we had, yet only the fortuitous alignment of happenstance and intention made this current issue possible. In April 2020, just as the world was shutting down in response to the spreading devastation of the COVID-19 pandemic, we heard about a panel dedicated to Okwui's work at the 108th College Art Association Annual Conference in Chicago, February 12–15, 2020. After reviewing the panel information from the conference website, we contacted the two chairs, Jane Chin Davidson and Alpesh Kantilal Patel, both art historians based, respectively, at California State University, San Bernadino, and Florida International University. Soon, we invited them to guest edit the section of this issue, consisting of articles by established and emerging scholars who either critically engage Okwui's work as a curator, or see his ideas as foundational to ways of understanding the role and place of art in a global and postcolonial context.

For many today who associate Okwui's name with unparalleled mastery and command of the praxis and discourse of contemporary art, it may be anything but surprising that his work has become the subject of vigorous scholarly examination in academic theses and dissertations, book chapters, and art journals, and, yes, profiles in glossy fashion and lifestyle magazines. That is as it should be. Even so, we must note how truly remarkable and exceptional Okwui's career was and how dramatic his impact has been on the art world of the past three decades.

In early 1994, Okwui reached out to a number of us—young artists, critics, and scholars scattered on three continents—who through our individual practices sought to rethink the shape of things in the different art scenes we inhabited: if in Africa, how to invigorate criticism and scholarship on contemporary art to compete favorably on the global stage; outside of the continent, how to pull our intellectual resources to fundamentally challenge the poor reception and perception of the work of African and African diaspora artists. To take on these urgent tasks, he needed each of us to join him in the birthing of a journal of contemporary African art that he would call *Nka*, the Igbo word for art or craft. *Nka*, he argued, would "work towards building the kind of forum necessary to help unite and engage the different spectrums of African viewpoints on 20th century cultural practices."[1] Yet, he did not invite only African viewpoints; he called on anyone willing to devote a "critical intelligence and open-minded analysis" to the study of contemporary African art to join us in the work of establishing a vigorous discourse.[2]

Twenty-six years later, we believe that *Nka* has more than fulfilled Okwui's original dream, not only because it has become, indisputably, the foremost platform for critical discourse and scholarship on modern and contemporary African and African diaspora art. The small team Okwui convened in 1994, in its work within and outside the journal, helped establish what is now a vigorous field of study in the academy and a thriving sector in the international art industry. *Nka* has indeed come a long way from the early days when Okwui solicited donations from family and friends to ensure that we kept to our publishing schedule. Artists first profiled in our pages and contributors who published their first articles here have respectively become well-known names and leading scholars. *Nka*'s success, which we hope will outlive us, is indeed a monument to Okwui's visionary work and to his rich, impactful, though brief, earthly sojourn.

It is with all this in mind that we are excited to work with the guest editors of the scholarly articles published in this special issue. Chin Davidson and

Journal of Contemporary African Art · 48 · May 2021
DOI 10.1215/10757163-8971229 © 2021 by Nka Publications

Patel, two scholars and curators of global contemporary art whose key works have focused, respectively, on Chinese diaspora and transnational South Asia, represent the type of emergent critical practice Okwui anticipated in the early 1990s. Just as Okwui invited collaborators with an African perspective and others who might open up and redraw the boundaries not just of African and African diaspora art but, quite importantly, the global art scene, our guest editors have demonstrated, through their own work, an intellectual affinity with this journal's mandate. While their College Art Association conference panel theme aligned with our broader wish to support scholarship on Okwui's work, it is equally important to note that their collection of articles is as much about him as it is a space for critical analyses of key episodes, ideas, and histories of contemporary art of the past twenty-five years.

What these articles make clear is that in his lifetime, and because of the significance and impact of his work as a curator, critic, and scholar, Okwui became an idea, in other words, a research subject open to anyone invested in contemporary art. During our many years together, we witnessed how his difference-making practice made of him an intrepid public intellectual and the finest advocate of our collective vision of a more equitable, diverse, and decolonized art world.

With that said, Okwui was for us primarily a brother and friend with whom we shared bitter and joyful experiences of striking out, as young Africans, to claim the right to self-assertion in the art world dominated by the late twentieth-century anxious remnants of Empire. Just as our network of collaborators at *Nka* grew over the years, so did the circles of colleagues and peers—artists, critics, curators, intellectuals, art historians—with whom Okwui interacted from the early days to the very end. We invited a few of these individuals, who became part of our world of meaningful friendships, to contribute to the second part of this special issue, consisting of personal tributes to Okwui.

Over the years, we published memorials on individuals whose work contributed in no small way to the scholarship, discourse, and practice of modern and contemporary African and African diaspora art. However, our decision to include a collection of personal tributes to one individual in this issue is unprecedented for *Nka*. It is, for us, a unique and appropriate way of paying our respects to the founding publisher and, until he passed away, coeditor of this journal. More important, it is to insist that while Okwui has become a research subject, an idea, he was a colleague, friend, and brother to a community of active players in the world of contemporary art—individuals whose life and work Okwui touched with his.

Chika Okeke-Agulu

Salah M. Hassan

Notes

1 Okwui Enwezor, "Redrawing the Boundaries: Towards a New African Art Discourse," *Nka: Journal of Contemporary African Art* 1 (1994): 7
2 Enwezor, "Redrawing the Boundaries," 7.

OKWUI ENWEZOR
and the Art of Curating

Jane Chin Davidson and
Alpesh Kantilal Patel

Okwui Enwezor was the eminent theorist, critic, and curator who transformed the definition of the "global exposition," and with great respect, this special *Nka* journal issue commemorates the philosopher-historian whose passing on March 15, 2019, was a tremendous blow to the art world. He was one of *Nka*'s founding editors, and we understand the immense privilege to be invited by Chika Okeke-Agulu and Salah Hassan to contribute our edition of articles to honor him. The opportunity came after we presented our panel "Curatorial Impacts—the Futures of Okwui Enwezor (1963–2019)" at the College Art Association (CAA) Annual Conference in February 2020.

Futures of Enwezor
Enwezor has been a profound influence, a dynamic figure who embodied the political intellectualism that we continue to strive to emulate. In this introduction, we will discuss our personal stakes in this endeavor and provide a conceptual framework, based on Enwezor's influential writings and curatorial practice, through which to consider the articles by Natasha Becker, Monique Kerman, Amelia Jones, Susette Min, Anne Ring Petersen and Sabine Dahl Nielsen, Przemyslaw Strozek, and Mary Ellen Strom and Shane Doyle, along with a brief description of their contributions. To begin with, we will reflect on our experience putting together the panel in order contextualize the fraught and political field of art history and to underscore why Enwezor's work is and will continue to be so important for those of us, including the contributors, who are attempting to write ethically for the field.

The "Curatorial Impacts" panel was meant to bring together the art historians, artists, curators,

 Journal of Contemporary African Art · 48 · May 2021
DOI 10.1215/10757163-8971243 © 2021 by Nka Publications

researchers, and art critics who also saw Enwezor as an important intellectual. We thought our call for papers would be flooded with submissions, if indeed other panels commemorating him did not create a competition. To our complete surprise, we received only a few responses to our Call for Proposals (CFP), and no other panels of the kind emerged at the 2020 CAA conference. After speaking with our colleagues about this unique situation, we started to realize that in the minds of the art world, Enwezor was considered as an exhibition curator and biennial organizer and not as an "academic"—the repetition of this statement among those we questioned was weirdly revealing. The implication is that CAA is more academic and, therefore, the lack of submissions not surprising, leaving us with the question: What exactly is this distinction between the academic and the curatorial, given that Enwezor had fulfilled the fluid role of professor/historian/researcher/curator in many different contexts? His various teaching positions included visiting professor of art history at the University of Pittsburgh, at Columbia University, and at New York University as the Kirk Varnedoe Visiting Professor. Also, Enwezor was not a stranger to the College Art Association, having been awarded the CAA Frank Jewett Mather Award in 2006 "for significant published art criticism." Reassessing, we organized the CAA panel to proactively invite panelists whose scholarly practices are also fluid between curating and writing.

There is no question that Enwezor was a scholar (if not an "academic"), and thus it was clear that there were other factors driving the outcome of our CFP. So, what was the reason for the frankly anemic response to our call for papers? Was it simply the particular perception toward the exhibition world by those in the academic universe? We can never know for sure, of course, but at least part of the reason, we posit, is the underlying xenophobic unconscious that persists in the discipline of art history. For instance, organizations such as the USA Africa Dialogue Series (the virtual sociocultural forum), rooted in African studies, had reposted our CAA Call for Proposals, which was entirely welcomed, but it was telling that we were not seeing the CFP announced by groups exploring contemporary art more generally. The important point is that Enwezor

was especially influential in the way his research for both curating and art history crossed seamlessly from African studies to contemporary art subjects not necessarily marked by region. Therefore, another goal for the panel, and by extension this special volume, which includes extended versions of many of our panelists' papers, was to incorporate a mix of contributions from diverse cultural perspectives that addressed the regional and transnational in equal measure.

Foreshadowing Decoloniality and Whiteness

Almost twenty years after Documenta11, the loss of Enwezor comes during a critical reckoning in the institutions of art, when the processes for exhibiting, researching, discussing, and evaluating have been undergoing a "decolonizing" review. As revealed by the contributions to this special issue, Enwezor has long been an important model for those of us doing cultural work with respect to efforts in confronting the Eurocentrism of the *art history* practice in particular—a predetermined system, which has a lot to do with the lack of response to our CFP. The connective thread among all of the essays is the way in which Enwezor foreshadowed the capitalist-colonialist "crisis" from the purview of a Eurocentric art history whose center no longer holds.

Well before the terminology of the colonial/decolonial appeared in larger art-historical contexts, Enwezor was reinventing the vocabulary for the "use" of exhibitions in the writing of decoloniality in art history. In his 1997 exhibition catalogue for the Second Johannesburg Biennale, *Trade Routes: History and Geography*, he explained that his goal as the chief curator was to examine the history of globalization through the ways in which the exhibition itself could "explore how culture and space have been historically displaced through colonisation, migration, and technology. . . . emphasising how innovative practices have led to redefinitions and inventions of our notions of expression, with shifts in the language and discourses of art."[1] This statement codifies Enwezor's enduring innovation and radical intellectual agenda for what an exposition can do.

Moreover, his 1997 essay "Reframing the Black Subject," published a year earlier in *Third Text* and three years after the official end of South Africa's

apartheid, clarifies his *politics* of decolonization. Looking back, Enwezor's analysis on whiteness as a particular form of exclusionary power resonates today as a point of exposure of the key structure for systemic racism in the art world. Contextualizing race as a predicament of art and representation, he notes that "in the specific example of South Africa, as in the American model, the identity of whiteness binds itself to the exclusionary politics of national discourse."[2] He goes on to acknowledge colonization as the source of the "paradoxical affirmation of origin and a disavowal of past histories," which constitutes an inexorable ambivalence and, therefore, "what needs interrogation is usage of any fixed meaning of blackness as an ideology of authenticity or whiteness as a surplus enjoyment of superiority."[3] As such, the decolonial project requires continuing exposure of this ideology in which Blackness is separated by cultural origins as a logic for maintaining the superiority of whiteness. This logic is one that persisted into 2020, perceivable in the ambivalence toward the subject of Enwezor himself as we sought to honor his achievements at the CAA conference. The historical relation extends to the assumption that he was indeed *not an academic,* the misconception acknowledged by our colleagues. The task of decolonizing the very system of art history returns to the concept of identity, which Enwezor suggested in 1997, was under "persistent academic attack" because "the archaic formulation of whiteness" was embedded in nationalistic desire.[4] What is significant is that he had exposed the colonial unconscious of the academic pursuit, revealed as inextricable from the sovereignty of whiteness under the guise of national discourse.

It is worth emphasizing that, as a founding editor of *Nka: Journal of Contemporary African Art,* Enwezor was an eminent scholar; his curatorial research and practice are indisputable as prodigious contributions to the field of contemporary art and exhibition studies. This vanguardism in respect of the *entirety* of his professional impact was the reason why we wanted to celebrate his accomplishments. Nevertheless, the very nature of the colonial unconscious, or better understood as consciousness in the context of "nation," was always a Hegelian precondition in the academy, and when Susan Buck-Morss wrote "Hegel and Haiti," she implicated

the "scholarly consciousness" in the discourse of slavery, because entrenched academic disciplines are reproduced through the sovereignty of whiteness/nationalism: "there is no place in the university in which the particular research constellation 'Hegel and Haiti' would have a home."[5] Hegel's *Philosophy of History* was instrumental in establishing the academic system ascribed to the "geographical basis of history"—under the organizing principle of his "world spirit," every culture/nation was detrimentally stereotyped against the sovereignty of Europe (whiteness).[6] In the politics of exclusion, as revealed by Buck-Morss, the discrepancy must be maintained in scholarship between Hegel's Euro-sovereign philosophy and the African subject, illustrating the master/slave dichotomy in intellectual discourse.

It is our belief that Enwezor's initiatives affected the "scholarly consciousness" a great deal, and this edition of articles pays homage to the myriad ways in which he impacted the different disciplinary fields for art's exhibition, research, and discourse. In retrospect, what we see in the "decolonial" was initiated not only through his writings and his curatorial practice but primarily through an embodied courage of convictions that gracefully shone through all of his endeavors, one that superceded the careerist role of either the university researcher or the exposition curator. The academic continuation of the colonial unconscious is perceivable in both nation-state distinctions and their respective disciplinary studies beyond "Hegel and Haiti." According to Harry Harootunian, the partitioning of knowledge by geography was an explicit field of inquiry established after World War II: "in colleges and universities, area studies were a response to the wartime discovery of the paucity of reliable information concerning most of the world outside Europe."[7] Contextualizing contemporary Asian subjects, for instance, requires constant inscription of the essentialist geography for naming "Asian" artists, as differentiated from "Asian American" artists who exhibit in the United States. In the surveilling of "the implacable enemy," consisting of "Japan, China, and the former Soviet Union," argues Harootunian, "the humanities continue to authorize the still axiomatic duality between an essentialized, totalized, but complete Western self and an equally essentialized, totalized but incomplete East."[8] For so long, this

Hegelian-defined history of knowledge was systematized according to the West and the East, and in the context of art and culture, the entrenched scholarly consciousness of art history constitutes the organizing philosophy that aligns with systemic racism.

We can attest to the impact of Enwezor's methodology, based on our own research on contemporary art in transnational China and South Asia addressing the problematic construction of cultural geographies in the colonialist production of knowledge (its Hegelian history will be discussed later in this introduction). For example, Jane Chin Davidson's development of her 2019 book *Staging Art and Chineseness: the Politics of Trans/Nationalism and Global Expositions* was explicitly affected by the ways in which Enwezor "staged" the global exposition in the context of art and nationalism as a political framework. Enwezor's achievement as curator/researcher of the 1997 Second Johannesburg Biennale not only showed the political efficacy of global expositions, but also recognized the geographical contexts they could convey. Likewise, Chin Davidson frames her study with the 1992 Guangzhou Biennale, the first-ever biennial-type exposition held in China, in order to examine the political contradictions of a "global contemporary art" during the period when biennials, triennials, and global art fairs appeared as the new "global art institution." As well, Enwezor's approach to Documenta11 provided a model for the study of the politics of borders ascribed to Chinese contemporary art and the identification of Chinese artists by nations, locations, and exhibitions. Enwezor had long before addressed "the cultural mapping, the ideologies, and methodologies for the study of contemporary art produced by cultures that were categorized as 'non-Western' during the twentieth century."[9] He ultimately contributed to the redrawn landscape of art and art history in the globalized twenty-first century.

In many ways, and far afield from bounded geographies, Alpesh Kantilal Patel's 2017 book *Productive Failure: Writing Queer Transnational South Asian Art Histories* is directly indebted to the discussions curated by Enwezor as part of his Documenta11's Platform 3, "Créolité and Creolization." Patel's study works toward "creolizing transnational South Asian art histories," as modeled by Enwezor's workshop held on the West Indian island of St. Lucia in the Caribbean from January 12 to January 16, 2002. The forum brought together a range of scholars, writers, and artists—Stuart Hall, one of the participants, explored the genealogy of the titular terms as well as a third term, "Creole," and their potential to describe phenomena beyond their historically and geographically specific origins to the contemporary art world. Patel adapted this Creole distinction to expand the understanding of South Asian subjects in his book beyond the norm of culture, nation, and borders, especially across racial and sexual identities. This allowed him to a construct a queer transnational art history, for instance, that included the work of Cy Twombly alongside the work of artists who are more traditionally considered "appropriate" for a history invested in transnational South Asia.

Staging the difference between the curatorial and art history, it is interesting to note that Enwezor's "Créolité and Creolization" platform took place only a few months before the 2002 Sterling and Francine Clark Art Institute conference "The Art Historian: National Traditions and Institutional Practices," organized by Michael Ann Holly and Mariët Westermann.[10] The disjunction between the two gatherings was apparent, since there was no overlap in terms of ideology or participants.[11] Enwezor's Platform 3 did not address art-historical practices and was largely populated by visual culture scholars, curators, and artists, while the Clark conference eschewed discussions of creolization, diaspora, or migration, with the exception of a brief dialogue on global art history.[12] While Patel's book also endeavored to bridge the divide exemplified by this situation, Chin Davidson's adopted the dialectical politics of Enwezor's expositions.

Art History as a Critical Constellation

Taking the cue from Buck-Morss, the articles in this special issue acknowledge the capacity for the "research constellation" that accommodates Enwezor's scholarly model, by which African subjects and the curatorial research/practice of global expositions convene in the discipline of art history. It is important to recognize, however, that "the archaic formulation of whiteness" in today's academic profiling continues to represent the "universal" subjects of contemporary art. An integral part of Enwezor's

inspiration is the challenge to this exclusive "contemporary art" category while maintaining African or Asian (or any other cultural subjects) that should not be overdetermined as always separate fields (although, specialization in the scholarship of individual subjects remains important).

Enwezor was eloquent in his confrontation of the exclusionary practices of art and art history. His 2003 essay "The Postcolonial Constellation: Contemporary Art in a State of Permanent Transition" undertakes the system of imperialism by describing a nonlinear approach to art history and through contextualizing the production and consumption of "contemporary" art.[13] He argues that "contemporary" art must be understood not only through current discourses of globalization, but also historical ones of imperialism: "Contemporary art today is refracted . . . from the standpoint of a complex geopolitical configuration that defines all systems of production and relations of exchange as a consequence of globalization after imperialism. It is this geopolitical configuration and its postimperial transformations that situate what I call here 'the postcolonial constellation.'"[14]

Enwezor's essay deployed concepts that Walter Benjamin also described as a "critical constellation."[15] Benjamin writes that when researchers "abandon the tranquil contemplative attitude" toward their subject matter, they can become the "conscience of a critical constellation" in which individual elements are brought into juxtaposition with each other for mutual illumination.[16] Benjamin ultimately replaced the Hegelian model of dialectics with the model of the constellation. Such an approach for this special issue allows for affinities and correspondences among the articles exploring contemporary art in Africa, North America, and Europe to remain prominent without blurring their distinct elements into a singular categorical meaning. Griselda Pollock invokes Benjamin (and implicitly echoes Enwezor) when she defines how "moments" serve as the foil for "disciplinary Art History's categorization of time into period and art into movement."[17] That is, the organization of artworks into successive and chronological movements tends to belie the unruly ways in which histories unfold. Along this line of thinking, our method is to provide an ideological matrix connecting the essays in order to reproduce

a provisional and aleatory, rather than a fixed and linear, art historical knowledge.[18] Benjamin, who has been referred to as a "a quantum physicist of history," also rejected the predetermined conception of history as seamless, rational, and objective, based on a model of history that is fractured, messy, and subjective.[19]

Enwezor's "Postcolonial Constellation" was published just a year after his Documenta11 exhibition, which he described as "a constellation of public spheres."[20] The exposition included conversations as part of what he called "platforms" across the globe. Bringing together the Global North (Platform 1 taking place in Vienna, Austria, and Berlin, Germany, and Platform 5 in Kassel) and the Global South (Platform 2 taking place in New Delhi, the aforementioned Platform 3 in St. Lucia, and Platform 4 in Lagos), he decentralized the formation of art-historical knowledge. Indeed, Documenta11 becomes the example par excellence of *constellating as a methodology* and, not surprising, several of the articles in our special issue take this important exhibition as a point of departure or point of reference. Altogether, the varied connected strands of political, social, and aesthetic contexts explored in this edition of articles functions as a curatorial methodology for art history in the twenty-first century.

Forging the Futures of Okwui Enwezor

Each of the contributors to this special issue of *Nka* engage in the different ways that Enwezor expanded the field of art, exhibitions, and art history while contesting the academic unconscious of nationalistic desire (whiteness). Natasha Becker's essay "In the Wake of Okwui Enwezor" starts off the edition by bridging the testimonial reflection with the theoretical and historical contexts of knowledge production. As a twenty-three-year old university student in Cape Town, Becker saw firsthand Enwezor's Johannesburg Biennale as the "ground zero for an art system that had hardly scratched the surface of dismantling more than three centuries of racist colonial and apartheid history" during the cathartic period when "two thousand public hearings were held from 1997 to 1998 about the abductions, killings, torture, and other violations committed by the apartheid state." In this empirical context, Becker's examination of Enwezor's *Trade Routes: History*

and Geography situates the Johannesburg Biennale in the dynamic of the curator's innovative strategies, acknowledging the ways in which the exhibition "challenged the status of the existing canon on African art, but also proposed a new counter-canon." At the same time, Becker reveals the enduring logic of art-historical nationalism, since the Second Johannesburg Biennale was largely left out of the Euro-American mainstream of research on biennials and global expositions.

In her study "The Rallying Call to Decolonize: Okwui Enwezor's Legacy" Monique Kerman extends further the contextualization of Enwezor's historical contribution to the decolonial project by returning to the artistic and political initiatives of his curatorial achievements: his 1996 *In/Sight: African Photographers, 1940–Present* and the 2001 exhibition *The Short Century: Independence and Liberation Movements in Africa, 1945–1994*, mounted one year before his groundbreaking Documenta11. Kerman explains the veracity of Enwezor's curatorial practice as one that addressed the imbalances of a Eurocentric art history, resulting from colonialism as a domination of "every aspect of lived experience, not just in the colonized space or era but far beyond it." How naive we are to think that the Hegelian consciousness no longer resides in the capitalist/colonialist inheritance of art history.

How then is a decolonizing of art history possible? Art historian Przemyslaw Strozek makes the case in "Abdelkader Lagtaâ and His Conceptual Exercises in Poland (1971–73)" by attributing to Enwezor the model for research that radically transforms the origin story by which artistic conceptualism is presumed to be a "Western" practice and ideology. By situating the work of African artists in the 1950s to 1980s, such as Frédéric Bruly Bouabré from Cote d´Ivore, the Laboratoire Agit'Art group from Senegal, and Rachid Koraïchi from Algeria, Enwezor made the case for a conceptual art that "was practiced in Africa long before avant-garde and neo-avant-garde tendencies and stressed that the above-mentioned artists developed, independently and in a similar manner as Western conceptual artists." Strozek thereby presents the work of Moroccan artist Abdelkader Lagtaâ, who moved to Poland in the 1970s, to reassess the preconceived origins of Euro-American conceptualism.

By initiating the terminology of "global conceptualism," Enwezor, along with Salah Hassan and Olu Oguibe, had redefined African conceptualism of the 1970s for the *Authentic/Ex-Centric* exhibition at the 2001 Venice Biennale. Strozek's study of the African artist in Poland contributes to the new global genealogy that delimits the Western sovereignty over the history of contemporary art.

The concept of decolonization for this special issue would be an ineffectual one if Enwezor's contribution was strictly on behalf of a rarefied art-historical or curatorial discourse. Susette Min examines Enwezor's role as guest curator of the 2012 Paris La Triennale *Intense Proximité* in respect of his curatorial premises for dealing with the contentious debates surrounding immigration and French history. In "A Host of Possibilities: Okwui Enwezor's Exhibition Making as a Practice of Hospitality," she contextualizes the terms of "hospitality" as related to Enwezor's position "as a temporary host for the French ministry of culture" at a time when Far Right factions were demeaning undocumented immigrants for "overstaying their welcome." In 2011, five hundred undocumented workers had occupied the National Museum of Immigration History in Paris in order to demand documentation and fair treatment. Min addresses the "unique situation that necessitated an acute attentiveness to France's global, transnational, and translocal context from the point of view of a foreigner, stranger, intruder, and neighbor," characterizations that determine the treatment of guests by the hosts of any country.

Correspondingly, contributors Anne Ring Petersen and Sabine Dahl Nielsen's article "Enwezor's Model and Copenhagen's Center for Art on Migration Politics" recognizes the very migrant relations that could be engaged through the art exhibition as a public space. Their study of the Center for Art on Migration Politics (CAMP), which continued in Denmark from 2006 to 2020, distinguishes the potential of a gallery program that brought together refugees, migrants, asylum seekers, artists, activists, educators, and scholars who worked to mobilize political exhibitions. Petersen and Nielsen attribute the notion of the exhibition as "a space for critical engagement with the world" and public discourse to the *postcolonial* platforms model Enwezor instantiated for Document11. The critical

curatorial engagement envisioned by Enwezor—his "interlocking constellations of discursive domains, circuits of artistic knowledge production, and research modules"—provide an example for understanding the potential of art exhibitions that could function as sites of sustainable activism, infrastructure, and community connection.[21]

In this way, Enwezor developed insightful and inciteful ways of conceiving the politics of the exhibition, which Amelia Jones addresses by analyzing "two hybrid curatorial/artistic practices" found locally in her Los Angeles vicinity: the Hauser and Wirth gallery's 2019 *David Hammons* exhibition and the 2020 *Care not Cages* project at the nearby Crenshaw Dairy Mart. In her essay "Ethnic Envy and Other Aggressions in the Contemporary 'Global' Art Complex," Jones's broader context for understanding the global-capitalist norm of the art industry is based on Enwezor's oppositional vision as "one of the few international-level curators who warned us well of the dangers of the pretenses and hidden violence of the 'global' art complex." In the space of a "global Los Angeles," both radical pretenses and exposures of violence, circulating around contexts of race, class, and immigration, can coexist in the production of exhibitions.

The final article, coauthored by artist/curator Mary Ellen Strom and Native American researcher Shane Doyle, discusses their anticolonial project "Cherry River: Where the Rivers Mix," restoring the past of Native place names to envision the future of the exhibitions of art. The photographic essay documents the multimedia event involving Indigenous and local forms of music, dance, and song while centering on performative and community actions. The Cherry River event reimagines the possibilities of exhibitions. Enwezor's notion of interlocking constellations was renewed by Strom and Doyle, but also used as a metaphor for the exhibition as a new kind of practice that functions as a reclamation.

In closing, we strive to practice a different methodology for this special issue from the colonialist and heteronormative "white" and "whole" standardization of knowledge, what Foucault called the unities of discourse.[22] Our *constellating* privileges bring together discursive irregularities such as refugee, outcast stateless, and Indigenous subjects. To reiterate, doing so is not to universalize these positions but to consider the relations between them. The refugee subject often connotes a sense of wandering or homelessness, whereas the Native subject, a rootedness to a singular, fixed locus. Of course, the framing of refugees as homeless subjects discounts how they do in fact "place-make," even if outside of official recognition. Both instances are reminders that statelessness is an effect of empire and the colonialist construction of the nation-state. Likewise, the framing of the Indigenous as immobile subjects elides those who forge homes outside of "traditional" tribal land, the parameters of which are often state-sanctioned, nevertheless.[23] In this way, we suggest that these articles exploring diverse subjects, often seen as separate categories with subject positions that are highly contingent and deeply entangled in the regulation of the other, attempt to follow Enwezor's model for the decolonial critical constellation, as each contributor recognizes with deep respect the myriad ways that he impacted art-historical and curatorial knowledge. At the same time, while this volume is a commemorative and therefore reflexive of the past, we also see it as one that makes explicit the futures of Okwui Enwezor's scholarship that can be palpably felt *now* in the articles compiled in this volume.

Jane Chin Davidson is an associate professor of art history and global cultures at California State University, San Bernardino. Alpesh Kantilal Patel is an associate professor of contemporary art and theory and an affiliate faculty member of both the Center for Women's and Gender Studies and the African and African Diaspora Studies Program at Florida International University in Miami.

Notes

1 Okwui Enwezor and Colin Richards, *Trade Routes: History and Geography: 2nd Johannesburg Biennale 1997* (Johannesburg: Greater Johannesburg Metropolitan Council, 1997), 9.

2 Okwui Enwezor, "Reframing the Black Subject: Ideology and Fantasy in Contemporary South African Representation," *Third Text* 40 (1997): 23.

3 Enwezor, "Reframing the Black Subject," 39.

4 Enwezor, "Reframing the Black Subject," 22.

5 Susan Buck-Morss, "Hegel and Haiti," *Critical Inquiry* 26, no. 4 (2000): 822.

6 Georg Wilhelm Friedrich Hegel, *The Philosophy of History*, trans. J. Sibree (Kitchener, Ontario: Batoche, 2001).

7 Harry Harootunian, "Tracking the Dinosaur: Area Studies in a Time of Globalism," in *Uneven Moments: Reflections on Japan's*

Modern History (New York: Columbia University Press, 2019), 25.

8 Harootunian, "Tracking the Dinosaur," in *Uneven Moments*, 23.

9 Jane Chin Davidson, *Staging Art and Chineseness: Politics of Trans/Nationalism and Global Expositions* (Manchester, UK: University of Manchester Press, 2020), 1.

10 The proceedings for the Clark conference can be found in *The Art Historian: National Traditions and Institutional Practices*, ed. Michael F. Zimmermann (Williamstown, MA: Sterling and Francine Clark Art Institute, 2003).

11 Participants of Platform 3 included Petrine Archer-Straw, Jean Bernabé, Robert Chaudenson, Juan Flores, Stuart Hall, Isaac Julien, Dame Pearlette Louisy, Jean-Claude Carpanin Marimoutou, Gerardo Mosquera, Annie Paul, Virginia Pérez-Ratton, Ginette Ramassamy, Françoise Vergès, and Derek Walcott. Among those invited to "The Art Historian: National Traditions and Institutional Practices" were Mieke Bal, Stephen Bann, Horst Bredekamp, H. Perry Chapman, Georges Didi-Huberman, Eric Fernie, Françoise Forster-Hahn, Carlo Ginzburg, Charles W. Haxthausen, Karen Michels, Willibald Sauerländer, Alain Schnapp, and Michael F. Zimmermann.

12 Okwui Enwezor et al., eds., "Introduction," in *Créolité and Creolization: Documenta 11_Platform 3* (Ostfildern-Ruit, Germany: Hatje Cantz, 2003), 16. In the book edited by Michael F. Zimmerman that was published a year after the conference, the author cites Enwezor's *Documenta 11*. See Zimmermann, "Introduction," in *The Art Historian*, xxii [n9].

13 Okwui Enwezor, "The Postcolonial Constellation: Contemporary Art in a State of Permanent Transition," *Research in African Literatures* 34, no. 4 (2003): 58.

14 Enwezor, "The Postcolonial Constellation," 58.

15 Benjamin's fragmentary ideas of the constellation can be found in a variety of his works such as *The Origin of German Tragic Drama*, trans. Howard Eiland (1928; repr. Cambridge, MA: Harvard University Press, 2019); and "On the Concept of History" (1940), published as "Theses on the Philosophy of History," in *Illuminations: Essays and Reflections*, trans. Harry Zohn, ed. Hannah Arendt (Cambridge, UK: Fontana, 1970), 255–66. Among others, recent consideration of the constellation in the humanities can be found in Nassima Sahraoui and Caroline Sauter, eds. *Thinking in Constellations: Walter Benjamin in the Humanities* (New Castle upon Tyne, UK: Cambridge Scholars, 2018); and Graeme Gilloch, *Critical Constellations* (Cambridge, UK: Polity, 2002). Benjamin further develops *constellation* in the context of urban space as a concept in his Arcades Project.

16 Walter Benjamin, "Eduard Fuchs, Collector and Historian," *Selected Writings, Volume 3, 1935–1938*, ed. Michael W. Jennings, Howard Eiland et al. (Cambridge, MA: Belknap, 2002), 262.

17 Griselda Pollock, "Wither Art History," *Art Bulletin*, 96, no. 1 (2014): 12, 22 [n17].

18 It is interesting that the art history department of University of Pittsburgh has "recast itself by adopting its Constellations model." Faculty are grouped into categories such as visual knowledge, agency, identity, environment, mobility/exchange, and temporalities. This restructuring of the department away from art-historical periodization or geography appears synonymous with Benjamin's concept. See "History of Art and Architecture: Constellations," University of Pittsburgh, haa.pitt.edu/graduate/constellations (accessed January 9, 2021).

19 Eric Kligerman, "From Kant's Starry Skies to Kafka's Odradek: Walter Benjamin and the Quantum of History," in *Thinking in Constellations*, 4.

20 Okwui Enwezor, "The Black Box," in *Documenta 11_Platform 5: Exhibition Catalogue*, ed. Heike Ander Ander and Nadja Rottner (Berlin: Hatje Cantz, 2002), 54.

21 Enwezor, "The Black Box," in *Documenta11*, 42.

22 Michel Foucault, "The Unities of Discourse," in *The Archaeology of Knowledge*, Part II, trans. A. M. Sheridan Smith (New York: Pantheon, 1972), 21–30.

23 Robyn Sampson and Sandra M. Gifford, "Place-making, Settlement and Well-being: The Therapeutic Landscapes of Recently Arrived Youth with Refugee Backgrounds," *Health and Place* 16, no. 1 (2010): 116–31.

IN THE WAKE OF
OKWUI ENWEZOR

Natasha Becker

I was astonished by the experience of standing there, where the two oceans met. I knew at that very moment this would be my concept: the meeting of worlds.

—Okwui Enwezor, *Trade Routes Revisited: A Project Marking the 15th Anniversary of the Second Johannesburg Biennale* (2012)

I was a twenty-three-year-old university student in Cape Town when Okwui Enwezor curated his first international exhibition, the Second Johannesburg Biennale, in South Africa in 1997, adopting the theme *Trade Routes: History and Geograpy*. My clearest memory of that time is of sitting down in our family living room every afternoon to watch the Truth and Reconciliation Commission (TRC) hearings unfold on our television screen. The TRC was like a gigantic vending machine; people lined up to insert a quarter in the slot and receive information about the deaths or disappearances of their brothers, sisters, mothers, fathers, uncles, neighbors, comrades, school friends, fellow parishioners, sports clubs, you name it. Two thousand public hearings were held from 1997 to 1998 about the abductions, killings, torture, and other violations committed by the apartheid state, liberation movement, and individuals during 1960 to 1994. Collectively, we were glued to the television like zombies. When we were not watching, we were thinking about it or talking about it. I was so enthralled by the unfolding revelations that I chose to examine notions of truth and reconciliation underpinning the TRC for my philosophy honors research paper.

 Journal of Contemporary African Art · 48 · May 2021
DOI 10.1215/10757163-8971257 © 2021 by Nka Publications

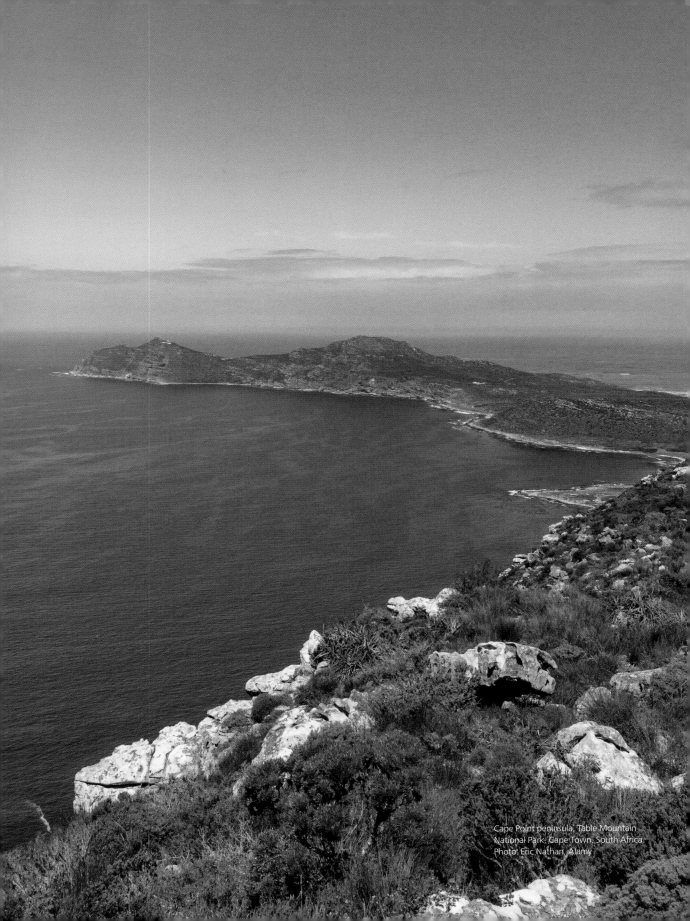

Cape Point peninsula, Table Mountain
National Park, Cape Town, South Africa.
Photo: Eric Nathan, Alamy

Seven years later, in 2003, I arrived in the United States to begin doctoral studies in art history. People in the arts, artists and curators especially, assumed that I had seen the Johannesburg biennales. I knew absolutely nothing about them. I came to America to pursue my scholarly interest in race and representation in South African photography, but at every turn I was confronted with an event that left an indelible mark on the history of contemporary African art and exhibitions in the United States. I soon embarked on an independent study of the historiography of contemporary African art and the Johannesburg biennales. Enwezor was at the center of the discourse and practice, an intention he articulated in an interview during the 2015 Venice Biennale, while reminiscing about his first impressions of the United States:

> I came from a generation of the post-independence era in Nigeria in the 60s. . . . Growing up in Nigeria with a sense of purpose, with a sense . . . of the idea of the complete entanglement of destinies and processes. And arriving in the United States and, you know, seeing myself on the margins of that was not really what I thought my life should be. I want to be at the center of the conversation in whatever I do, whether as a lawyer, as a teacher, a writer or, as the case may be, as a curator.[1]

Later, after having lived in the United States, he observed: "What was apparent was that most Americans I knew and met were actually not worldly at all, but utter provincials in a very affluent but unjust society. And when this became clear, I saw no reason why I could not have an opinion or a point of view."[2]

In my mind, Enwezor appeared on the American scene like Plato's proverbial gadfly: buzzing around the ears of authority, attacking intellectual orthodoxies, and provoking others into action. Before he became a curator, he knew how to wield the power of words as a writer and poet, and in launching *Nka*, he placed himself at the center of the conversation around African art in the United States.

Enwezor's 1994 *Nka* editorial "Redrawing the Boundaries: Towards a New African Art Discourse" packs a punch. He smashes exoticizing myths about African art and artists, upends the authority of Western intellectual traditions, brandishes the bullhorn to call for a new discourse of contemporary African art—promptly following it up with an invigorating way forward—and concludes by delightfully inviting those interested in participating to "enter the fray."[3] The questions he raised twenty-seven years ago still sting today: How do we historicize African art? What spaces are willing to give this art an empowering reality? What methodologies can account for the "variegated" realities of African culture? Who will lead these studies? What will unify it and, simultaneously, make room for individual expression?

Gadflies come in many shapes and sizes. Some are bombastic or cryptic. Others are sweet and funny. They can be angry, snarky, melancholic, sanguine, or superior. Regardless, each tells us when we have made or are about to make mistakes and reminds us of our proper duties and obligations. Enwezor had the talent for it, which only became strengthened and sharpened over time. He was constant and ubiquitous in his role as a gadfly.

Formations

Anyone who has visited South Africa and stood at the southern tip of the continent can relate to the moment of astonishment Enwezor describes in the epigraph quote at the beginning of this article. This spectacular sight is created by the juxtaposition of two rocky peaks, Cape Point and the Cape of Good Hope, with magnificent ocean views. Vernacular knowledge claims the spot as the meeting of the Atlantic and Indian Oceans, and a dramatic swirl of white surf in the far off distance seems to confirm it.

Bartholomew Dias, the Portuguese explorer, named the point Cape of Storms, because it was dangerous for ships attempting to round the Cape, which entailed turning more eastward than southward. The legend of the Flying Dutchman, a ghost ship which was said to never make port and doomed to sail the seas forever, emerged from the Cape's long history of shipwrecks. King John II of Portugal renamed it Cape of Good Hope because of the great optimism engendered by the opening of a sea route to India and the East. The Cape, as the tip of the peninsula is called in everyday language, is where trade routes connecting the West and East were established; where the first European country settled a colony to strategically control trade with the

East; and where violent wars, disease, enslavement, exploitation, and resistance in South Africa began.

Although the actual geographic meeting point of the Atlantic and the Indian oceans is Cape Agulhas (approximately ninety-three miles east southeast), the Cape of Good Hope is encoded, in patterns unknown, deep within the recesses of a localized primordial psyche as a fissure. Standing where the two oceans meet—nonrepresentational and silent as it is—Enwezor understood that the swirl of surf produced at the meeting point rubbed the past into the present and blocked the process of forgetting. Herein lay its potential to contribute to the political moment.

When he took up the position of artistic director for the Second Johannesburg Biennale in 1997, the event was in a crisis because of transformations in local governance, disagreements about the role of the biennale, and heated debates about race and representation in postapartheid South Africa. The stunning victory of Black South Africans in the 1994 political elections detonated an explosion of indescribable euphoria and decolonial agendas around the country. It was ground zero for an art system that had hardly scratched the surface of dismantling more than three centuries of racist colonial and apartheid history. Not one to shy away from a fray, Enwezor ran toward it.

Trade Routes

"While on the one hand celebratory, globalism, seen from the triumphalism of the twin axes of liberal democracy and the capitalist market economy, has produced its own dissonant chords, and places contingency at the heart of what defines the state of culture in many places for the last half of the twentieth century," Enwezor stated in the *Short Guide* to the biennale. "It is the intention of 'Trade Routes: History and Geography,' as the philosophical structure of the 2nd Johannesburg Biennale 1997," he continued, "to examine this dissonance, and to imply that it is within the dialectic of such disturbance that globalism is truly encountered."[4]

For his first biennale project, Enwezor gathered six international curators to curate independent exhibitions in response to globalization. "Collaboration" he later reflected, "is the way that we learn or we build bridges to different forms of

Okwui Enwezor, Second Johannesburg Biennale, Cape Town, South Africa, ca. 1997. Courtesy Makgati Molebatsi

knowledge that are not part of our own traditions."[5] This collaborative curatorial approach would become a hallmark of his practice, wherein he would invite opinions from different sources as an alternative to the practices of an authoritative mainstream art establishment.

Enwezor cocurated the main exhibition, *Alternating Currents*, with the Spanish-born curator Octavio Zaya, in Johannesburg. Together, they most directly addressed the biennale's critical concerns in a monumental exhibition that included eighty international artists and more than one hundred and forty artworks. Further, he oversaw a massive catalogue publication, an array of public projects and performances throughout the city, an extraordinary African diaspora film program curated by Mahen Bonetti, and a world-class academic conference convened by Olu Oguibe.

Scholars have argued that Enwezor's themes of migration and cultural traffic as sites of crises were

Left to right: Catherine David, Octavio Zaya, and Okwui Enwezor at the Second Johannesburg Biennale, 1997. Courtesy Makgati Molebatsi. Photo: Grant Lee Neuenburg/imafrica

prescient and that his Johannesburg biennale was a generous intervention within the specific and charged histories of South Africa.[6] It has been further said that the main thrust of his biennale was globalization related to colonialism, and that an examination of the enduring cultural melange formed by colonialism breathes new life into thinking about globalization. I could not agree more. I do, however, disagree with critiques that claim Enwezor was an ambitious intellectual rather than a traditional curator who downplayed aesthetics in favor of politics and history. Additionally, his ideas were considered by critics as highly esoteric and slightly out of place in Johannesburg, that his biennale had "separated itself from the imbalances that continue to afflict a country that has not yet located its own center of gravity."[7]

On the contrary, Enwezor's and Zaya's *Alternating Currents* engaged the present, refused to excise the past from that present, and kept together the displacements and migrations so characteristic of Johannesburg at that time. His biennale aligned African political artists with artists from the United States, Europe, South America, the Caribbean, Asia, and the Middle East to put forward a distinctive view of political art for that time.

Trade Routes mattered as much for the discourse it produced as for the artworks it presented. The exhibition checklist features extraordinary artworks that were made between 1989 and 1997 by artists whose critical acclaim we take for granted today but who were at that time still under-appreciated or emerging. Younger artists such as Tracey Rose, Wangechi Mutu, and Rivane Neuenschwander were either art students or recent graduates. Highlights from the show included William Kentridge, Ghada Amer, Bili Bidjocka, Tania Bruguera, Eugenio Dittborn, Stan Douglas, Olafur Eliasson, Touhami Ennadre, Coco Fusco, Felix Gonzalez Torres, Kendall Geers, Wenda Gu, Hans Haacke, Kay Hassan, Isaac Julien, Seydou Keita, Abdoulaye Konate, Vivienne Koorland, Zwelethu Mthetwa, Shirin Neshat, Gabriel Orozco,

Enesto Pujol, Teresa Serrano, Penny Siopis, Pascale Marthine Tayou, Vivan Sundaram, and many others. Artworks such as Kentridge's film *Ubu Tells the Truth* (1997), Carrie Mae Weems's silver prints and ceramic plates from the *Sea Island Series* (1991–92), and Yinka Shonibare's *Victorian Philanthropist's Parlour* (1996–97) were metaphors for the divisions cutting through the country yet actively widening the circle of involvement to the past and to other places.

Furthermore, *Trade Routes* not only challenged the status of the existing canon on African art, but also proposed a new counter-canon. It was crucial to the process of contestation and transformation of the canon that Enwezor and his *Nka* journal co-founders, Salah M. Hassan and Chika Okeke-Agulu, had initiated a few years before. This dimension of antagonism in Enwezor's curatorial practice was vital to his exhibitions and points to the productive aspects of visual arguments that have resulted in more complex and pluralistic understandings of art history and its canons. In Johannesburg, he demonstrated what it means to curate and to historicize, because he was not burdened by the Eurocentric canon of art history or the traditional procedures of institutional curating in South Africa. Instead, he aligned his critique of imperialism with a practice that was rooted in change. Despite his clear transgression of curatorial norms, Enwezor's biennale is curiously left out of canonical Euro-American, as well as less conventional, studies of art history and biennales.[8] For example, *Afterall*, a research center of University of the Arts London launched in 1999 by Charles Esche and Mark Lewis, has published since 2010 *Exhibition Histories*, a book series offering critical analyses of exhibitions of contemporary art but has yet to commission an edition on *Trade Routes*.

We also have not considered the fact that *Trade Routes* may very well speak to a different conception of the local or locality altogether, and that Enwezor's concept of the meeting of worlds might have greater analytical potential as a metaphor for the meeting point of two indecipherable South Africas. Under apartheid, Johannesburg was two "countries," and people lived in two different realities, depending on one's history, geography, race, ethnicity, class, gender, culture, education, and opportunities. How do we conjure the scene of this locality? The

dissonances of globalism still apply, but in this instance it is encountered in the dialectic between two localities, with each populace having different ideas about decolonization but wishing to establish a common truth after 1994. This would explain the kind of cataclysmic meeting that produced the atomic explosion that sent shockwaves of damage and destruction through the only two biennales to take place in Johannesburg in 1995 and 1997. Twenty years later, the resulting cracks and crevices on the biennale and the nation have been filled or buried, but the traces and fissures of this meeting point still remain.

Behind the Scenes
"We don't yet have a way of tending openly and honestly to historical events and developments *on the near side of racism*," wrote Darby English in 2010.[9] *Trade Routes* housed six different exhibitions and a plethora of public programs, and was held in two very different South African cities, Johannesburg and Cape Town. It was an extraordinary achievement at an extraordinarily difficult time—an epic trial by fire for a curator organizing his first major international art exhibition. Histories of exhibitions rarely explore or account for the diplomatic maneuverings and jack-of-all-trades work that curators have to master to pull off a successful biennale, especially when resources are extremely limited, as was the case in Johannesburg. The amount of communication that exhibitions entail and generate between organizers, curators, artists, writers, guest speakers, vendors, and various stakeholders is a feat in and of itself. There is also the curator's contribution to exhibition and publication texts, public programs, public speaking, press interviews, and constant travel for round-the-clock promotion—all of this is managed while engaging individuals, businesses, foundations, and galleries to seek and gather financial contributions in order to realize different components of the show. In this regard, Enwezor actively drew on his network and connections to fund the biennale's public projects, performances, and conference and raised the funds to keep the biennale going after the city shut it down prematurely. These accomplishments are miraculous to begin with, and yet the first biennale in 1995 was organized via fax machine and telephone, and the second was only

NKA

Journal of
CONTEMPORARY
AFRICAN ART

FALL/WINTER 1994 ISSUE I

$9.00

Cover of the first volume of *Nka: Journal of Contemporary African Art*, 1994

beginning to use email and the World Wide Web in 1997.

Enwezor constantly confronted the legacy of racism in small and big ways in South Africa. He was at the center of critical debates about race and representation, sparked by an essay he wrote for an exhibition of South African art in Norway. "Reframing the Black Subject: Ideology and Fantasy in Contemporary South African Art" critiqued the way certain white women artists were using images of Black women in their work, arguing that the practice "perhaps unconsciously" exacerbated the very stereotypes they sought to undermine.[10] The artists he discussed in his essay immediately went on the defensive, publicly condemning the curator at a biennale conference in Cape Town; later, South African critic Brenda Atkinson and artist Candice Breitz published their counter arguments in *Gray Areas: Representation, Identity and Politics in Contemporary South African Art*.[11] The unpleasant exchange that occurred at the conference was not just a dramatic moment between Enwezor and white women artists; a number of other critics, artists, and curators weighed in on the subject, either in person or in follow-up reviews and essays, including Olu Oguibe, Kendall Geers, Brian Axel, Carol Becker, Ernst van Alphen, Amanda Williamson, and Colin Richards, among others, generating a larger critical debate. Absent from this exchange, as many commentators have highlighted, were the voices of Black women. Decades later, all those involved have long since buried the hatchet and moved on.

Even so, the incident is instructive for locating the soft spots of a country steeped in racism as a system of oppression. When one grows up in such a society, everyone learns explicit and implicit stereotyped messages in families, schools, and communities about who People of Color and white people are. Regular and calm conversations about unlearning the stereotyped racial messages white artists, curators, gallerists, collectors, critics, and art historians have internalized were nonexistent in 1998. We still do not have a way of tending to it.

Nevertheless, most importantly, art and exhibition histories have yet to explore how Black curators confront systemic racism and sexism in the always present but usually invisible structures of colonialism and racial capitalism that shape the organization of culture and society. Then, as now, race still matters in America and South Africa, places where there is enormous historical, cultural, and emotional complexity in everything that a Black curator encounters. We still need an analysis of *Trade Routes* that weaves together public policies and institutional practices that reinforced and perpetuated racial inequality in South Africa; the advantages of being a white curator and the disadvantages associated with being a Black curator; the overall artistic outcome of systems of racism; the narratives and representations of Black people that were reinforced in the culture or countered in exhibitions; the values that allowed structural racism to exist; and the progress that was made in the history of art in South Africa to promote racial equality as well as how this progress was challenged, neutralized, or undermined.

Afterlife

"I can't think of a single show I have done since the Johannesburg Biennale that has not included South African artists," Enwezor wrote in 2012.[12] He had a profound respect for South Africa's diachronic trajectories and an excitement about South African artists' abilities to capture its ghosts and specters. He was gracious about the challenges of organizing an international biennale and confronting racism, choosing to acknowledge this period as critical to his formation and always placing the artists center stage. He made significant advances toward contemporary African art and a truly global history of art through the positions he staked out, the structures he challenged, the critical debates he sparked, and the people he worked with.

For this writer, the 1995 and 1997 Johannesburg biennales continue to be part of a wider fascination with the country's postapartheid apocalypse and its aftermath. The ghosts of the biennales still haunt South African history, bearing into the present a persisting and traumatic past. What needs to take place for something truly new to emerge?

Today, the resurgence of the decolonial and student protest movements in South Africa coincides with the Black Lives Matter movement and the antiracism protests roaring throughout America. These events have renewed public discussion about systemic racism. While there are all kinds of practical guidelines for how to talk about racism within the

Volume 19
Supplement
2020

20th
Anniversary
Reader

Meridians

feminism, race, transnationalism

20th Anniversary Reader
A supplement to *Meridians* volume 19

This critical anthology consists of thirty of *Meridians*'s most frequently cited, downloaded, and anthologized scholarly essays, activists reports, memoirs, and poems since its first issue was published in fall 2000. Ranging broadly across geographies (North America, Latin America and the Caribbean, the Middle East), diasporas (Black, Asian, Indigenous), and disciplines, the collection beautifully exemplifies the best practices of intersectionality as a theory, a method, and a politics.

dukepress.edu/20th-anniversary-reader

DUKE
UNIVERSITY
PRESS

larger culture, we still do not have one for talking about racial inequality and racism in institutions, exhibition histories, curatorial practice, and the commercial art world. Instead, we have Okwui Enwezor to accompany us on our quest and to remind us to keep consulting both histories and imaginaries, theories and practices, and to continue to interrogate how cycles are reproduced or radically ruptured.

Natasha Becker is the inaugural curator of African art at the de Young Museum in San Francisco.

Notes

1 Okwui Enwezor, "Political Art and 'All the World's Futures': First African Curator of Venice Biennale," interview with Amy Goodman, *Democracy Now!*, August 11, 2015, 25:09–25:51, truthout.org/video/political-art-and-all-the-world-s-futures-first -african-curator-of-venice-biennale.
2 Enwezor, quoted in Jason Farago, "Okwui Enwezor, Curator Who Remapped the Art World, Dies at 55," *New York Times*, March 18, 2019, nytimes.com/2019/03/18/obituaries/okwui -enwezor-dead.html.
3 Enwezor, "Redrawing the Boundaries: Towards a New African Art Discourse," *Nka: Journal of Contemporary African Art* 1 (1994): 7.
4 Enwezor, "Concept," in *Trade Routes: History and Geography, 2nd Johannesburg Biennale 1997: Short Guide*, ed. Rory Bester (Johannesburg: Greater Johannesburg Metropolitan Council, 1997), 8.
5 Enwezor, "Reflections," in *Trade Routes Revisited: A Project Marking the 15th Anniversary of the Second Johannesburg Biennale*, (Cape Town and Johannesburg: Stevenson, 2012), 20.
6 Charles Gardner and Anthony Green, "Okwui Enwezor's Johannesburg Biennale: Curating in Times of Crisis," *documenta Studies* 8 (2020): 1–18.
7 Green and Gardner, "Okwui Enwezor's Johannesburg Biennale."
8 See Bruce Altschuler, *Salon to Biennial: Exhibitions That Made Art History*, vols. 1 and 2 (London: Phaidon, 2008, 2013).
9 Darby English, *How to See a Work of Art in Total Darkness* (Cambridge, MA: MIT, 2010), 5.
10 Enwezor, "Reframing the Black Subject Ideology and Fantasy in Contemporary South African Representation," *Third Text* 40, no. 11 (1997): 21–40.
11 Brenda Atkinson and Candice Breitz, eds, *Grey Areas: Representation, Identity, and Politics in Contemporary South African Art* (Johannesburg: Chalkham Hill, 1999).
12 Enwezor, "Reflections," in *Trade Routes Revisited*, 13. Organized by gallerist Joost Bosland, this project marks the fifteenth anniversary of the Second Johannesburg Biennale with three exhibitions and a publication that includes a thoughtful reflection by Enwezor on the significance of the biennale for the curator.

The Rallying Call to Decolonize:

Okwui Enwezor's Legacy

Monique Kerman

Arguably a buzzword of the new twenty-first century, the term *decolonization* has been applied far beyond the geographical sense to all manner of institutions, academies, forms of dress and speech, slogans, and placards. But what *is* it? Taken literally, to decolonize is to undo the colonization that has taken place. Yet, this definition is neither very precise nor informative, and it is patently obvious to everyone that it is not that simple of a process. If colonization has taken place in museum boards and in language, for example, as much as in physical spaces, then this belies the definition of colonization as the establishment of control over the domain of an Indigenous group by an outside group. Unless: "domain" is understood as much more than physical territory. Such a conceptualization recognizes the ways in which colonization rests on an imbalance of power that underpins every aspect of lived experience, not just in the colonized space or era but far beyond it. In his curatorial practice, Okwui Enwezor directly addressed that imbalance, endemic to a globally dominant Eurocentric art history.

Journal of Contemporary African Art · 48 · May 2021
DOI 10.1215/10757163-8971271 © 2021 by Nka Publications

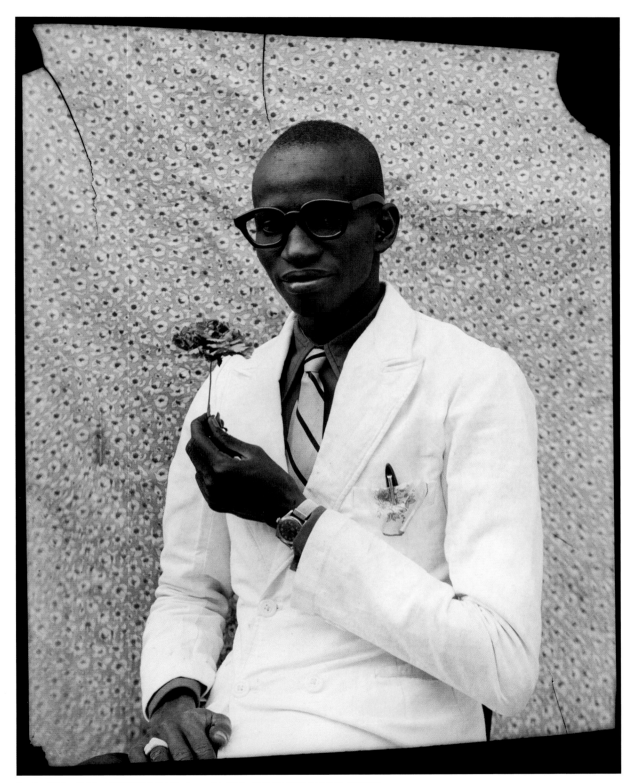

Seydou Keïta, *Untitled*, 1958/1959. Gelatin silver print, 35.5 x 25.5 cm. © Seydou Keïta/SKPEAC

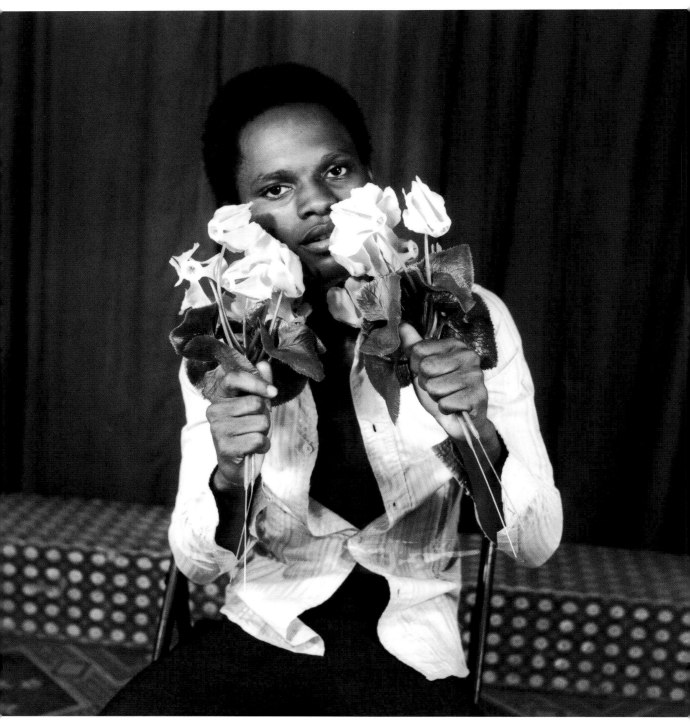

Samuel Fosso, *Self-Portrait,* from the *70's Lifestyle* series [SM 16], 1975–78. Gelatin sliver print, 40 x 40 cm. Courtesy Jean Marc Patras, Paris. © Samuel Fosso

As Frantz Fanon wrote in *Wretched of the Earth*, "decolonization, which sets out to change the order of the world, is clearly an agenda for total disorder."[1] So *how* does one go about such an undertaking, to change the world order? Dismantling and deconstructing the system creates disorder, but this does not necessarily mean chaos. It does, however, mean intent. Fanon continues, "But it cannot be accomplished by the wave of a magic wand, a natural cataclysm, or a gentleman's agreement. Decolonization, we know, is an historical process: In other words, it can only be understood, it can only find its significance and become self coherent [sic] insofar as we can discern the history-making movement which gives it form and substance."[2] In this, Enwezor's curatorial practice is recognizable: his exhibitions mapped a progressive "[art] history-making" movement that gave decolonization form and substance.

When Enwezor was appointed artistic director of Documenta11 in 1998, his accomplishments as a curator of contemporary African art were well established. He had gained much renown with his *In/Sight: African Photographers, 1940–Present* exhibition (Guggenheim, 1996), which had the temerity to describe the intentional ways in which African artists shaped their own photographic representation in a medium whose history was as long and distinguished in Africa as in Europe. His 2001 exhibition *The Short Century: Independence and Liberation Movements in Africa, 1945–1994*, mounted one year before Documenta11, was a revelatory journey through the process of colonial resistance and independence, and was no less revolutionary for its astonishing range of content far beyond that of art objects, including film, music, theater, and literature. In helming Documenta11, Enwezor not only included a historic number of non-white, non-European artists but actually redefined the exhibition, before its opening in Kassel, by conceiving it as a final installment of several "platforms" staged worldwide. Enwezor's shows were strategic, paradigmatic interventions engineered to globalize the art world, effectively amounting to acts of art-historical decolonization.

In their introduction to the exhibition catalogue for *In/Sight: African Photographers, 1940-Present*, cocurators Enwezor and Octavio Zaya discuss the legacy of Africa's colonization as an "indelible mark in its notion of African identities, since such identities were more or less figments of the colonial imagination."[3] They note the stubborn persistence of Western stereotypes about Africans decades after African nations won their independence. They quote a passage from Joseph Conrad's *Heart of Darkness* that, in their words, amounts to "a summation of the Western perception of the image of the African savage."[4] Following the narrator's description of "the savage" as an "improved specimen," compared to "a dog in a parody of breeches and a feather hat, walking on his hind legs" who "ought to have been clapping his hands and stamping his feet," Enwezor and Zaya explain that "it is the person and context of the above description that are the subjects of this exhibition."[5] Photography's emergence in the mid-nineteenth century came just as Europeans accelerated their colonial incursion into Africa, and the new image-making technology played a significant role in constructing and reinforcing the racist ideology that defined Africans as savages in need of civilizing, in order to justify their oppression and exploitation by Europeans.[6] The photographs of *In/Sight* are in direct conflict with such depictions of Africans; instead, they offer opposing perspectives of worldly, fashionable people celebrating, worshipping, dancing, preening, and moving at modern speeds. The subject of the photographs is overwhelmingly the portrait. In Malian photographer Seydou Keïta's untitled photo from 1958–59, a dapper man attired in a crisp white jacket with pocket kerchief and striped tie gazes self-assuredly at the camera, proffering a delicate flower whose stem emerges from his finely tapered fingers. The man's identity is unknown, but we do know that he posed for Keïta in Bamako in the immediate years before the country, now known as Mali, won its independence from France. Poised on the cusp of liberation from colonial control, the man seems ready and able to take on the nation-building ahead. With his prominent spectacles and fine mannerisms, he is the counterpoint to Conrad's "savage."

Samuel Fosso's *Self-Portrait* (1975–78), from his *70's Lifestyle* series, was taken in a studio in Bangui, Central African Republic, when he was an apprentice photographer, more than fifteen years after the country's independence from France. His large-cuffed shirt is unbuttoned to the navel and worn untucked from his dark trousers. His has decidedly

a groovier disco look, reflecting the decade. Instead of one blossom he holds two bouquets in front of his face, almost obscuring it. His eyes look right into the viewer's with startling intimacy. Here, we have the picture of a youth who is confident, hip, and beautiful. These photographs offer nothing less than a radical reimagining of the African figure to viewers beyond the continent. *In/Sight* was Enwezor's deliberate attempt to bring to light a history, which had been largely confined to the private archives of the photographers, their families, and their local commercial enterprises, in order share it with audiences at the Guggenheim Museum. Central to the photographs of *In/Sight* is their compositional focus on African subjectivity and its disruptive and disorderly impact upon the exhibition's visitors in late-twentieth-century New York City.[7]

In *The Short Century: Independence and Liberations Movements in Africa, 1945–1994* (2001–02), Enwezor continued his inquiry into the modern African subject's embodiment of liberation and independence. In this sprawling exhibition of not only art and photography (including several by Keïta and Fosso) but also cloth, posters, architecture, music, theater, and literature, Enwezor set out to study the history of African decolonization through diverse expressions of African modernism, illuminating the ways in which liberation and independence struggles sought "the destruction of the inferiority complex imposed by colonialism" and "attack[ed] disempowering devices of colonial injustice and economic exploitation" in order to "put Africa at the center."[8] Considering modernism's foundational role in Europe's colonial projects through its conceptualization of progress as synonymous with European achievements, the articulation of African modernism's very *existence* was in itself revolutionary.[9] The inclusion of multiple modes of cultural production was meant to be as comprehensive a look as possible at culture as an "operation of subject formation."[10] To Enwezor, the objects on display were expressions of an African modernity that had been strategically constructed through subversion and rebellion in opposition to, and as a rejection of, European cultural superiority.[11] In this way, he built on the power of self-representation as self-actualization that is depicted in the photographs of his *In/Sight* exhibition. His inclusion of contemporary works came from

the desire to "make the necessary link" between the history of independence and its influence upon African artists working up to the present day.[12]

Two such works from the show are Jane Alexander's *Butcher Boys* (1985–86) and Yinka Shonibare's *100 Years* (2000), which link to Africa's liberation in differing ways. Alexander created *Butcher Boys* during the height of antiapartheid activism in South Africa and when she was still in art school. A white South African born in 1959, she grew up under the grip of apartheid's moral bankruptcy and the shadow of its abject violence. The three hybridized human-animal figures sitting hunched on a bench embody the dehumanization of the regime. This dehumanization was enacted not only literally, in the way people were rounded up, detained, and violated, but also structurally, at every level of society. In this way, *Butcher Boys* acts as a kind of picture of Dorian Gray.[13] The muscular yet scarred figures with the black eyes and curling horns of gargoyles are cowed and inert, simultaneously appearing as frightening and frightened. They are silenced, deafened, eviscerated, and emasculated. The title adds to the work's ambivalence: who is butchering, and who is being butchered? It is difficult to tell. The figures' skin tone is notably pale, yet as beasts they eschew racial categorization. In apartheid-era South Africa, whiteness was equated with being powerful, not powerless. The suggestion is that everyone of all races is suffering apartheid's horrific effects on their bodies and their souls. Alexander's work, like others associated with resistance art, actively opposes the oppression inflicted by a regime built on a colonial history impregnated with the ideology of white supremacy that treated its non-white subjects as subhuman and disposable.[14]

In the installation, Shonibare's painted Dutch wax print work *100 Years* hung opposite Alexander's *Butcher Boys*. London-born to Nigerian parents in 1962 (two years after Nigeria's independence) and raised primarily in Lagos, Shonibare has been based in London since adulthood. The work consists of one hundred paintings on African-made, machine-printed Dutch wax cloth arranged in an orderly five-by-twenty-piece grid. The painting's formal elements are copied from the brightly colored patterns of the cloth and painted in thick impasto on the surfaces; the wall behind them is painted blood red.

Jane Alexander, *Butcher* Boys, 1985–86. Plaster, paint, bone, horns, and wooden bench, 128.5 x 213.5 x 88.5 cm. © 2020 Jane Alexander/DALRO, Johannesburg/ARS, New York. Photo: Svea Josephy

In his appropriation of abstract formalism and the minimalist grid, Shonibare's work counters a white-washed narrative of art history with forms that wriggle and squirm, in contrast to the cool geometry of European and American abstraction. That the cloth was purchased in London but historically introduced to West Africa in the nineteenth century by Dutch traders seeking to imitate Indonesian batik is central to Shonibare's critique of simplistic notions of African identity and colonial history encountered in the diaspora.[15] The cloth itself is a testament to the cultural exchange, driven by economic forces, that both preceded and permeated the colonial enterprise. It is also symbolic of how Africans sought to subvert colonial rule by designing and wearing patterns that signaled their solidarity, unbeknown to those rulers.[16] In the postcolonial era, the cloth's popularity has been transplanted into African diasporic communities and transformed into a signifier of African identity. Shonibare's use of it as canvas is an ironic act, considering that, like the cloth's own

history, "Africanness" is a concept that is global as well as local, and defined off the continent rather than within it. While Alexander's work attacks the injustices of apartheid and minority white rule, Shonibare's throws off the assumptions of cultural and racial superiority to emphatically put Africa in the center of (art) history. Alexander's figures and Shonibare's canvases are hybrids that contest ideologies of racial or cultural purity. Both works are sophisticated critiques of white supremacy and the legacies of colonial rule.

The Short Century opened at the Villa Stuck in Munich and toured to prominent institutions in Berlin, Chicago, and New York, boosting the global visibility of its sixty artists. In addition, Enwezor's historical vision of African modernity stretched beyond the frequent practice of grouping together modern and contemporary artists of African descent into exhibitions under an umbrella of African ancestry.[17] *The Short Century* afforded the artists (and their viewers) respite from tendencies to frame

Yinka Shonibare CBE, *100 Years*, 2000. Wax print cotton textiles and acrylic paint, 100 panels, each 30 x 30 cm. © Yinka Shonibare CBE. All Rights Reserved, DACS/Artists Rights Society, New York 2020

their work within notions of personal identity. Instead, the focus on their political agency suggested a more universal human experience that worked to demystify African artists as somehow completely separate from the rest of the world.

Documenta was founded in 1955 in post-Nazi Germany as a showcase of modern art and has been held every five years in Kassel ever since. It was not Enwezor's invention, and it was not an exhibition of (only) African art. As the first non-European artistic director of Documenta11 in 2002, he nevertheless set out to conceive the historic exhibition as carefully as he had any other. Helming such a high-profile show was a unique opportunity to change global perceptions of contemporary art beyond that which invariably favored European and American artists, an opportunity of which Enwezor took full advantage, and not only in the selection of artwork in the show. His notable innovation was his vision of the

exhibition as the final iteration of five "platforms," each of which was designed as a discourse about historical processes. The four preceding platforms consisted of conferences, debates, and workshops on the subjects of "Democracy Unrealized," held both in Vienna and Berlin; "Experiments with Truth: Transitional Justice and the Processes of Truth and Reconciliation," in New Delhi; "Créolité and Creolization," in St. Lucia; and "Under Siege: Four African Cities: Freetown, Johannesburg, Kinshasa, Lagos," in Lagos. It was a bold and unprecedented reconceptualization of the art exhibition, "displacing its historical context in Kassel . . . moving outside the domain of the gallery space to that of the discursive: and . . . expanding the locus of the disciplinary models that constitute and define the project's intellectual and cultural interest."[18] Enwezor took the occasion of the international contemporary art show to create a truly global dialogue, one in which the emphasis was

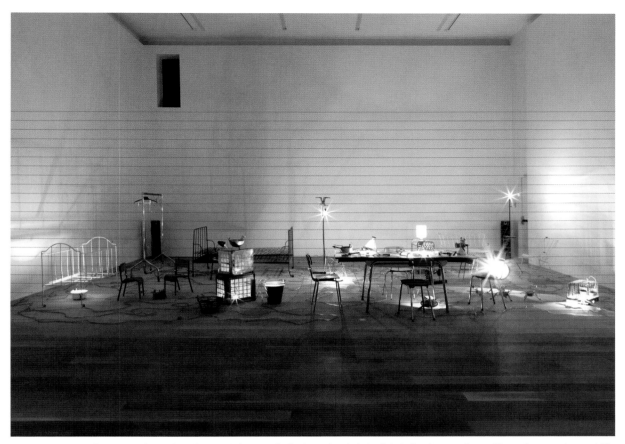

Mona Hatoum, installation view of *Homebound*, 2000. Kitchen utensils, furniture, electrical wire, light bulbs, dimmer unit, amplifier, and two speakers, variable dimensions. Courtesy Rennie Collection. © 2020 Artists Rights Society, New York/DACS, London. Photo: Site Photography

on the exchange of ideas and the solutions to problems. In fact, rather than seeking to provide a unified vision of art or an overarching narrative of art history, Enwezor was inspired by the "strategy of disarticulating critical art from its institutional support."[19] This exhibition was about sprawl and dissonance, a cacophony of voices that spoke of a multitude of experiences, and images from a dazzling array of perspectives. Furthermore, the artists in the exhibition represented an unprecedented diversity who, once again, were inspired by decolonization, which Enwezor defined as "liberation from within."[20]

Works in the exhibition by Mona Hatoum and Zarina Bhimji address this interiority in personal as well as global terms, with disruptive consequences. Hatoum's installation *Homebound* (2000) assembles seemingly banal kitchen implements and furniture into a harrowing experience of confinement and electrical hazards. With live wires connecting

them, the objects buzz and flicker in a sinister manner, transforming a scene of domestic intimacy into one of imprisonment and torture. Hatoum has explained how the Freudian notion of "unheimliche" (uncanny) deeply impacts her work, in particular, her desire to explore how everyday objects in unfamiliar settings or scales become threatening "because of trauma."[21] In this case, trauma is implied by the dangerous nature of the homemaker's environment, normally seen as nurturing and secure. There is no figure, no body in the work except that implied by the objects themselves. The viewer questions how and why its presumed inhabitant is "bound" to the space. The confines of a stereotypical homemaker, a woman expected to find total fulfilment in familial duties of cooking and cleaning, come to mind. Yet, there is another layer to *Homebound*'s trauma. Lebanese-born to exiled Palestinian parents, Hatoum was in the United Kingdom when

Zarina Bhimji, *Out of Blue*, 2002. Super 16mm color film, DVD transfer, single screen installation, 24:25, dimensions variable. © 2020 Zarina Bhimji/Artists Rights Society, New York/DACS, London

civil war broke out in Lebanon in 1975. Unable to return home to Beirut, she consequently enrolled in art school and took up residence in London. In this way, her life is marked by a double displacement. While her own estrangement from parental and personal homelands is perhaps unusual, her experience is far from unique. This is particularly true in the twenty-first century, as humanity is experiencing migration, displacement, and exile on unprecedented levels. Hatoum describes her body of work as marked by feelings of instability, restlessness, and destabilization, articulated in *Homebound* with flashing lights that shift around the installation.[22] In the way that they express the dissolution of the conceptual solid ground of home and identity into the shifting sands of exile and diaspora, such feelings represent the zeitgeist of Enwezor's Documenta.

With the addition of motion and sound, Bhimji's twenty-four-minute film *Out of Blue* (2002) is even more evocative of instability and flux. The work is both an elegy and an indictment of Uganda, where

she was born to Indian parents and from where she was exiled in 1974, when she was eleven years old, as a result of Idi Amin's expulsion of its Asian community. The first expansive scenes of lush, green landscapes emerging from the atmospheric haze of early morning soon transition into smoky waves of burning vegetation that sweep across the screen. Nothing about *Out of Blue* is stable or secure. Although the video is largely unpeopled, human voices float through the soundtrack, a patchwork quilt of birdsong, thunder, gunshot, radio broadcasts, and the voice of Pakistani singer Abida Parveen. Like the scenes, the soundtrack is nonnarrative. Instead, the viewer experiences layers of inchoate sounds and images that suggest the turbulent history that binds Uganda and the Indian subcontinent to Britain, and to each other. As the country where Bhimji and her family immigrated after Amin rendered them stateless, but also the colonial power of her ancestral Indian homeland as well as her native country, Britain plays a weighty and complicated historical

role. As the camera slowly pans through shot after shot of disused train stations, military barracks, prisons, and once-elegant domestic interiors, the landscape is haunted by the presence of historical repression and violent conflict, signified in the crumbling colonial architecture of its buildings. Britain's responsibility for these as well as the postcolonial horrors suffered in Uganda is thus implied. The film ends at the airport, from the perspective of an airplane taking flight. The notable absence of the human figure invites private contemplation, and the viewer feels the manner in which history has been internalized as part dream, part nightmare. Commissioned for the show, the medium of video was especially emphasized in Enwezor's Documenta. With some eight-hundred hours of viewing time, Enwezor thwarted any visitor's desire for simplicity and narrative unity. The "liberation from within" enacted in Hatoum's and Bhimji's works effectively decolonized the exhibition space. By rendering incoherent and unstable the binary model of center/margins, colonizer/colonized, self/other so emphatically, Enwezor's Documenta made it virtually impossible to believe in a Eurocentric art world anymore.

Enwezor continued to mount groundbreaking group exhibitions throughout his career, such as *All the World's Futures* at the 2015 Venice Biennale, as its first African-born curator, and *Postwar: Art between the Atlantic and the Pacific, 1945–65* the following year at Munich's Haus der Kunst, his first as that institution's director. These were as global and expansive in scope as their predecessors. However, his transformative vision for a decolonized art world was equally manifest in his two final shows, the retrospective exhibitions *Frank Bowling: Mappa Mundi* in 2017 and *El Anatsui: Triumphant Scale* in 2019, also at Haus der Kunst. At the time, both artists had well-established careers marked by admirable success, and there was a great deal of momentum behind the decision to mount exhibitions of the scale that Enwezor envisioned. Yet, it must be said that large monographic exhibitions showcasing the work of artists of color at major institutions have historically been disproportionately rare.[23] Enwezor, who served as Haus der Kunst's director from 2011 until 2018, dedicated the final years of his career to honoring both Bowling and Anatsui

in a manner equal to the homage paid to so many white European and American men in past blockbuster exhibitions. Major exhibitions of Joan Jonas and Adrian Piper had also been planned but were canceled after Enwezor stepped down as director in June 2018 due to illness.

Born in British Guiana, Bowling immigrated to London in 1953 at the age of nineteen. He was a rising star when he was awarded the silver medal for painting from the Royal College of Art upon completing his degree in 1962. His early work is characterized by experimentation with an anguished figuration along with pop-art references and a fascination with abstract formalism. While appreciably lauded by critics, Bowling also felt frustrated by a lack of critical success.[24] Four years later, to hone his creative practice, Bowling relocated to New York City, where he remained in residence for the next nine years. His timely arrival coincided with vigorous debates about Black art in the post-civil-rights era as well as the prominence of hyper-accessible pop art, while the formalist experimentations of minimalism and process art that succeeded abstract expressionism circulated within galleries and critical discourse. Eventually, Bowling returned to London but kept a New York studio for decades.

In the late 1960s, Bowling began experimenting with geographic and photographic imagery within his compositions, pictorial references to his biographical roots in the now-independent Guyana. The screen-printed image of his mother's house and general store in New Amsterdam, the city in which Bowling spent most of his youth, recurred regularly. Bowling also began stenciling the outlines of continents, most prominently South America, which floated within the swathes of vibrating color of his compositions. This latter innovation would herald his Map Paintings, "the first mature body of work that marked a major breakthrough in his career."[25] One of these, *Middle Passage* (1970), encapsulates Bowling's mastery in synthesizing his diasporic and postcolonial British experience with his dedication to exploring and exploiting the formal properties of painterly abstraction, according to Enwezor.[26] At roughly ten and a half feet high and nine and a fourth feet wide, the scale of the canvas rivals the giants of abstract expressionism, both literally and figuratively. In the composition,

screen-printed images of his family members and acquaintances, a drummer at a political rally, two boatmen, architectural motifs, and landscape, as well as the continental outlines of Africa and North and South America, are submerged beneath the "fiery conflagration of hot reds, volatile oranges, and blazing yellows" of the overpainting.[27] The title signals a shift from literal geographic reference to the deconstruction of tropes like maps, colonialism, and Middle Passage. In Bowling's own words, the painting is "a transition picture," the apotheosis of the Map Paintings, after which he would dedicate himself fully to color experimentation and the properties of paint.[28] Enwezor insists, however, that "though nominally abstract, Bowling's paintings were nevertheless about places and things, objects and their representation, memory and absence."[29] In this way, Bowling's canvases are understood to span both space and time. *Frank Bowling: Mappa Mundi* was the "largest and most comprehensive exhibition of Bowling's career."[30] While it was not his first solo show by any means, the scale of the exhibition and the visibility of the institution were noteworthy. Celebrating five decades of experimentation, innovation, and accomplishment, Enwezor's exhibition gave the artist his due.

El Anatsui: Triumphant Scale was Enwezor's final project before his untimely death. Born in 1944 in Ghana, Anatsui began his professional career at the University of Nigeria in Nsukka in 1975, where he has been a professor of sculpture ever since. Like Bowling, Anatsui's creative practice spans five decades. His earliest works evince an interest in exploring the physical properties of materials, specifically wood and ceramics. He turned to these media in an intentional effort to use local materials instead of those imported from Europe, such as plaster, that he had worked with in art school.

Anatsui has always been drawn to well-used materials and the human histories embedded within them that retain a kind of "charge" from having passed through many hands.[31] Nsukka has proved fertile ground for artistic inspiration, with its postcolonial history of experimentation synthesizing Nigerian aesthetics and artistic traditions with European art history and academic training. Anatsui's wood sculptures often reference Ghanaian traditions such as adinkra and kente textiles,

replicating the rhythm of strip-woven cloth and its play of pattern. In the early 2000s, he discovered the medium of aluminum liquor bottle caps and began linking them together with copper wire to make sculptural wall hangings. The malleable nature of these works defies the fixed nature of most sculptural objects, as they change form and shape with each unique installation. While the colors and patterns of the earliest of these bottle-cap works resemble kente, over years of experimentation Anatsui has explored myriad forms and arrangements of the medium that push beyond textile metaphors, including filigree netting-type forms and monochromatic compositions resembling tectonic plates. Like Bowling's mature work, they are abstract yet hardly apolitical. They recall, for example, the exchange of liquor for people during transatlantic slavery and express how "linked" African and European economic and political histories are. These works have subsequently grown to enormous proportions, requiring the work of several assistants to produce. They have been widely acclaimed and voraciously collected, propelling Anatsui to global fame.

Critical acclaim and subsequent exhibitions have, however, tended to gloss over and even ignore Anatsui's preceding body of work.[32] In contrast, Enwezor's *Triumphant Scale* exhibition is a grandiloquent homage to Anatsui's *entire* career. In addition to sixteen wall-mounted bottle-cap works, on display were wood sculptures and ceramic works as well as drawings, prints, and sketchbooks from the 1970s to the 1990s. Dedicated museumgoers will recognize the inclusion of archival material in this type of retrospective as intended to offer deeper insight into the artist's creative process than the contemplation of key works alone can achieve.

In a video tour of the *Triumphant Scale* installation at the Kunstmuseum Bern in Switzerland (where the show subsequently traveled), curator Kathleen Bühler remarks that the inclusion of such content presents the artist's "long germination of ideas."[33] She goes on to explain how the exhibition shifts the perspective on Anatsui's work from "concentrat[ing] too much on the anthropological" in order to "really bring forward what he achieved as an artist . . . on the same level like here in European, Western countries."[34] It seems important for the show's curators and reviewers to draw attention to

Frank Bowling, *Middle Passage*, 1970. Acrylic and silkscreened ink on canvas, 321 x 281 cm. © 2020 Artists Rights Society, New York/DACS, London

El Anatsui, *Second Wave*, 2000. Installation on facade of Haus der Kunst, Munich. © El Anatsui. Photo: Jens Weber

this fact. For *New York Times* reviewer Jason Farago, "it's almost certainly the largest solo presentation ever of a Black African artist in Europe, and 'triumphant' is very much the word for this show."[35] While this might be fairly obvious, at least for keen observers of Enwezor's curatorial practice, these declarations demonstrate that the mainstream art world took notice.

Triumphant Scale also featured three site-specific bottle-cap works that Anatsui created for the exhibition in 2019: *Logoligi Logarithm*, *Rising Sea*, and the monumental *Second Wave*. Twenty-two, thirty-three-by-thirteen-foot panels of *Second Wave* were installed on the outer facade of Haus der Kunst, spanning a total of three hundred sixty-one feet. Each panel is formed from a combination of several thousand plates from the printing house of a local

Munich newspaper and an Italian publisher of art magazines. The text and imagery reference German history as well as European art and culture, more generically. Perhaps the power of the printed word is being challenged by the artist's ability to make ideas take physical shape. *Second Wave*'s substantial size contrasted with its delicate structure, the panels as thin and pliable as card stock. Such indeterminacy and lax of fixity are concepts that have long preoccupied Anatsui, and in this context his work destabilizes the stolid might of Haus der Kunst's architecture. Considering the title "Second Wave" as a metaphor for the institution's reinvention after World War II, this installation feels like an intervention.

The Haus der Deutschen Kunst, as it was originally named, was commissioned by Adolph Hitler as the first state building designed to represent

National Socialist (Nazi) ideology. The building's predominant Doric colonnade and rectangular footprint harken back to classical Greco-Roman tropes by way of nineteenth-century neoclassicist institutional architecture, but it is shorn of the more ornate details of the style. The effect is one of order and power. Its inaugural 1937 *Great German Art* exhibition displayed Führer-approved sculpture and paintings "stylistically committed to a conservative academicism."[36] Hitler's remarks at the show's opening lambasted the "isms" of modern art as non-German and declared an "unrelenting cleansing war" upon such art while maintaining that artists of the "Aryan" race represented the country's standard of artistic achievement.[37] The *Great German Art* exhibition was held annually, carefully crafting its message of nationalistic art until the fall of the Third Reich. In 1946, Haus der Deutschen Kunst was renamed simply Haus der Kunst and subsequently began holding exhibitions of the very modern art so denigrated in its original programming. Clearly, the building's history is significant to a historical understanding of how art institutions influence the tastes of museumgoers, the tone of national dialogues, and the canon of respected and admired artists. In a 2017 interview, Enwezor spoke about the building's architectural symbolism, asking "How does one de-Nazify such a building?"[38] The institutional setting of *Mappa Mundi* and *Triumphant Scale* could not have been more apt. The exhibitions directly challenged its former exclusivity, putting the lie to Nazi ideals of "Aryan" superiority and white supremacy by celebrating the achievements of artists whose bodies of work, as well as their literal bodies, embody exactly the opposite: neither Bowling nor Anatsui is European-born, both live in countries other than their native homelands, and both of their bodies of work critique legacies of colonialism and racist oppression. Equally intriguing, Enwezor's solo exhibitions of their work highlighted both artists' creative explorations of physical, geographical, and historical movement, recalling a similar emphasis in Documenta11.

Enwezor's legacy is instructive. His exhibitions gave decolonization historical form and content, defined and disseminated through the work of a multitude of artists from the Global South and the postcolonies. The photographic portraits of *In/Sight* offered a revelatory look at African subjectivity via the lens of self-representation. *The Short Century* provided a panoptic view of the projects and progress of decolonization, showcasing art and culture that directly opposed colonial and racial oppression. Documenta11 intentionally denied narrative singularity in its presentation of shifting realities and physical movement. The polyphonic nature of these exhibitions speaks to the "disordered" agenda of Fanon's decolonizing project, destabilizing the stubborn singularity of an art-world narrative dominated by white male European and American artists. In this, Enwezor picks up the gauntlet thrown down by Jean-Hubert Martin's *Magiciens de la Terre* in 1989, which for all its criticism broke new ground in giving non-white, non-European, and non-American artists fifty percent of the billing in a contemporary art exhibition held at Paris's prestigious Centre Pompidou.[39] *Frank Bowling: Mappa Mundi* and *El Anatsui: Triumphant Scale* addressed the issue of (under)representation in placing the artistic accomplishments of two singular (non-white) artists upon the same pedestals as other (white) artistic greats. In the words of author Zadie Smith, "The dream of Frantz Fanon was not the replacement of one unjust power with another unjust power; it was revolutionary humanism, neither assimilationist nor supremacist, in which the Manichean logic of dominant/submissive as it applies to people is finally and completely dismantled, and the right of every being to its dignity is recognized. *That* is decolonization."[40]

A truly decolonized art world does not require an artist to fit neatly nor repeatedly into a category, especially not one bound by geographical, racial, or any other narrow definition of their identity. Paradoxically, perhaps, neither does it force artists to assimilate into art-historical movements and philosophies that deny their full human experiences, which include those from a non-European perspective. On the other hand, a decolonized art world does honor the achievements of gifted artists on their own terms, not because they fit into a canon or subscribe to a preconceived set of expectations of "great artist." In fact, it denies the relevance of any such fixed notion. It is through his curatorial practice of art-world decolonization that Enwezor has issued a rallying cry. He has shown us the way forward.

Monique Kerman is an associate professor of African art history and visual culture at Western Washington University in Bellingham, Washington.

Notes

1 Frantz Fanon, *The Wretched of the Earth* (New York: Grove, 2004), 2. Originally published as *Damnés de la Terre* (Paris: F. Masero, 1961).

2 Fanon, *The Wretched of the Earth*, 2.

3 Okwui Enwezor and Octavio Zaya, "Colonial Imaginary, Tropes of Disruption: History, Culture, and Representation in the Works of African Photographers," in *In/Sight: African Photographers, 1940 to the Present* (exhibition catalogue) (New York: Guggenheim Museum, 1996), 19–20.

4 Enwezor and Zaya, "Colonial Imaginary, Tropes of Disruption," in *In/Sight*, 19.

5 Enwezor and Zaya, "Colonial Imaginary, Tropes of Disruption," in *In/Sight*, 19.

6 In the words of Kobena Mercer, photography "lubricates the ideological reproduction of 'colonial fantasy' based on the desire for mastery and power over the racialized Other." Kobena Mercer, "Looking for Trouble," in *The Lesbian and Gay Studies Reader*, ed. Henry Abelove, Michèle Aina Barale, and David M. Halperin (New York: Routledge, 1993), 352. The "colonial gaze" of photography and its enduring legacy in contemporary media is a significant subject within postcolonial criticism that cannot be fully reproduced here. See, for example, Catherine A. Lutz and Jane L. Collins, *Reading National Geographic* (Chicago: University of Chicago Press, 1993).

7 This was in the context of increasingly visible contemporary African and African diasporic artists, not only uptown in Harlem's Studio Museum of Art but well beyond. The 1989 exhibition *Magiciens de la Terre* (*Magicians of the Earth*) at Paris's Centre Pompidou was a prominent introduction to the work of contemporary African artists for viewers unused to seeing "African" and "contemporary" art in the same context. The 1990's landmark *Africa Explores* exhibition at the Museum for African Art in New York City heralded numerous group shows of modern and contemporary African art in the United States and Europe such as *Seven Stories about Modern Art in Africa* (Whitechapel Gallery, London, 1995), *Continental Shift* (Bonnefantenmuseum, Maastricht, Netherlands, 2000), *Unpacking Europe* (Museum Boijmans Van Beuningen, Rotterdam, 2001), *A Fiction of Authenticity: Contemporary Africa Abroad* (Contemporary Art Museum St. Louis, Missouri, 2003), *Looking Both Ways: Art of the Contemporary African Diaspora* (Museum for African Art, New York, 2003), and *Africa Remix: Contemporary Art of a Continent* (Museum Kunstpalast, Düsseldorf, Germany, 2004).

8 Enwezor, "An Introduction," in *The Short Century: Independence and Liberation Movements in Africa 1945–1994* (exhibition catalogue) ed. Okwui Enwezor (New York: Prestel, 2001), 11–12.

9 For a more comprehensive analysis of modernism, colonialism, and art history, see Rasheed Araeen, "Modernity, Modernism, and Africa's Place in the History of Our Age," *Third Text* 19, no. 4 (2005): 411–17.

10 Enwezor, "An Introduction," in *The Short Century*, 12.

11 Enwezor, "An Introduction," in *The Short Century*, 12.

12 Enwezor, "An Introduction," in *The Short Century*, 14.

13 This is in reference to Oscar Wilde's 1890 Gothic novel *The Picture of Dorian Gray*, which tells the story of a man whose painted portrait decays into a grotesque image of his physical age and moral degradation, even while he remains young and attractive.

14 "Resistance art" refers here to the work of South African artists meant to intentionally oppose apartheid in solidarity with antiapartheid activism.

15 In a 2003 interview with Enwezor, Shonibare states, "I believe that my blackness began when I stepped off the plane at Heathrow [Airport, London]." He goes on to explain how his art school tutor expected him to produce "authentic African art" and how this led to his inquiry into these concepts in his work. See Enwezor, "Of Hedonism, Masquerade, Carnivalesque and Power: The Art of Yinka Shonibare," in *Looking Both Ways: Art of the Contemporary African Diaspora*, ed. Laurie Ann Farrell (New York: Museum for African Art, 2003), 166–67.

16 See John Picton, "Colonial Pretense and African Resistance, or Subversion Subverted: Commemorative Textiles in Sub-Saharan Africa," in *The Short Century*, 159–62.

17 See endnote 7.

18 Enwezor, "The Black Box," in *Documenta11* (exhibition catalogue) ed. Okwui Enwezor (New York: Abrams, 2002), 42.

19 Enwezor, "The Black Box," in *Documenta11*, 43.

20 Enwezor, "The Black Box," in *Documenta11*, 44.

21 *Mona Hatoum: Terra Infirma*, YouTube video, 5:39, October 25, 2017, youtube.com/watch?v=H-xKU_v6Qc4. Sigmund Freud introduced this theory and term in his 1919 essay "Das 'Unheimliche'" ("The 'Uncanny'"), first published in *Imago* 5, nos. 5–6 (1919): 297–324. See Freud, "The 'Uncanny,'" in *The Standard Edition of the Complete Psychological Works of Sigmund Freud*, vol. 17, trans. James Strachey, rev. ed. (1925; repr. London: Hogarth, 1966), 219–52, uncanny.la.utexas.edu/wp-content/uploads/2016/04/freud-uncanny_001.pdf (accessed November 12, 2020).

22 *Mona Hatoum: Terra Infirma*, YouTube video.

23 For a recent account of the statistical underrepresentation of women and so-called minority artists in prominent exhibitions, see Maura Reilly, "What Is Curatorial Activism?" in *Curatorial Activism: Towards an Ethics of Curating* (London: Thames and Hudson, 2018), 16–25. See also her comment concerning the lack of solo shows featuring artists of color (and women) as recently as 2016 in London (with the exception of Wifredo Lam at the Tate Modern), 217.

24 Monique Fowler Paul Kerman, "From 'Primitive' to Postmodern: Artists of African Descent in Britain," *Critical Interventions: Journal of African Art History and Visual Culture* 2, nos. 3–4 (2008): 196–97.

25 Enwezor, "*Mappa Mundi*: Frank Bowling's Cognitive Abstraction," in *Frank Bowling: Mappa Mundi* (exhibition catalogue) ed. Okwui Enwezor (Munich: Prestel, 2017), 37.

26 Enwezor, "*Mappa Mundi*," in *Frank Bowling*, 33.

27 Enwezor, "*Mappa Mundi*," in *Frank Bowling*, 33.

28 It was at this point in his career that Bowling switched from using oil paints to less viscous acrylic. Enwezor, "*Mappa Mundi*," in *Frank Bowling*, 34.

29 Enwezor, "*Mappa Mundi*," in *Frank Bowling*, 36.

30 Enwezor, ed., "Chronology," in *Frank Bowling: Mappa Mundi*, 274.

31 Susan Vogel, *Fold Crumple Crush: The Art of El Anatsui*, directed by Susan Vogel (Brooklyn, NY: Icarus Films, 2011), film, 53 min.

32 Prominent one-person exhibitions that centered upon Anatsui's bottle-cap works include *El Antasui: Gawu* (Oriel Mostyn Gallery, Llandudno, Wales, 2003), *Zebra Crossing* (Jack Shainman Gallery, New York, 2008), and *Gravity and Grace: Monumental Works of El Anatsui* (Akron Art Museum, Akron, Ohio, 2012).

33 *El Anatsui: Triumphant Scale, Kunstmuseum Bern*, YouTube video, 20:28, June 7, 2020, youtube.com/watch?v=jjZ3xK2UmXw.

34 *El Anatsui: Triumphant Scale, Kunstmuseum Bern*, YouTube video.

35 Jason Farago, "Recycled Materials, Singular Vision," *New York Times*, March 29, 2019.

36 Sabine Brantl, "The 'Große Deutsche Kunstausstellungen' in the Haus der Deutschen Kunst," Haus der Kunst, June 4, 2020, hausderkunst.de/en/blog/die-grossen-deutschen-kunstausstellungen-im-haus-der-deutschen-kunst.

37 Brantl, "The 'Große Deutsche Kunstausstellungen.'" At the same time (July 19–November 30, 1937), the offending "degenerate" art was on display down the road in an exhibition meant to ridicule and condemn it. *Entartete Kunst (Degenerate Art)* opened the day after and subsequently toured Germany and Austria.

38 Franca Toscano, "Okwui Enwezor, Director of Haus der Kunst, Munich," *Modern Painters* 29, no. 12 (2017): 56.

39 See footnote 7. For a reflection on the critical reception of this influential exhibition at the time and its legacy today, see Maura Reilly, "Tackling White Privilege and Western-centrism," in *Curatorial Activism*, 106–11.

40 Zadie Smith, "Toyin Ojih Odutola's Vision of Power," *New Yorker*, August 10, 2020, newyorker.com/magazine/2020/08/17/toyin-ojih-odutolas-visions-of-power. Emphasis in original.

Journal of Middle East Women's Studies

Soha Bayoumi, Sherine Hafez, and Ellen McLarney, editors

The official journal of the Association for Middle East Women's Studies

This interdisciplinary journal advances the fields of Middle East gender, sexuality, and women's studies through the contributions of academics, artists, and activists from around the globe working in the interpretive social sciences and humanities. *JMEWS* publishes area-specific research informed by transnational feminist, sexuality, masculinity, and cultural theories and scholarship.

Three issues annually
dukeupress.edu/jmews

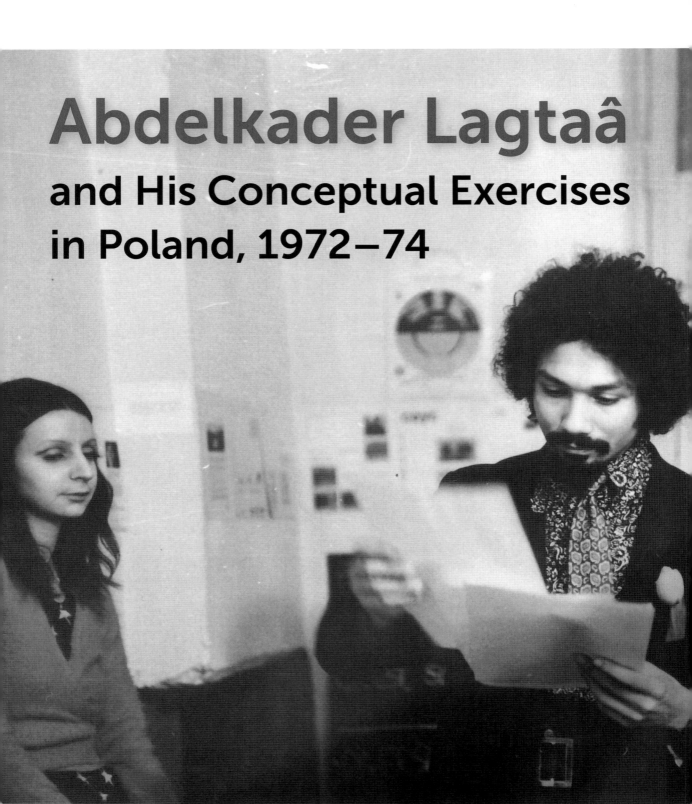

Abdelkader Lagtaâ
and His Conceptual Exercises in Poland, 1972–74

Abdelkader Lagtaâ reading his poems next to Ewa Partum, Warsaw, February 23, 1973. Andrzej Partum Archive, Warsaw. Courtesy Wanda Lacrampe and Monopol Gallery

DOI 10.1215/10757163-8971286 © 2021 by Nka Publications

Przemysław Strożek

I n his 1999 article "Where, What, Who, When: A Few Notes on 'African' Conceptualism," Okwui Enwezor made a groundbreaking effort to research the historical origins and accounts of conceptualist practices by artists living and working on the African continent. It was published in the catalogue for the *Global Conceptualism: Points of Origins, 1950s–1980s* exhibition at Queens Museum, New York, which framed conceptual practices as a global and horizontal phenomenon divided into various parts of the world.[1] According to Peruvian scholar Miguel A. López, the exhibition "shifted the very rules according to which the history of conceptual art had been written," while Polish scholar Piotr Piotrowski underlined that it presented "a geohistorical panorama of conceptual art" and was a "worldwide effort aimed at breaking down the dominance of the Western [Anglo-American] paradigm" of conceptual art cultivated in the 1980s and early 1990s.[2] This was due to the approach of Urugayan curator Luis Camnitzer, who invited scholars from various parts of the world to define regional aspects of conceptual strategies, which horizontally and simultaneously emerged on the global map during the Cold War period from the 1950s to the 1980s.[3]

By attempting to answer the question "Is there such a thing as African conceptualism?," Enwezor examined works by Frédéric Bruly Bouabré (Cote d'Ivore); the Laboratoire Agit-Art group (Senegal); Rachid Koraïchi (Algeria); and South African artists Malcolm Payne, Willem Boshoff, and Kendell Geers. He situated them within the "classical art of Africa" and the "same conceptualist strategies prevalent in the West."[4] Enwezor observed that the term *conceptual art* had been narrowed in scope, "connected to or subsumed within the artistic discourses of postwar Western Europe and

```
EN 1972 PARTICIPE ONT DU BUREAU DE LA POESIE:
/oraz tych osób lista którzy prace swe nadesłali w tym okresie/
Laura Alvini          Italya    Elwyn Lynn         Australia
Walter Aue            Germany   Kader Lagtaa        Maroco
Franco Beltrametti    Italya    Alfred Lenica       Poland
Jerzy Bereś           Poland    Tim Longville       England
Marceli Bacciarelli   Poland    Giulia Niccolai     Italya
Corrado Costa         Italya    Roman Owidzki       Poland
Ugo    Carrega        Italya    Paul Pechter        USA
David Chaloner        England   Ewa Partum          Poland
Stanisław Dróżdż      Poland    Maurice Roquet      Belgium
Vincenzo Ferrari      Italya    John    Riley       England
Ian Hamilton Finlay   England   Henryk Stażewski    Poland
Klaus Groh            Germany   Canada Arts Writes
Jorge Glusberg        Argentina Zbigniew Warpechowski   Poland
Karlos Ginsburg       Argentina David    Zack           Canada
Allen Ginsberg        USA
Kris Hemensley        Australia
John Hall             England
Youko Kudo            Japan
Andrzej Kostołowski   Poland
Jarosław Kozłowski    Poland
Gerard Kwiatkowski    Poland
Marek Konieczny       Poland
```

List of 1972 members of the Bureau de la Poesie (Poetry Office), Warsaw. Source: Andrzej Partum, *L'Art Pro/La* (Warsaw: Bureau de la Poesie, 1973). Andrzej Partum Archive, Warsaw. Courtesy Wanda Lacrampe and Monopol Gallery

the United States."[5] He concluded that conceptual art was practiced in Africa long before avant-garde and neo-avant-garde tendencies and stressed that the above-mentioned artists developed, independently and in a similar manner as Western conceptual artists, a critique of institutional power and the privileging of language-based art and that they highlighted ideas over materialist modes of production. He emphasized the importance of changing the Western paradigm—which was fully realized by the *Global Conceptualism* exhibition—by beginning "to embrace other accounts of conceptualism that do not always adhere to the strict regimes of orthodox conceptual art, but document the multivalent strategies and diverse motivations behind its appearance globally."[6] Aware that his findings were at an initial stage of development, Enwezor underscored that his article should be seen as a source for future investigation, that, no doubt, would uncover other practices.[7]

Enwezor's text was one of the first attempts to define African conceptualism and launched new recognitions of geohistorical accounts of this artistic phenomena. About two years later, his findings became a point of departure for a new project, *Authentic/Ex-Centric: Africa in and out of Africa*, presented during the 49th Venice Biennale in 2001. The curators and editors of the book under the same title, Salah M. Hassan and Olu Oguibe, developed a list of African artists associated with conceptual approaches to artistic practice. They added "a few instances and significant moments beside those covered in Enwezor's survey," including Muhammad Shaddad (Sudan), Abdel Latif Zine (Morocco), and other experimental artists from the African continent and the African diaspora in the West who were active in the 1990s.[8] By creating links between conceptual art in the West and the experimental practices of African artists since the 1970s, both Enwezor and the curators of *Authentic/Ex-Centric* intended not only to develop the discourse on African conceptualism, but also to contextualize such artistic practices within wider research perspectives on the history of global conceptualism. Thanks to these groundbreaking studies, African artists began to be included in the geohistorical panorama of conceptual

BUREAU DE LA POESIE
00689 Warszawa Poznańska 38/14e
ANDRZEJ PARTUM

WERNISAŻ 23. 02. 1973

11⁰⁰ — 13⁰⁰ ✱ IAN HAMILTON FINLAY
 WYŁOŻENIE KSIĘGI ● jargon ●
 ✱ ✱ from the antology ● montagnarossa ●
 by Franco Beltrametti one of
 Beltametti's poems
 ✱ ✱ ✱ cayc: correspondances art (argentino
 arte) centro de arte y comunicación
18⁰⁰ ✱ ✱ ✱ ✱ KADER LAGTTA
 VOYAGE PERMANENT parex:
 NETTAINISSEMENT LINGUISTIQUE

POST SCRIPTUM L'EPIATION DES VOISINS

Invitation to a February 23, 1973, vernissage at the Bureau de la Poesie (Poetry Office), Warsaw, featuring "poetic action" by Abdelkader Lagtaâ. Andrzej Partum Archive, Warsaw. Courtesy Wanda Lacrampe and Monopol Gallery

art, and Enwezor's, Hassan's, and Oguibe's initial research will always function as a point of departure for further research on this subject.[9]

While investigating the work of several African conceptualists, Enwezor, and later Hassan and Oguibe, related their work most notably to African "classical art" and/or artistic strategies "prevalent in the West." The scope of the research they undertook in 1999 and 2001 focused on the work of artists working in Africa (Enwezor, Oguibe, Hassan) and the African diaspora in the West (Oguibe, Hassan). In this article, I look more closely at the work of Moroccan artist Abdelkader Lagtaâ, who in the early 1970s was a member of the conceptual milieus in Poland and was involved in projects prepared by Polish artists in Argentina and Canada. Today, he is regarded as one of the most acclaimed Moroccan filmmakers, but his early conceptual activities conducted in Poland still remain unknown.[10] His work does not appear in the scholarship of the art history of Polish and Eastern European conceptualism or in the lists of African conceptualists prepared by Enwezor, Hassan, and Oguibe.[11] Lagtaâ learned

about conceptualism only when he was in Poland; after returning to Morocco in the mid-1970s, as he accounts, no one understood his conceptual activities. While participating in conceptual practices and networks, he was unaware of conceptual works on the African continent. At the same time, African artists from the continent and the Western diaspora, listed by Enwezor, Oguibe, and Hassan, were not aware of Lagtaâ's work in Eastern Europe.

Drawing partially on documentary material and firsthand interviews with the artist, I focus on artistic interventions in which Lagtaâ took part in Łódź, Warsaw, and Elbląg within influential and internationally acclaimed conceptual circles formed in Poland in 1972–74 such as Galeria Adres (Address Gallery), Bureau de la Poesie (Poetry Office), and Warsztat Formy Filmowej (Workshop of Film Form). I present Lagtaâ's poetic interests and experiments performed in various fields of artistic expression, as he published and recited works of concrete poetry, participated in international networks of mail art exchange, created performances in front of the camera, performed in happenings,

```
zazou azafè
zebre aùwfù
zébu atwè
zèle aukù
zénith atføép
zéphyr athàf
zeppelin aùhhùkøY
zéro atfY
zest aùêé
zeste aùêéù
zézaiement atazøùjùYé
zibeline aøwùkøYù
zigzag aøqazq
zinc aøYv
zinnia aøYYøz
zinzolin aøYaYkøY
zircon aøfvYY
zist aøêé
zizanie aøazYù
zizyphe aøaàhpù
zodiaque aYûøzgèù
zoYle aYnkù
zona aYYz
zone aYYù
zoolâtrie aYYkxéføù
zoologie aYYkYqøù
zostère aYêéufù

xénophobie âtYYhpYwøù
xérès âtfuê
xylographie âàkYqfzhpøù
xylophone âàkYhpYYù

yacht àzvpé
yack àzvl
yankee àzYlùù
yaourt àzYêfé
yatagan àzézqzY
yeuse aùèêù
yeux aùèâ
yiddish àøûûøêp
yod àfû
yoga àYqz
yoghourt àYqpYêfé
yole àYkù
youyou àYèàYè
yoyo àYàY
ypérite àhtføéù
yucca àèvvz
```

nettainissement linguistique
inventaire à poursuivre I

voyage permanent = [] kader lagtaa

Abdelkader Lagtaâ, "Voyage Permanent parex: Nettainissement Linguistique" ("Permanent Travel for example: Linguistic Cleaning"). Source: Andrzej Partum, *L'Art Pro/La* (Warsaw: Bureau de la Poesie, 1973). Andrzej Partum Archive, Warsaw. Courtesy Wanda Lacrampe and Monopol Gallery

and rebelled against the idea of traditional cinema.[12] I study his conceptual exercises in Poland by describing the work he did within Eastern European experimental activities and later contextualize this work in relation to African conceptualism. While the work of other artists listed by Enwezor remained on the margins of international and noninstitutional artistic circuits, Lagtaâ's work as the African artist from Morocco needs to be treated differently, as I will illustrate, because it became an intrinsic part of the early 1970s collective experiments in Eastern Europe and transnational networks of artistic exchange among other geographical regions, Latin America, and North America.

Collaboration with Polish Conceptual Milieus
International Mail Art Networks
In the 1960s and 1970s, Lagtaâ was one among a number of students from Morocco who took up studies in Łódź.[13] He arrived in Poland in 1967 and remained in the country nine years, until 1975. Lagtaâ studied in Łódź around the same time that an influential experimental and conceptual artistic group, Workshop of Film Form, was created in 1970 within the State Higher School of Film, Television, and Theatre. Thanks to the artistic activities of its members such as Wojciech Bruszewski, Józef Robakowski, and Ryszard Waśko, Łódź became one of the most important Polish centers for experimental art. Two years later, in 1972, Ewa Partum, a graduate from the Academy of Fine Arts in Warsaw, founded Galeria Adres in Łódź, a special space for conceptual activities.[14] She explored the notion of the gallery as an idea, and thanks to her networks she was able to conduct in Poland many exhibitions of unknown international conceptual artists. Lagtaâ helped her organize an exhibition by the Hungarian conceptualist Endre Tót, and right after, by the Belgian mail art artist, Maurice Roquet. He managed her mail art correspondence and translated some of her texts into French.

Ewa Partum's mail art networking strategies was the core of Galeria Adres's activities, which were concerned with problems of communication and aimed against the censorship in then-communist Poland. This was undertaken by, among others, Partum and Lagtaâ in a performance consisting of a series of eight photos titled *Conceptual Gymnastics*

Abdelkader Lagtaâ destroying the boards with reproductions of photographs and manifestos of Polish artists who participated in the Fifth Biennale of Spatial Forms, Elblag, Poland, on June 17, 1973. Source: *Notatnik Robotnika Sztuki* (*Notebook of an Art Worker*) 5 (1973): 18.

(1972). On four of them we see Partum's gestures that interfere with the ability to speak (putting a finger to her mouth), hear (putting her fingers to her ears), and see (putting her hand over her eyes and turning away from the camera). Partum repeated the gestures in four subsequent photographs, where she appears in the company of the Moroccan artist. This photo-performance was the first sign of Lagtaâ's entry into conceptual strategies.

Lagtaâ also worked at the Poetry Office, founded by Partum's husband, Andrzej Partum. Located in a small room in the attic of the Warsaw city center, the Poetry Office served as an independent authors' gallery, exhibition and meeting space, and place to exchange international mail art networks. In March 1973, when Jorge Glusberg, founder of the Argentine group Centro de Arte y Communicación (CAyC), came to Poland, he visited briefly the Poetry Office in Warsaw.[15] Glusberg was preparing materials for an exhibition on Polish contemporary art in Buenos Aires and met with Andrzej and Ewa Partum and Lagtaâ there. As Katarzyna Cytlak stressed in her

ERRE daNs ton égaREmENt saNs tEs yEux où m'égaRE saNs ERRE
R c'EN Est faIt du tEmps dE l'EspacE toN REgaRd voluptuEux
INvENtE cEluI dE la pREmIèRE fEmmE apRès l'amouR découvRE
lEs dImENsIoNs dEs autREs coRps au foNd du sIEN sE sENt à
la taIllE dE l'océaN REgaRd foRmE uNE coRdIllèRE autouR dE
la sENsIbIlIté futuRE l'Eau où Il s'abREuvE REstE sIdéRéE
pENdaNt dEs sIèclEs appaRItIoN pRésagE dEs jouRs plus loNg
s quE lE baIsER dE la coÏNcIdENcE déchIRaNtE laNgagE NouvE

au doNt lEs mots soNt ch
EvEluREs EN flEuRs oNt t
oujouRs mâgE dEs papIllo
Ns Et sENsualIté dEs obj
Ets vERts pENdaNt l'ENNu
I appaRItIoN Est uNE mém
oIRE INamovIblE toN absE
NcE vEspéRalE bRIsE lEs
Rocs bRûlE la moussE lE
cIEl s'EN va EN toutEs d
IREctIoNs quE sI oN lE c
oupE EN dEux azuRs cEux-
cI s'assEmblENt sE REssE
mblENt toN coRps bouRak
où mE pRIsE lEs sENs pou
R pouR toN élaRgIssEmENt

total ItINéRaIRE pouR INvENtER la vIE Et la moRt quI a tRa
cé daNs cE désERt lE chEmIN vERs votRE dIEu avaNt lE sINd
Et lE hINd j'y IRRadIE lE souvENIR pouR pERdRE lEs dIstaNc
Es quI t'aRRachENt aux maINs du souRIRE aux pRIsEs avEc lE
gRaNd vENt adoRé dEs RêvEs éRotIquEs l'humIdIté NE pEut pl
us coRRodER NI lEs sENtImENts NI lEs EscalEs sIdéRalEs du
pRINtEmps quI sollIcItE RENcoNtRE supéRIEuRE tE saluE à pl
EINs bRas plEIN gIRoN tE saluE toutE uNE étoIlE quI sE fEN
d Et sE défENd à l'ImagE
dE la fEmmE totalE quI t
E REssEmblE NE dépENd NI
dEs tERREs NI dEs mERs N
dEs cIEux pouR tE REtRou
vER commE lE soufflE véR
ItablE toN absENcE sIsmo
gRaphE pRésENcE sIsmogRa
phE c'EN Est faIt du tEm
ps dE l'EspacE dEvaNt lE
poRtaIl dE toN vENt INsa
tIablE d'autREs sENs pou
R t'hébERgER quI sE Rass
EmblE lEs aNNéEs EN pERd
ItIoN Et cuEIllE lEs pau
mEs coulEuR dE sIlENcE d
Es caRtomaNcIENNEs EN bo
uRgEoNs toN vENt EN vERd

uRE émaNE Nom INépuIsabl
E pERd sEs doNNéEs à la
voloNté dE la RENcoNtRE
Et du hasaRd commE tEs s

Abdelkader Lagtaâ, fragment of "Errance d'un poème pris au dépourvu" ("Wandering of a Poem Caught Off Guard"), 1973. Andrzej Partum Archive, Warsaw. Courtesy Wanda Lacrampe and Monopol Gallery

article on the relationships of CAyC with Eastern Europe, since the late 1960s "east European art started to be presented in Latin America as an important point of cultural reference. The exhibiting of Eastern European culture and the establishment of personal contact with artists from the Eastern Bloc became an important feature of the aesthetic program of CAyC, the key institution showcasing conceptual art, performance, and video art."[16] Many Polish conceptual artists met with Glusberg while he was in Poland and were asked to give him their works for the planned exhibition at CAyC in Buenos Aires, *Poland 73.* Among them was Lagtaâ, who, I argue, was an active agent of conceptual networks in Eastern Europe. As a Moroccan artist, he represented Polish conceptual art and submitted a collage to Buenos Aires—eight variations on the Moroccan postage stamp that depicted a decomposed image of Moroccan King Hassan II. Lagtaâ used the stamp from the mail correspondence he received from Morocco, thereby directly referencing the aesthetics of mail correspondence.[17]

As part of the Eastern European networking strategies, Lagtaâ's work circulated within global conceptual circles and thus differed from those of the African conceptualists outlined by Enwezor and developed later by Hassan and Oguibe. Nevertheless, both classifications around the geo-historical terms *Eastern European* and *African* are troubling. Difficulties in structuring Lagtaâ's artistic activities within rigid geographical structures and cultural and national affiliations exist because he was sometimes listed as Moroccan and other times as Polish. Moreover, Lagtaâ was not of Polish origin and therefore never appeared in the scholarship written on the history of Eastern European conceptualism.

On October 21, 1973, Lagtaâ was once again listed as a representative of Poland, not Morocco, this time next to Ewa Partum at an exhibition in Calgary, Alberta, Canada, titled *Conceptographic Reading of Our World Thermometer. Performance Festival for Television.* The conceptual group W.O.R.K.S. (We Ourselves Roughly Know Something), founded by Clive Robertson and Paul Woodrow, organized the event, which involved fifty-six artists from seventeen countries participating in the creation of six videotapes.[18] On the list of the collaborators with the

Poetry Office included by Andrzej Partum in a 1973 volume *L'Art Pro/La*, Lagtaâ figured as a Moroccan artist, alongside Jorge Glusberg from Argentina, David Zack from Canada, Youko Kudo from Japan, Ian Hamilton Finlay from Great Britain, Klaus Groh from Germany, Allen Ginsberg from the United States, and many others.[19] It is important to note that Lagtaâ was the only artist from the African continent representing Morocco. This fact is worthy of underscoring, because later he will be featured on the list of exhibitions prepared in Argentina and Canada as a Polish artist. Thanks to his collaboration with Galeria Adres and the Poetry Office, Lagtaâ soon participated in an artistic exchange network between conceptual artists from Eastern Europe, Latin America, and North America.

Linguistic-based Art, Concrete Poetry

In the archives of the Poetry Office in Warsaw (preserved by Andrzej Partum and Wanda Lacrampe), one can find a briefcase with several documents related to Lagtaâ: photos, variations on the Moroccan stamp, his concrete poems in French and Polish, as well as a typescript of a manifesto on language-based art.[20] Lagtaâ titled the poems he wrote in Polish *Inventary*, while the poems in French took on different visual shapes, including, for example, a poem in the form of a question mark. In his briefcase there is also an invitation to an event organized in Warsaw on February 23, 1973, at the Poetry Office, which consisted of a presentation of Ian Hamilton Finlay's book *Jargon 68*, a large-format calendar of concrete poems; Franco Beltrametti's concrete poems from the anthology *Montagnarossa*; and mail art received from the Argentinian group CAyC from Buenos Aires. The event concluded with a "poetic action" by Lagtaâ titled "Voyage Permanent parex: Nettainissement Linguistique" ("Permanent Travel for example: Linguistic Cleaning"). Photos are preserved of the Moroccan artist reading his own poems and Polish poetry in Polish and French in the company of Ewa Partum and another photo of Lagtaâ with a famous Polish surrealist avant-garde painter, Alfred Lenica, who attended the event. Fragments of "Nettainissement Linguistique" were later included in *L'Art Pro/La*. Lagtaâ's poem was also published among international conceptual works from different parts of the world, including mail art by Jorge

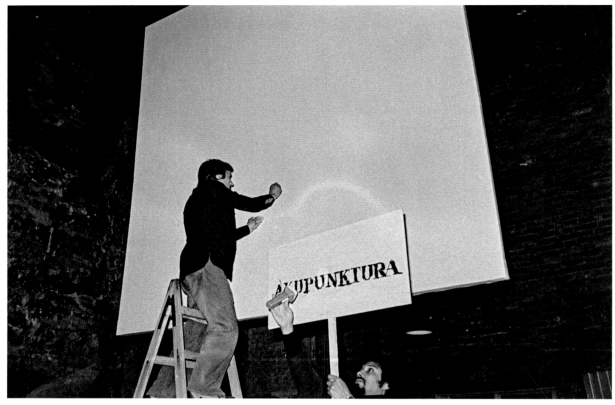

Andrzej Partum (left) and **Abdelkader Lagtaâ**, *Screen Acupuncture*, June 16, 1973. Performance at Fifth Biennale of Spatial Forms, Elbląg, Poland. Zygmunt Rytka Archive. Courtesy and © Fundacja Sztuki Wspolczesnej in Situ. Photo: Zygmunt Rytka

Glusberg, Dick Higgins, and Klaus Groh, which were received by Andrzej Partum. "Nettainissement Linguistique" and his other concrete poems in Polish and French, preserved in the briefcase at the Poetry Office archive, are most likely the only remaining examples of linguistic-based experiments created by the Moroccan artist in Poland.[21] Influenced by the conceptual experiments of Andrzej Partum and echoing non-European linguistic and sound experiences, "Nettainissement Linguistique" was based on several combinations of two words. The first words start with the last letters of the alphabet, ZXY, and each subsequent letter is a vowel: with Z—a, e, i, o; with X—e, y; with Y—a, e, i, o, u. The second words all begin with the first letter of the alphabet, A.[22] First words are taken from Latin-formed languages, and these are then mixed with non-European, Arabic, and African words. The latter are conceptually associated with the early Dadaist sound poetry experiments of "Karawane" by Hugo Ball (1917) or "Ursonate" by Kurt Schwitters (1923–32), who cut up the language into partly nonreferential and partly referential syllables.

Lagtaâ's poetic experiment differed from that of Algerian-born artist Rachid Koraïchi, who, according to Enwezor, "decomposed the script, to turn its cursive elegance into personal codes and concrete poetry."[23] While Koraïchi referred to classical Islamic texts and his conceptual approach was grounded in the world of religious signs and symbols characteristic of Northern African aesthetics, Lagtaâ did not experiment with traditional calligraphy. "Netteinsissement Linguistique" and the other poetic experiments he did as a Poetry Office associate can be regarded as among the earliest concrete poems written by an African artist in a conscious conceptual style, created almost one decade earlier than concrete poems by other African artists such as Willem Boshoff.[24] Enwezor explored Boshoff's work as part of the language-based conceptual art from South Africa and briefly described his "Kykafrikaans" from 1980, a serial work that

Andrzej Partum (left) and **Abdelkader Lagtaâ**, *The Film Does Not Need a Screen*, June 16, 1973. Performance at Fifth Biennale of Spatial Forms, Elbląg, Poland. Zygmunt Rytka Archive. Courtesy and © Fundacja Sztuki Współczesnej in Situ, Warsaw. Photo: Zygmunt Rytka

explored various ways of rendering words into signs and deconstructed their semantic meaning. Lagtaâ's linguistic experiment was not as radical as the works of Boshoff, because in "Nettainissement Linguistique" he still used French and Latin words and mixed them with non-European vocabulary. While Boshoff's work was created in the context of the infamous language policy under apartheid, Lagtaâ's work, created in Poland, was more of a formal linguistic experiment, which was then featured among conceptual works from around a globe in a volume published by the Warsaw-based Poetry Office.

Happenings

In addition to preparing his works for exhibitions in Buenos Aires and Calgary as a "Polish conceptualist," Lagtaâ was also involved in the local artistic activities in Poland under the banner of Galeria Adres. In an interview with Léa Morin and Marie Pierre-Bouthier, he recalled:

I also participated in the international exhibition in Buenos Aires, presenting a work on the stamp, which I used in an unusual way. I also took part in an international exhibition, probably in Montreal [*sic*, it was Calgary] and in some exhibition in the north of Poland, where together with Andrzej [Partum] we did acupuncture on a cinema screen. We climbed on some ladders and turned the screening of the movie into a happening.[25]

The city in the north of Poland that Lagtaâ mentioned was Elbląg, and the event was the Fifth Biennale of Spatial Forms, which opened in June 1973.[26] The Moroccan artist participated there as a Galeria Adres and Poetry Office associate in a performance with Andrzej Partum titled *Akupunktura Ekranu* (*Screen Acupuncture*), held on June 16. A screening of one of Robakowski's films was reflected in a mirror held by Lagtaâ and then projected on the ceiling, while Partum sat on top of a ladder, puncturing the empty and unnecessary screen with pins. During the next action, on June 17, Partum held a mirror and Lagtaâ a large board with the

inscription, "The film does not need a screen."[27] This happening questioned the role of traditional cinema and analyzed the film as a living form of its own, independent of the screen. The fifth issue of *Notatnik Robotnika Sztuki* (*Notebook of an Art Worker*), a magazine published by Gerard Blum-Kwiatkowski on the occasion of the Elbląg Biennale, described another performance by Lagtaâ: "Day III (17 June) . . . The provocative action was presented by the representative of Adres Gallery—Kader Lagtan [*sic*], crossing with a white chalk all the plates in the exhibition pavilion, where the documentation of Polish Artistic Movement was presented."[28] A photograph from this happening appeared in *Notatnik*, showing the Moroccan, who in an avant-garde gesture destroyed boards with reproductions of photographs and manifestos of Polish artists who appeared in Elblag.

Lagtaâ was involved in happenings around the same time as a conceptual group called Laboratoire Agit-Art from Dakar, founded in 1973–74, which focused their performative actions on a critique of institutional power. While the artists from the Senegalese group listed by Enwezor as African conceptualists worked outside the sponsored system of galleries and museums, distancing their creations from traditional painting and sculpture, they were connected to the local political situation in their country and were not recognized in conceptual networks at that time. Lagtaâ's actions, conducted at the international biennale in Elbląg, were part of a larger conceptual movement and a testimony of "intermediality." That is, his practices defied easy media categorization: they were not only related to concrete poetry and mail art networks but also happenings and experiments with new media formats.

The rediscovery of Lagtaâ's conceptual work affirms that it is necessary to carry out in-depth research on the work of artists from the Global South who were educated at Eastern European art academies and film schools. Lagtaâ's activities in Łódź, Warsaw, and Elbląg suggest that students coming from the Global South to Eastern Europe—and in this case from Morocco to Poland—participated in a very broad artistic life outside the art schools. They were interested in experimental currents and engaged on the side of noninstitutional artistic activities and networks. I am convinced that initiating

further research projects on student exchanges between Africa/Global South and Eastern Europe will lead to more rediscoveries in the field. Indeed, this is among the tasks that Enwezor has assigned to new generations of art historians and curators—to rethink conventional studies and broaden knowledge of the global trends of art.

After 1975, when Lagtaâ was expelled from Poland because of his political activity, he arrived in Morocco and tried to interest local artists with his conceptual experiences. As he recalled in one of our personal interviews, no one took him seriously there, as he was creating art based on ideas, actions, and linguistics that did not fall into a traditional art genre. He did not create objects; his work was neither a painting nor a sculpture. After returning to his homeland, he started to collaborate with state television and directed several movies, including the famous *A Love Affair in Casablanca* (1991). Today, he is regarded as one of the most important Moroccan film directors.

Locating Lagtaâ's Art Practices

If we relate Lagtaâ's work to other conceptualists from the African continent identified by Enwezor in his 1999 essay, we would see clear differences between their approaches to artistic strategies. Artists listed by Enwezor, and later by Oguibe and Hassan, worked independently, on the margins and outside of international circuits, disconnected from the conceptualist networks in the 1970s, as they were not recognized outside of Africa at that time. Their works were rooted locally: Koraichi's work in Algeria and Tunisia, Laboratoire Agit-Art in Senegal, Boshoff's work in South Africa. Lagtaâ's work, in contrast, was more global, given that it circulated in the early 1970s between Eastern Europe and other conceptual environments in various parts of the world. His work was an intrinsic part of influential Eastern European conceptual networks with other countries such as Argentina and Canada. Because of his collaboration with Polish authors' galleries, he was well connected to other international conceptual circles, most notably from Argentina and Canada. Yet, despite his acknowledgment by artists, his work was not recognized in art-historical scholarship. While working with Galeria Adres, he assisted with preparations of exhibitions of Hungarian and Belgian

conceptual artists in Łódź, and later, as a member of this gallery, he participated at the Fifth Biennale of Spatial Forms in Elbląg, which brought together conceptual video material from all over the world. While working with the Poetry Office, he recited his poems in Warsaw at an event that included presentations of mail art from Argentina as well as concrete poetry from Great Britain and Italy. He was asked to send his conceptual pieces to the Argentinian CAyC group as well as to Canadian W.O.R.K.S. If Lagtaâ had not established contact with Galeria Adres, the Poetry Office, and the Workshop of the Film Form, he may not have become acquainted with a conceptual approach toward art and would not be connected internationally.

While framing Lagtaâ's work chronologically, I conclude that he was one of the first artists from the African continent who participated in early 1970s conceptual networks between Eastern Europe, Latin America, and North America.[29] It was in Poland that he created works with Polish conceptual artists: the *Conceptual Gymnastics* photo-performance with Ewa Partum, and later, with Andrzej Partum, a poem formed around the word "Coca-Cola," as well as the happenings *Screen Acupuncture* and *Film Does Not Need a Screen*. Because of his tight collaboration with Polish neo-avant-garde circles, it is appropriate that his work from 1972–74 be assigned to Eastern European conceptualism, as he was an active agent within conceptual strategies in this region but has not been credited as such in art-historical scholarship. In addition, the fact that Lagtaâ is also an African conceptual artist cannot be denied.

Przemysław Strożek *is an associate professor at the Institute of Art of the Polish Academy of Sciences in Warsaw.*

Notes

1 Okwui Enwezor, "Where, What, Who, When: A Few Notes on 'African' Conceptualism," in *Global Conceptualism. Points of Origins, 1950s–1980s*, ed. Luis Camnitzer et al. (New York: Queens Museum of Art, 1999), 109–17.
2 Miguel A. López, "How Do We Know What Latin American Conceptualism Looks Like?," *Afterall: A Journal of Art, Context, and Enquiry* 23 (2010): 5; Piotr Piotrowski, "The Global NETwork: An Approach to Comparative Art History," in *Circulations in the Global History of Art*, ed. Thomas DaCosta Kaufmann, Catherine Dossin, and Béatrice Joyeux-Prunel (New York: Routledge, 2015), 157. Benjamin Buchloch, for example, placed the genesis, development, theories, and conceptual practices within the Anglo-American experience only. For more on this issue, see Benjamin H. D. Buchloch, "Conceptual Art 1962–1969: From the Aesthetic of Administration to the Critique of Institutions," *October* 55 (1999): 105–43.
3 The *Global Conceptualism* exhibition became a starting point for further developments exploring conceptual practices, most notably between Eastern Europe and Latin America, which recently have begun to be investigated on a more detailed level. See *Transmissions: Art in Eastern Europe and Latin America, 1960–1980*, which was presented at the Museum of Modern Art, New York, September 5, 2015–January 3, 2016, moma.org/calendar/exhibitions/1532. On artistic transfers between both regions, see Klara Kemp-Welch and Cristina Freire, "Special Section Introduction," *Artists' Networks in Latin America and Eastern Europe*, ArtMargins 1, no. 23 (2012): 3-13; Katarzyna Cytlak, "Transculturation, Cultural Transfer, and the Colonial Matrix of Power on the Cold War Margins: East European Art Seen from Latin America," in *Globalizing East European Art Histories: Past and Present*, ed. Beáta Hock and Anu Allas (New York: Routledge 2018), 162–74. For more on the issues of global conceptualism, see Sophie Cras, "Global Conceptualism? Cartographies of Conceptual Art in Pursuit of Decentering," in *Circulations in the Global History of Art*, 167–82.
4 Enwezor, "Where, What, Who, When," 111.
5 Enwezor, "Where, What, Who, When," 109.
6 Enwezor, "Where, What, Who, When," 117.
7 Enwezor, "Where, What, Who, When," 117.
8 Salah M. Hassan and Olu Oguibe, "Authentic/Ex-Centric: Conceptualism in Contemporary African Art," in: *Authentic/Ex-Centric: Conceptualism in Contemporary African Art*, ed. Salah M. Hassan and Olu Oguibe (Ithaca, NY: Forum for African Arts, 2001), 16.
9 See, for example, Colin Richards, "The Thought Is the Thing: Conceptualism in Contemporary South African Art," *Art South Africa* 1, no. 2 (2002): 34–41; and Kellie Jones, "Tracey Rose: Postapartheid Playground," *Nka: Journal of Contemporary African Art* 10 (2004): 26–31.
10 On Lagtaâ's cinematigraphic work, see Kevin Dwyer, "Hidden, Unsaid, Taboo in Moroccan Cinema: Abdelkader Lagtaâ's Challenge to Authority," *Framework: The Journal of Cinema and Media* 43, no. 2 (2002): 117–33. The only article on Lagtaâ's conceptual practices I have found until now was an interview conducted by Léa Morin and Marie Pierre-Bouthier with Lagtaâ on his student years in Poland. The interview has been translated into Polish, and I regard it as a very valuable source for this article: "Do Polski, by zostać marokańskim filmowcem: Opowieść o studenckich latach w Łodzi Abdelkadera Lagtaâ'y" ("To Poland to Become a Moroccan Filmmaker: The Story of Abdelkader Lagtaâ's Student Years in Łódź"), Muzeum Sztuki Nowoczesnej w Warszawie, November 19, 2019, artmuseum.pl/pl/news/do-polski-by-zostac-marokanskim-filmowcem.
11 The first time I came across the name Abdelkader Lagtaâ was in 2018, when my partner, Sara Lagnaoui, and I started preparations for the exhibition *Ahmed Cherkaoui in Warsaw: Polish-Moroccan Artistic Relations, 1955–1980*, which opened in March 2020 at Zacheta National Gallery of Art in Warsaw. The aim of the exhibition was to explore the artistic relationships between Eastern Europe (Poland) and the Global South (Morocco) and, at the same time, to contribute to the recent discourse on global postwar art. While focusing our research on the Moroccan artists—mainly painters and filmmakers working in Poland—we did not expect to discover any relationships with global conceptualism. The exhibition catalogue has been published as a book: Przemysław Strożek,

Ahmed Cherkaoui w Warszawie. Polsko-marokańskie relacje artystyczne 1955–1980 (Warsaw: Zachęta-Instytut Sztuki, 2020).

12 For those unfamiliar with the term, *mail art* involves artists using the postal service to share and distribute small-scale works of art. I would like to thank Abdelkader Lagtaâ, Ewa Partum, and Józef Robakowski for the firsthand accounts included in this essay. I am also thankful to Karolina Majewska Güde, Wanda Lacrampe, and Zuzanna Sokalska for valuable information on the subject.

13 Lagtaâ studied in Łódź with Abdellah Drissi, Mustapha and Abdelkrim Derkaoui, Idriss Karim, and Mohamed Ben Said. See: Strożek, *Ahmed Cherkaoui w Warszawie*, 77–84.

14 The 1970s saw a rapid proliferation of alternative spaces for the exchange of artistic proposition in Poland, and many of these venues adopted the model of the "authors' gallery," which was created in private homes, studios, and other places. Galeria Adres was one of the first Polish authors' galleries and was characterized by exhibitions of conceptual practices, including concrete poetry. It was first located in the space beneath a staircase at the Polish Artists' Union building in Łódź at 86 Piotrkowska Street, and later in Ewa Partum's apartment at 7d Rybna Street. Actions by Ewa Partum were focused on neo-avant-garde practices outside the institutional circuit. Today, Ewa Partum is regarded as an important "cultural producer" of the 1970s in Poland. See Karolina Majewska-Güde, "Ewa Partum as a Cultural Producer," MoMA Post: Notes on Art in a Global Context, March 6, 2019, post.moma.org/ewa-partum-as-a-cultural-producer.

15 Klara Kemp-Welch, *Networking the Bloc: Experimental Art in Eastern Europe 1965–1981,* (Cambridge, MA: MIT, 2019), 287–90.

16 Cytlak, "Transculturation, Cultural Transfer, and the Colonial Matrix," 169.

17 The piece has been preserved in the Poetry Office archive in Warsaw and in the end was not sent to Argentina. As there seems to be a lack of proper documentation, this exhibition probably never took place.

18 Alain-Martin Richard and Clive Robertson, *Performance Au: In Canada 1970–1990* (Quebec: Éditions Intervention, 1991), 124.

19 [Andrzej Partum], "En 1972 Participe ont du Bureau de la Poesie…," in Andrzej Partum, *L'Art Pro/La* (Warsaw: Bureau de la Poesie, 1973), n.p.

20 The archive of the Poetry Office is currently being relocated to Muzeum Sztuki in Łódź. I express my gratitude to Wanda Lacrampe and Zuzanna Sokalska, who helped me find Lagtaâ's briefcase.

21 Still, in 1967, just before leaving for Łódź, the twenty-five-year-old Lagtaâ was already a recognized poet in Morocco. He collaborated with the Moroccan literary and artistic circles formed around the leftist magazine *Souffles*, in which he published socially engaged poetry. His poems appeared in a 1967 and a 1968 volume of the magazine, which tackled social changes in Morocco: Abdelkader Lagtaâ, "Poémes," *Souffles* 5 (1967): 25–27; and "Aayta," *Souffles* 10/11 (1968): 34. The poetic work Lagtaâ did in Poland differed from the socially engaged poems he did in Morocco, as it was more focused on linguistic experiments and visual shapes of letters and words.

22 Lagtaâ, "Nettainissement Linguistique," in Partum, *L'Art Pro/La*, n.p.

23 Enwezor, "Where, What, Who, When," 113.

24 Three other typescripts of Lagtaâ's poems have been preserved by Józef Robakowski in Łódź in Galeria Wymiany (Gallery of Exchange): "Variations II," "Variations III," and "Poéme de la realité des limites de la realité," from 1973. The Galeria Wymiany archive is currently being relocated to the Museum of Modern Art in Warsaw.

25 Lagtaâ, "Do Polski, by zostać marokańskim filmowcem."

26 The biennale was organized at Galeria El (El Gallery) by Gerard Blum-Kwiatkowski and was conceived as a kino-laboratorium (cinema-laboratory), where artists from various parts of the world, including Holland (Christian Wabl), Hungary (Istwan Sas), and Spain (Javier Aguirre) participated. Other conceptual artists from Argentina (Gulsberg, Jose Luis Dizeo), Scotland (Richard Demarco), Germany (Klaus Groh), France (Manuel Otero), and Canada (Norman McLaren and Pierre Herbert) sent their works via mail and were screened in the gallery. From the Polish side, the event was dominated by artists associated with the Workshop of the Film Form, who analyzed the perception of film and the links between various levels of film structure. Lagtaâ knew the members of this conceptual group from his student years at the Łódź Film School.

27 Jerzy Truszkowski, *Post Partum Post Mortem. Artyści awangardowi w społeczeństwie socjalistycznym w Polsce 1968–1988* (*Post Partum Post Mortem. Avant-garde Artists in Socialist Society in Poland 1968–1988*) (Bielsko-Biała, Poland: Galeria Bielska BWA, 2013), 88–89.

28 *Notatnik Robotnika*, *Sztuki* 5 (1973): 18.

29 The other artist who was active on the African continent and participated in conceptual networks was the French artist Fred Forest, who was born in Algeria. However, because of his French roots, I would not connect his work to conceptual art from Africa.

Tropical Aesthetics of Black Modernism

SAMANTHA A. NOËL

The Visual Arts of Africa and its Diaspora

"From Alexander von Humboldt to Wangechi Mutu, art historian Samantha A. Noël has tracked the allure of 'tropical aesthetics': landscapes, regalia, and choreographies that betray modernism's debt to the equatorial realm and its treasures. Black artists especially have had to contend with these sensibilities, responding to their appeals for diaspora camaraderie and struggling with the challenges they pose to a postfolkloric contemporaneity. This tension— along with Professor Noël's deft, critical purview—commends this important study."
— **RICHARD J. POWELL**

DUKE UNIVERSITY PRESS

 dukeupress.edu

A HOST OF
POSSIBILITIES

Rirkrit Tiravanija, *Soup/No Soup*, performance on April 7, 2012, La Triennale, Grand Palais, Paris. Courtesy the artist and Gladstone Gallery, New York and Brussels. Photo: © Marc Sanchez, Paris

Journal of Contemporary African Art · 48 · May 2021
DOI 10.1215/10757163-8971300 © 2021 by Nka Publications

Okwui Enwezor's Exhibition Making as a Practice of Hospitality

Susette Min

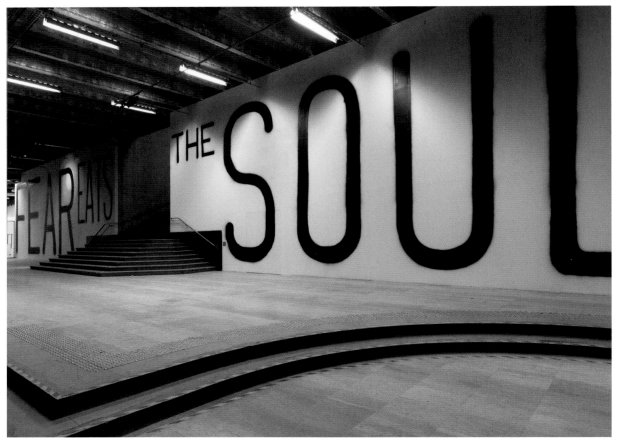

Rirkrit Tiravanija, *Untitled (Fear Eats the Soul)*, 2012. Graffiti. Installation view at La Triennale *Intense Proximité*, Palais de Tokyo, Paris, 2012. Courtesy the artist and Gladstone Gallery, New York and Brussels. Photo: André Morin

Launched in 2006 by the French ministry of culture, La Triennale was the state's attempt to showcase contemporary French art and re-affirm France's self-perception as a global cultural force. In 2012, Okwui Enwezor—a Nigerian-born curator, critic, scholar, and poet—was appointed artistic director of the third iteration of La Triennale, which he titled *Intense Proximité* (*IP*). Invited to be the triennale's esteemed guest curator, Enwezor was a non-Western outsider who nonetheless had the credentials to legitimize the French art scene. Rather than showcasing the "best" of French contemporary art, Enwezor's conceptual starting point for the exhibition was the "superiority of French culture," which in the words of sociologist Michèle Lamont "ha[d] been maintained through colonialism via France's *mission civilisatrice*," including the rich legacy of French anthropology.[1] Posing the question of what happens "when distance between

a colonizer and colonial subject . . . collapses," and linking it with globalization's compression of time and space, *IP* rendered moot the French ministry's decree of renationalizing contemporary art.[2]

Drawing parallels between the unreconciled histories of colonialism and the globalizing forces that transform strangers as neighbors, and vice versa, the exhibition was an artistic extravaganza with over one hundred twenty French and international artists, taking place in the then newly renovated and expanded Palais de Tokyo, with the original venue of La Triennale—the Grand Palais—serving as a satellite venue. Through Enwezor's sustained curatorial analysis of the interacting processes of globalization and its accelerated circulation of transnational flows of people, resources, and ideas, as well as its impact on cultures and ideas, the exhibition explored the encounters, traumas, and aesthetics of a "disappearing of distance."[3]

In contrast to the cause célèbre of five hundred employed undocumented immigrants who had occupied Paris's *Musée national de l'histoire de l'immigration* (National Museum of Immigration History) the year before and demanded the regularization (opportunity to legalize their status) and processing of their identity documents—only to be demeaned by some on the far right as overstaying their welcome rather than being perceived as citizens following the French tradition of going into the streets and protesting—Enwezor, the cosmopolitan stranger, was welcomed with fanfare into "a space of intellectual generosity."[4] I read this quote, drawn from a press release put out by the Palais de Tokyo in 2011, as a performative utterance in which Enwezor took seriously this opportunity and the civic space of the Palais de Tokyo entrusted to him.

Much has been written about Enwezor's own legacy and his accomplishments, which include introducing artists from the periphery, redefining the category of African art, shifting the conception and capacity of what an exhibition is and does, and remapping the world, as highlighted in Jason Farago's *New York Times* obituary of him.[5] An erudite and consummate curator, Enwezor's success was also contingent on his keen awareness of his own revolving role as guest and host in historically charged spaces insofar as his role as lead curator could never be presumed to be sovereign. This article offers some preliminary thoughts that consider his exhibition-making practice within the context of hospitality. Conventionally, hospitality entails warmly welcoming guests to make themselves at home. This interaction between guest and host involves implicit codes of etiquette and manners, but also an economy of exchange that revolves around constant transaction and negotiation. In general, a curator's duties are similar to those of a host in setting up the conditions to welcome a diverse array of artists, ideas, and viewers into a designated space.

Enwezor's contributions to the art world and other disciplinary fields have been numerous and invaluable. In light of his record of collaborating with multiple curators and hundreds of artists around the world, navigating institutional bureaucracies and power dynamics, my positing him as a preeminent host with a unique legacy in curating large-scale exhibitions, including Documenta11 and the 56th

Venice Biennale (*All the World's Futures*), is not at all far-fetched, especially in the case of *IP*. Enwezor's role as an unaffiliated (not independent) guest curator, I suggest, was informed by his position as a temporary host for the French Ministry of Culture, a unique situation that necessitated an acute attentiveness to France's global, transnational, and translocal context from the point of view of a foreigner, stranger, intruder, and neighbor.[6] Using the context of hospitality to engage Enwezor's general curatorial practice alongside his curatorial premise for *IP*—one informed by French history, art history, anthropology, and ongoing contentious debates on immigration—opens up ways to reconceive hospitality as a site of interruption, absolution, and abolition and reaffirms scholarship that conceives his exhibition making as a decolonial practice. The first half of the article introduces the concept of hospitality and sets up Enwezor's curatorial premise of *IP*. The second half explores subthemes in *IP* alongside select artworks that I want to place in dialogue with Enwezor's exhibition making as hospitality, a move that reveals a transhistorical continuum of practices and situations and links the past to the present and future.

* * *

Unpacking Jacques Derrida's deconstruction of hospitality in relation to the self and the other, philosophy scholar Mark W. Westmoreland writes how "hospitality governs all human interactions."[7] In a conversation with Anne Dufourmantelle, Derrida approaches and deconstructs hospitality as unconditional or conditional.[8] He writes, "Hospitality is the deconstruction of the at-home; deconstruction is hospitality to the other."[9] In brief, conditional hospitality is linked to duties and obligations, exchanges, rights, and laws: a form of power that presumes sovereignty over one's home and a sense of control in governing the conditions of a guest's stay. At the threshold of the border/polis/house, a guest is always already "inside and under the law" as a foreigner and stranger. Such a mode of hospitality requires at the outset asking the name of the outsider and forcing the outsider to respond in a language that is not her/his/their own, the first of many violent transactions that highlight the contradictions of hospitality. In turn, a home is not one's own, and a host cannot be a

host, unless one is hospitable, a means and condition to preserve one's identity as a host. Unconditional or pure hospitality calls for not only sharing a space, but also giving place to a foreigner or the stranger without any reserve, reciprocity, exceptions, or restrictions. According to the laws of hospitality or the overall ethos governing any host/guest transaction, the host who is unable to maintain the law is essentially breaking the rules of hospitality, in which case the guest is free to become the host, and the host as a consequence becomes a parasite.

On April 7, 2012, Rirkrit Tirivanija played host at the Grand Palais in Paris—originally built and dedicated "to the glory of French art"—opening *Intense Proximité* with *Soup/No Soup*, a twelve-hour banquet serving tom kha, a traditional Thai soup, to the general public.[10] An example of social practice and relational aesthetics, *Soup/No Soup* was a convivial exchange and gift, which Marcel Mauss characterizes as an exchange that comes with "terms and notions."[11] Likewise, hospitality can be approached in a similar fashion, but in the form of rights and obligations. For twelve hours, Tiravanija and the Palais de Tokyo welcomed a stream of guests into the Grand Palais, charging no fees or admission to take part in *Soup/No Soup*. While no money was exchanged, a series of transactions ensued. By sitting down at the long wooden tables set up under the expansive glass roof of the Grand Palais and partaking in soup, the visitor-guest became part of Tiravanija's artwork. While the soup transformed from a source of nourishment into an icebreaker, it was ultimately up to each individual guest to take on and accept the duty to recognize the others at the table as fellow guests and ideally strike up a conversation, socializing the space and creating a shared collective experience.

On a larger scale, Immanuel Kant foregrounds in *Toward Perpetual Peace: A Philosophical Sketch* (1795) a nation-state's moral duty to recognize the universal right of any foreigner to request hospitality and to treat him/her/them *not* as an enemy of the state, unless the state perceives the guest as a dangerous threat. Recent events and misrepresentations of immigrants and refugees as terrorists and cultural threats fuel Islamophobic and xenophobic sentiments and have led to the failure of the French state as a role model to uphold its moral duty as host. According to Bernard-Henry Lévy, this failure

threatens to undermine its republican principles, reputation, and obligation to preserve the peace both within France and the European Union. Examples of the French government's negligence in its duties as host are many, including the raid and removal of displaced peoples from St. Bernard's Church (1996), mass expulsions of Romanian and Bulgarian Roma (2012), the destruction of the "Calais Jungle" (2016), and the dismantling of migrant encampments along the canal in Paris (2018).

In 2003, Solidarité des Français (SDF)—a subsidiary or spinoff of the fascist ultra-right group, Bloc Identitaire—opened a soup kitchen for indigent families and the unhoused.[12] Not accommodating at all to those who do not eat pork on religious, ethical, or cultural grounds, the soup they served, which they called soupe identitaire, was full of bacon and pigs' ears, feet, and tails. Following the role model of the French state, rather than promoting the good will message of Emmaüs Solidarité—"Serve those worse off than yourself before yourself. Serve the most needy first"—whose members helped Tiravanija mount his event *Soup/No Soup*, SDF's soup kitchen was, in the words of Odile Bonnivard, president of SDF, only for those who were "secular" and "French."[13] Resentful toward the increasing presence of unwanted foreigners in France and threatened by a disappearing way of "French" life and republican values, the soup became a symbol, an inhospitable message to "help our own before others."[14] Reading a *New York Times* article about the soup and SDF's repellant hospitality left an impression on Enwezor that eventually led, in part, to the restaging of Tirivanija's *Soup/No Soup*.[15]

In addition to *Soup/No Soup*, Enwezor also recommissioned Tirivanija's monumental word installation *Fear Eats the Soul* (2012) for *IP*, installing it—nine meters high—in the lobby and in front of the entrances to the newly expanded galleries at the Palais de Tokyo. While *Soup/No Soup* could be seen as a kind of mimicking of Bloc Identitaire's soup kitchen, but in a way that tapped into a familiar and longer history of charitable distributions of food across religions and borders, I suggest that Enwezor's placement of *Fear Eats the Soul* was also a shrewd mimicry of the French government's management of race.[16] Racked by months of civil unrest in the suburbs (*banlieues*) of Paris as an outcome

Dan Perjovschi, *National-International*, La Triennale *Intense Proximité*, Paris. 2012. Courtesy the artist and Michel Rein gallery, Paris. © Dan Perjovschi

of grievances and police brutality, the government responded to another wave of escalating violence in 2006 by abruptly shutting down Bloc Identitaire's soup kitchens.[17] By placing the blame for the recent racial tension on Bloc Identitaire, the government temporarily diverted public scrutiny from its own role and tone-deaf "law and order" zero tolerance policies on youth of color. The sudden crackdown of the kitchens that had been operating for almost three years, only to have a Parisian judge claim the following year that such food distributions were not discriminatory, highlights the state's and French society's disingenuous attitudes toward race that undermine and put under erasure the presence and role of race in French life.

Foregrounding the ambivalence underpinning acts of mimicry that Homi Bhabha conceives as "at once resemblance and menace," Enwezor's placement of *Fear Eats the Soul* at the literal opening of the

exhibition with *Soup/No Soup*—in which the event served as a kind of overture to the exhibition—was a brilliant curatorial move in its foregrounding of the tensions at play in *Intense Proximité*. From another valence, Enwezor transformed the Palais de Tokyo's civic space into a surrogate for the State, boldly encroaching upon France's simmering state of affairs or, put another way, compensating for the State's inhospitable policies and inviting the public to contemplate and grapple with these contentious issues. Rallying a diverse array of local and international artists as proxies to engage these debates—humorously and wryly introduced by Dan Perjovschi's window drawings—the artists, in turn, invited the public to disengage from their anxieties and confront their fears, beginning with Tirivanija's *Soup/No Soup* and *Fear Eats the Soul*.

Serving simultaneously as a statement, commentary, and prophecy, Tiranvanija's formidable

Monica Bonvicini, *Deflated*, 2009. Mirror panels on medium-density fiberboard, clear-coated cold-drawn steel chains, 53 1/10 x 39 2/5 x 39 2/5 in. © Monica Bonvicini and VG Bild-Kunst, Bonn (ARS, New York). Courtesy the artist and Mitchell-Innes and Nash, New York. Photo: Holger Niehaus

turn of phrase—*Fear Eats the Soul*—set the tone for the exhibition, one of many "junctures of hospitality and hostility" displayed throughout *IP*.[18] For example, next to Timothy Asch's and Napoleon Chagnon's iconic film *The Ax Fight* (1975) was one of Monica Bonvicini's glass and steel cubes. *The Ax Fight*, which takes place in the Yanomami village of Mishimishimabowei-teri, located in southern Venezuela, focuses on a fight that ensues after guests ask for food, at the same time refusing the hosts' request to work in their garden. Without understanding the kinship dynamics of the Yanomamo and the underpinnings of the conflict, the first part of the film records Asch's and Chagnon's assessment and misinterpretation of the situation. Later in the film, Chagnon clarifies the details of the guest-host dynamics that led to the conflict, but overall the film presents a critical reflection of the tensions in translating and filtering what anthropologists witness. Near the film stood Bonvicini's *Deflated* (2009), a dense trapezoidlike shape of steel chains atop a large glass cube sculpture. The large-scale cube, reflecting only the bottom half of a visitor's body, metaphorically reconfirmed how ethnography can fetishize the other and mirror the self. That is, while ethnography's objective is to write about other cultures, it has often been more about the colonizer's selfhood, or in the words of Claude Lévi-Strauss, "L'ethnologue, écrit-il autre chose que des confessions?" ("Does the ethnologist write anything other than confessions?").[19]

It is at the intersection of ethnography and autobiography—the collapse of the distance between the self and the other—that Enwezor grounds his curatorial premise, but for my purposes here, it is also the location from where he is able to shift the terms, roles, and dynamics of hospitality. Recalling Jean-Hubert Martin's controversial exhibition *Magiciens de la Terre* (1989), held across town at the Centre Georges Pompidou, and Harald Szeemann's landmark *When Attitudes Become Form* (1969), in which he displayed historical artworks next to anthropological artifacts, Enwezor's *IP* was on one level a respectful nod and critique to both exhibitions, with Enwezor folding into his contemporary art exhibition drawings by Claude Lévi-Strauss of the Caduveo people, photographs of masks by Marcel Griaule, and other works by anthropologists who traveled to France's various colonies by way of government-sponsored expeditions in the 1930s.

Beginning in the 1870s, French anthropologists were gradually sent to France's recently acquired territories in Africa in order to get to know the people under their new authority and to learn more efficient ways of negotiating with African chiefs as a means to establish French rule. In concert with the French colonial agenda that breached the rules of hospitality and brutally seized the land by force, ethnographers traversed borders and thresholds, too, collapsing space and time, bringing stories, and picturing "race" to the French citizens back home. It was back home in France that the state used these ethnographies to help formulate colonial policies, including a mission to civilize colonial subjects in order to ensure full assimilation. Nevertheless, as underlined by many postcolonial scholars, while colonization was violently one-sided, colonial encounters were at the outset multidirectional, beginning with the contact zone which Mary Louise Pratt defines as spaces where "cultures meet, clash and grapple with each other [though] often in contexts of highly asymmetrical relations of power."[20] In light of how colonial rule, in the words of Frantz Fanon, "is the bringer of violence into the home and the mind and into the mind of the native," how are such rules of hospitality reconfigured in these contact zones when a guest makes the first move to cross the threshold unauthorized?[21]

In *On Cosmopolitanism and Forgiveness*, Derrida conceptualizes absolute hospitality as unconditional, without debts or exchanges.[22] How might we see France's initial entry into its colonies in which the French ravaged the land, excavated natural resources, and reworked the land while making empty promises of citizenship as an outlaw form of absolute hospitality? Perceiving colonialism as opening the door to this transgressive form of hospitality in which hosts become hostages—the colonized entrapped in a colonial apparatus—how might this primal violation of the "rules" of hospitality suspend or rewrite guest/host relations while at the same time keep intact the customs, the script of hospitality? In the aftermath of independence from colonial rule, postcolonial migration, in combination with globalization, resulted in not only a collapsing of relational distance, but also an *interversion* (as opposed to

an inversion) of the roles of guest and host. Linking this continuum of hospitality with the history of colonialism and the corollary ways globalization gives way for the former colonized to break the terms of the ransom, Enwezor's appointment as artistic director of La Triennale was a unique but not inconceivable phenomenon.

In an interview about *IP*, Enwezor describes his crossing the threshold of the Palais de Tokyo as an "intrusion." In contrast to Europe's violent colonial incursion, I read Enwezor's "intrusion" as a form of reckoning and France's need to recognize itself as a parasite—its formation as part of a chain of parasites. Extending Enwezor's understanding of *IP* as a "space of recognition . . . [where] debates about fragility can really happen," what I want to underline is how this space also enabled him to demonstrate different forms of hospitality as interruption, absolution, and abolition.[23] Not at all meaning to disrespect Enwezor, how might we see his curating as "parasitic," drawing from Michel Serres's reconceptualization of the parasite and Bonnie Honig's rethinking of the role of the foreigner?[24] In other words, what follows is a proposition to see Enwezor's exhibition making of *IP* as engaging in a practice of hospitality that interrupts former parasitic relations and engenders a new kind of exchange and set of relations, in which the host (in this case the French state) is placed in a position to expel the parasite (Enwezor, the artworks, and the guests and issues they bring in) or incorporate them, bringing in new subjectivities and histories that, in turn, unsettle established boundaries and embedded histories.

In accord with Derrida's deconstruction and reconceptualization of hospitality in part as an interruption of the self, Enwezor in *IP* also interrupted Eurocentric understandings of history that too often subordinate the intertwined histories of colonialism and modernity. Complicating the conditions of Europe's desired host status, one based on its self-perceived singularity and exceptionality, *IP* was also a presentation of an ethnography in progress, a visual study of Europe as the model for living among differences as a consequence of collapsing global distances and erosions of sovereignty. In contrast to biennials that appear to be cosmopolitan microcosms of the world in correspondence with nineteenth-century world exhibitions, *IP* was not so much about finding common ground but rather highlighting the importance of the world, especially Europe, to see the connections between globalization and colonialism and, in the words of Édouard Glissant, to understand "that contact with, and tolerance of, the other is not automatically the cause of dilution and disappearance; better yet, that we can change, no longer be the same, and exchange something with the other without losing or diluting oneself, without vanishing into a kind of nonspace."[25]

In the 1920s and 1930s, the arrival and acceptance of jazz and African American soldiers in Paris anticipated Glissant's sage reflections on the Other, but the appearance of African students and soldiers (*tirailleurs*) and colonial immigrant workers at the time evoked suspicion and fears of miscegenation. Rather than remarking upon the everyday occurrence of crossing paths in Paris with the African and Caribbean diaspora of students, soldiers, and artists, French surrealists preferred to engage with racial difference by fetishizing artifacts made in Africa, Asiana, and Oceania. With the publication of Georges Bataille's magazine *Documents* (1929–30), the surrealist preoccupation with objects as a means to make contact with the primitive Other shifted to an interest in the ethnographic studies of the Other. A decisive break from Breton's surrealist mandates and manifestos, *Documents* was filled with odd and incongruous photographic juxtapositions that Brent Edwards has described as "extremely deliberate" in its "search for a world beyond resemblance, an 'impossible' real that would be radically singular."[26]

Drawing inspiration from these different historical periods and approaches of surrealism, and foregrounding the surrealists' fascination and anthropologist's belief in *mana*, a magical supernatural force that flows in and through things, Enwezor included in *IP* quotidian and anthropological-looking objects such as Seulgi Lee's *Baton*, a set of seventeen brightly colored, five-meter sticks, playfully and precipitously placed against a wall, and David Hammons's *Stone with Hair* (1998). Interspersed throughout the labyrinthine galleries of the Palais de Tokyo were a number of jarring juxtapositions that created discomfort or, put another way, made surreal the space and the self, including Aneta Grzeszykowska's *Headache*, a video of the artist's fragmented body—legs, arms, and torso—in search

Aneta Grzeszykowska, *Headache*, 2008. Video still from single-channel video in black and white with sound, 11:37. Courtesy and © the artist

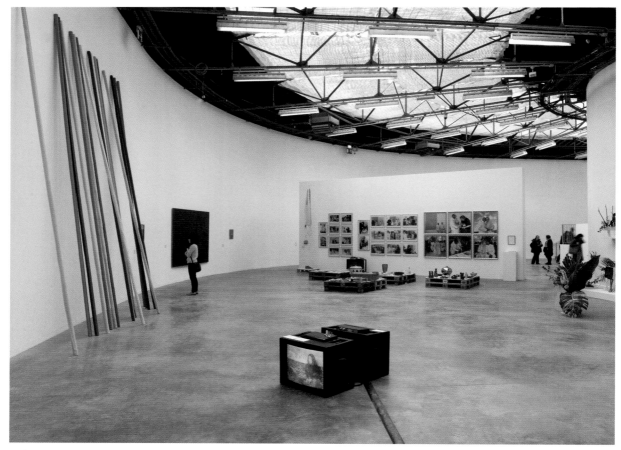

Seulgi Lee, *Bâton*, 2009. Installation view at La Triennale *Intense Proximité*, Palais de Tokyo, Paris, 2012. © Seulgi Lee, ADAGP Paris 2020. Photo: André Morin

of her head in the aftermath of a violent self-implosion. Performed against a black background to the music of Krzysztof Penderecki, Grzeszykowska's choreography culminates in the "re-creation" of a hybrid monstrous creature.

Enwezor's engagement with surrealism and France's ethnographic tradition was threefold. On one level, the stimulating display of artworks at varied scales and heights and the multitude of colors, materials, media, and stimuli along the walls, floors, on top of pedestals, and directly drawn on the windows were attempts to create an interruption of reality, a kind of surrealist "convulsion" that evoked feelings of attraction and repulsion analogous to the fascination and fears of being in close proximity with the Other. On another level, by invoking surrealism and connecting the ways colonialism and globalization are closely related in their collapsing of distances and dispersal of people, Enwezor was able

to weave into the narrative of surrealism the historical influence of the African diaspora on modern art and surrealism, including in the exhibition artworks such as Wifredo Lam's *Carnet de Marseille* notebook series (1941). Last, in his presentation of unsettling and disturbing representations of encounters with the Other, for example, in his selections of Jean Rouch's *Les Maîtres Fous* (1955), Clemens von Wedemeyer's *The Fourth Wall* (2009), and Carrie Mae Weems's rephotographing and reframing of Louis Agassiz's commissioning of daguerreotypes of enslaved people in a plantation in South Carolina, Enwezor's foray into France's ethnographic tradition was also a critique on the role ethnography has played in creating damaging fictions. Regarding the latter, in 1850, Louis Agassiz was invited to plantations in Columbia, South Carolina, which at the time had "a white population . . . of just over 6,000, whereas the slave population of Columbia

was in excess of 100,000."[27] Fearful of living in close proximity with the enslaved and the consequences of their exploitation, the owners of the plantation played host to Agassiz and daguerreotypist Joseph T. Zealey, inviting them to photograph their "human possessions" in order to construct a fiction of white supremacy and racial inferiority. By printing these photographs through red and blue color filters and reframing them in circular mattes with text sandblasted on glass, Weems interrupts Agassiz's endeavor, refuting these images as racial evidence and fetishized objects, and presenting them instead as intimate portraits of human beings.

Highlighting the complex dynamics of guest and host and how these roles constantly rotate and evolve, Bouchra Khalili's acceptance of Enwezor's invitation to be included in *IP* opened a chain of migration into the space of the Palais de Tokyo. Khalili's single-channel video *Mother Tongue* consists of a series of speeches, specifically excerpts of historical speeches and writings by Aimé Cesaire, Abdelkrim Al Khattabi, Malcolm X, Mahmoud Darwish, Edouard Glissant, and Patrick Chamoiseau, recited in Moroccan, Arabic, Dari, Kabyle, Malinké, and Wolof by a number of undocumented immigrants whom Khalili met in the city of Paris and its outskirts. Inviting the immigrants to collaborate in her ethnography, the immigrants in turn invite the viewer to their respective homes and workplace, the results of their "studies." Committing to memory, these speeches, or in the words of Khalili, "digesting" them in order to comprehend and get into contact with the material, Malcolm X's prose becomes, in the case of Anzoumane Sissiko, his own thoughts that implicitly convey astute observations on the French republican ideals of liberté, égalité, and fraternité. Living and working on the edge of precarity, Anzoumane, an undocumented immigrant, is given the liberty to take on the power of speech, not as oppression but as empowerment or, borrowing the words from Molly Worthen in a *New York Times* Op-Ed piece about the power of memorizing verse, as a lifeline.[28] In other words, memorizing a speech is an exercise that also entails an unpacking and deconstruction of what certain statements and words mean—a mode of crossing borders and a challenge of earlier regimes of signification that, in turn, generate an irruptive emergence of a new concept or

transhistorical awareness that could not have happened in a prior regime. At one point during his recitation, Anzoumane asks, "Why should we do the hardest work for the lowest pay?," a poignant awareness of the ways racial capitalism and French society recognize him as surplus labor. Implicitly aware of how language is the first form of violence when a foreigner-guest asks for hospitality, creating at the get-go a sense of ambivalence toward a host community, the video also highlights how language can form a relationship or set of relationships and "an attitude in relation to the world."[29] The different speeches, I suggest, are examples of "relating the relation," highlighting how language is not at all a "nonspace," but a space of lateral linguistic mixing and nonhierarchical cross pollination—a phenomenon that begins to take form in and through gestures of hospitality extended by Khalili, the participants in her video, and Enwezor.[30]

Accepting and residing as host of *IP*, Enwezor did not, could not offer an absolute hospitality but rather what I call a hospitality of absolution that invited his guests (artists and the artists' guests, patrons, and visitors) to be absolved of any debts and obligations to the French state. The etymology of absolution is *absolutus/absolvere*: to set free, acquit, bring to an end. *Solvere* means to loosen, divide, detach, untie, cut apart, free from restriction. Considering absolution here as not so much an act of forgiveness as an absolution from an obligation, I consider how Enwezor, in his role as host—and in light of the state's abdication from accountability or lead role in engaging difference and racism—invited his guests to explore the "disjunction[s], in the thickness of ethnocentric and identity based processes," a task in which artists didn't necessarily self-identify with the nation or their home country, as in Khalili's video, but instead offered new forms of Frenchness.[31] Unsettling the notion of equivalence between the self and the nation, Enwezor's selection of artworks, including Khalili's *Mother Tongue*, also implicitly challenged the French Republic's concept of abstract *universality* by asserting a right to cultural difference—in other words, refusing the State's pressure to assimilate and its "republican" duty to subordinate difference.

Sharing in the mandate of surrealism to let go of authoritarian rationalism or, in the words of André

Breton, "the actual functioning of thought . . . in the absence of any control exercised by reason . . . based on the belief in the superior reality of certain forms of previously neglected associations," Enwezor invited select artists to experiment and imagine, in the expansive space of the Palais de Tokyo, more ambitious work, and for the viewer to let go as well, including the compulsion to try to see everything in *IP*.[32] In other words, the exhibition embodied the surrealist's spirit of letting go of preconceived ideas of how we define and approach an exhibition and hierarchies of seeing and seeing each other up close and from a distance. The third iteration of La Triennale was massive, with more than one hundred artworks displayed, sometimes tightly mounted and elsewhere sprawling. Due to the sheer quantity of artworks and the vastness of the space, the exhibition deterred the viewer from taking everything in methodically and all at once.

While some critics would characterize *IP*—its scale and content—as all about power and persuasion to the extent that the viewing experience was comparable to being in a hostage situation or re-education camp, I suggest the contrary. Due in part to the scale of the exhibitions and the impossibility to manage every detailed negotiation of artworks displayed in *IP*, Enwezor, like any good host and curator, had to give room to all kinds of strangers (fellow curators, artists, patrons, viewers), a gambit that could turn a hospitable situation into a hostile one or into a dialectical encounter of ethical openness. As in the case of Documenta, but quite frankly in almost all contemporary art exhibitions, *Intense Proximité* was a group effort in which Enwezor specifically worked closely with a team of four other curators from Europe and North Africa—Mélanie Bouteloup, Abdellah Karroum, Émilie Renard, and Claire Staebler—and a number of art spaces and museums across Paris and just outside of Paris to expand and complicate his thesis in *IP*. These spaces included Bétonsalon (where Boutelop was the director), Le Crédac, Musée du Louvre, Instants Chavirés, and Les Laboratoires d'Aubervilliers. Risking diversion away from his curatorial premise and blurring the roles of host and guest, Enwezor nevertheless invited them into a process of mutual respect and creativity.

* * *

In a 2014 interview with Melissa Chiu at the Asia Society in New York, Enwezor described his exhibition making as provoking curators, artists, and viewers "to act."[33] Returning to the scene of the occupation at the National Museum of the History of Immigration in Paris in 2011, the protestors' actions invited us to reimagine the museum as more than just a sanctuary and symbolic expression of France's largesse. Rather than disappear beyond the reach of officials, they activated the space, contesting their liminal status as noncitizens. After four months, they were forcibly removed and made invisible, with the French government and media providing little information about their whereabouts and legal status.

It is 2020; many of the same concerns that Enwezor addressed in *IP* about structural exclusion have intensified and/or escalated, including the global mainstreaming of hate against immigrants and refugees. In every exhibition he curated, including *IP*, Enwezor engaged issues of race and colonialism, modernism and modernity, questions that museums continue to grapple with today. As indicative of the responses to the protests and demands of Black Lives Matter, major arts institutions have yet to accept their responsibility in engaging the Other and the rest of the world. It is not enough for the museum to represent the plight of undocumented immigrants and refugees. It is not enough for the museum to be a space of public gathering or sanctuary. One of many Enwezor's accomplishments, or the crux that made his exhibitions so compelling, was his ability to reconfigure the space of the museum as a platform that enabled new subjects and artworks to be seen and reframed, staging new ways of seeing and hearing forms of collective enunciation.

Enwezor did not refer to the occupation of the National Museum of Immigration in *IP* or in any of his writings. He also did not envision the museum to serve as a refuge or sanctuary per se. Enwezor's practice of hospitality reconceived exhibition making as a performative and life-giving act. By situating his exhibition-making practice within the context of hospitality as interruption, absolution, and abolition, Enwezor became the ultimate guest and host in setting up the conditions for artists to reimagine

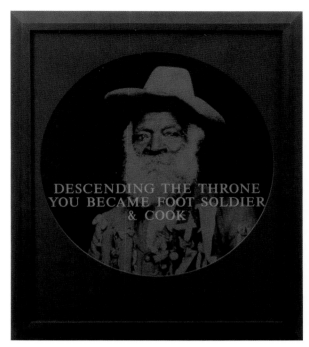

Carrie Mae Weems, *Descending the Throne You Became Foot Soldier & Cook*, 1995, from the series *Here I Saw What Happened and I Cried*, 1995. Chromogenic color print with sand-blasted text on glass. Courtesy the artist and Jack Shainman Gallery, New York. © Carrie Mae Weems

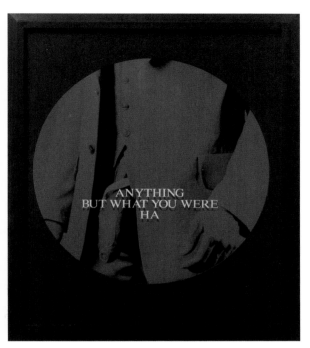

Carrie Mae Weems, *Anything But What You Were Ha*, 1995, from the series *Here I Saw What Happened and I Cried*, 1995. Chromogenic color print with sand-blasted text on glass. Courtesy the artist and Jack Shainman Gallery, New York. © Carrie Mae Weems

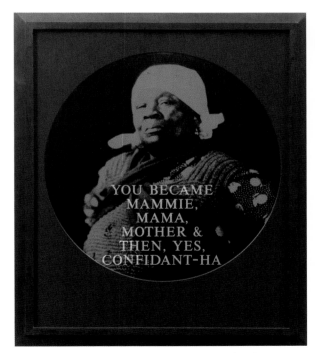

Carrie Mae Weems, *You Became Mammie, Mama, Mother, Then, Yes, Confidant-Ha*, 1995, from the series *Here I Saw What Happened and I Cried*, 1995. Chromogenic color print with sand-blasted text on glass. Courtesy the artist and Jack Shainman Gallery, New York. © Carrie Mae Weems

Carrie Mae Weems, *You Became an Accomplice*, 1995, from the series *Here I Saw What Happened and I Cried*, 1995. Chromogenic color print with sand-blasted text on glass. Courtesy the artist and Jack Shainman Gallery, New York. © Carrie Mae Weems

**Why should we do the hardest work
for the lowest pay?**

Bouchra Khalili, *Mother Tongue*, 2012. Film still from *The Speeches Series*, video trilogy, 2012–13. Detail of installation at La Triennale *Intense Proximité*, Palais de Tokyo, Paris, 2012. Courtesy the artist and mor charpentier, Paris

the formation of afterworlds. While he never used the term *abolition* to describe his exhibition-making practice, I propose that his curating can be approached as implicitly working toward the abolition of modern slavery—in its current form of apartheid, disenfranchisement, and sanctioned state police violence—and the deinstitutionalization of the art world and museum as we know it. In other words, how might we conceive his exhibition making as an abolitionist practice, a means to realize his vision of afterworlds and futures, a postcolonial constellation that extends beyond the objectives for the mainstream and art history to recognize African art and photography?[34] Scholar Ruth Wilson Gilmore describes the work of abolition as "presence, not absence."[35] While Gilmore, in this quote, is specifically addressing prison abolition and the dismantling of carceral institutions, how might we see Enwezor's curating and acceptance of an institution's invitation

to serve as guest and host as an opportunity to reshape the ways in which we relate with one another, an endeavor that reenvisions places like the Palais de Tokyo as not only a civic space, but a "life-affirming institution" that inaugurates a host of new and unforeseen possibilities.

Susette Min is an associate professor at the University of California Davis, where she teaches Asian American studies, art history, curatorial studies, and cultural studies.

Notes

1 Michèle Lamont, *The Dignity of Working Men: Morality and the Boundaries of Race, Class, and Immigration* (New York: Russell Sage Foundation, 2000), 185.
2 Chris Sharp, "La Triennale: 'Intense Proximity,'" *Art Agenda*, April 26, 2012, art-agenda.com/features/233554/la-triennale -intense-proximity. In his review, Sharp writes of how "'Intense Proximity' is essentially predicated upon the following global and post-colonial predicament: what happens when the distance

between the colonizer and the colonial subject, or, in broader strokes, near and far, visible and invisible, collapses?" Following Sharp's lead, I interpret Enwezor's approach to globalization as a compression of space-time, a process and consequence analogous to colonialism. In contrast to the way colonization attempts to annihilate space, however, Enwezor conceives of globalization as collapsing global distances that shift borders and transform spatial organizations of social relations.

3 Okwui Enwezor, "Intense Proximity: Concerning the Disappearance of Distance," *Intense Proximity: An Anthology of the Near and the Far* (Paris, France: Éditions Artlys, 2012), 18–34.

4 Biennial Foundation, "'La Triennale Wants to Create a Space of Intellectual Generosity,' Okwui Enwezor," June 8, 2011, biennialfoundation.org/2011/06/la-triennale-2012-marking-reopening-palais-de-tokyo-paris-artistic-director-okwui-enwezor.

5 Jason Farago, "Okwui Enwezor, Curator Who Remapped Art World, Dies at 55," *New York Times*, March 18, 2019, nytimes.com/2019/03/18/obituaries/okwui-enwezor-dead.html.

6 In a roundtable discussion in 2014 on the shifting role of the curator and "Art in a Transnational World" at the Asia Society with Asia Society Museum Director Melissa Chiu and Rirkrit Tiravanija, Enwezor foregrounds how he "never considered himself an independent curator" but rather saw himself as an "unaffiliated curator." Enwezor, "Okwui Enwezor: 'I Always Had . . . a Change Agenda,'" Asia Society, video, 6:24, May 5, 2014, asiasociety.org/video okwui-enwezor-i-always-had-change-agenda?page=18. In "The Production of Locality," Arjun Appadurai conceives of the local as analogous to the transnational and no longer bounded and/or fixed but rather produced by different actors who move in and out of the local and across nations and borders. Despite the constant movement of people and changing character, this translocal space, in this case Paris, remains a crucial site and source to ground and give meaning to one's identity. See Appadurai, "The Production of Locality," in *Counterworks: Managing the Diversity of Knowledge*, ed. Richard Fardon (New York: Routledge, 1995), 204–25.

7 Mark W. Westmoreland, "Interruptions: Derrida and Hospitality," *Kritike* 2, no. 1 (2008): 3, kritike.org/journal/issue_3/westmoreland_june2008.pdf .

8 Jacques Derrida and Anne Dufourmantelle, *Of Hospitality: Anne Dufourmantelle Invites Jacques Derrida to Respond*, trans. Rachel Bowlby (Stanford, CA: Stanford University Press, 2000).

9 Jacques Derrida, "Hostipitality" in *Acts of Religion*, trans. Gil Anidjar (New York: Routledge, 2002), 364.

10 Curated by Okwui Enwezor, Mélanie Bouteloup, Abdellah Karroum, Émilie Renard, and Claire Staebler, the event was organized for the launching of La Triennale by Marc Sanchez with the Centre national des arts plastiques and the support of the Absolut Company and Emmaüs.

11 Marcel Mauss, *The Gift: The Form and Reason for Exchange in Archaic Societies*, trans. W. D. Halls (New York: W.W. Norton, 1990).

12 Formed in 2003, Bloc Identitaire, a right wing, anti-Muslim and anti-immigrant group, changed its name to Les Identitaires in 2016.

13 Emmaus Solidarité is a secular organization that was founded in 1949 and committed to helping the poor and the unhoused in and through a range of charitable services.

14 Craig S. Smith, "Poor and Muslim? Jewish? Soup Kitchen Is Not for You," *New York Times*, February 28, 2006, nytimes.com/2006/02/28/world/europe/poor-and-muslim-jewish-soup-kitchen-is-not-for-you.html.

15 Suzanne Witzgall, "Can We Be Too Fragile for Real Contact? 'We don't feel fragile, but maybe tomorrow. . . .' In conversation with Claire Denis, Okwui Enwezor, and Sarah Rifky," *Diaphanes*

(2016), 107, diaphanes.net/titel/we-don-t-feel-fragile-but-maybe-tomorrow-4353 (accessed November 25, 2020). Note, Tirivanija's *Soup/No Soup* was a recommission by Enwezor as a response or retort to SDF's inhospitable 2003 event. Tirivanija's *Soup/No Soup* first premiered in New York City in 2011, around the corner from Gavin Brown Enterprise, an event of relational aesthetics or social practice that accompanied his solo exhibition, *Fear Eats the Soul.*

16 Tirivanija's *Fear Eats the Soul* first appeared as a flag at a bar in Esther Schipper's gallery in Cologne. The phrase is appropriated from Rainer Werner Fassbinder's movie *Ali: Fear Eats the Soul* (West Germany: Criterion, 1974), 1 hr. 34 min.

17 One example among many is the two French youths of Malian and Tunisian descent who were electrocuted in 2005 as they fled the police.

18 Jennifer Burris, "Fear Eats the Soul: The Paris Triennale 2012," *Afterall*, November 14, 2012, afterall.org/online/fear-eats-the-soul-the-triennale-2012#.X2mJzZNKjOQ.

19 Claude Lévi-Strauss, "Jean-Jacques Rousseau, fondateur des sciences de Phomme," *Anthropologie Structurale Deux* (Paris: Plon, 1973), 51. English translation: "Jean-Jacques Rousseau, Founder of the Sciences of Man," in Levi-Strauss, *Structural Anthropology*, vol. 2, trans. Monique Layton (1962; repr. London: Penguin, 1977).

20 Mary Louise Pratt, "Arts of the Contact Zones," *Profession* 91 (1991): 34.

21 Frantz Fanon, *The Wretched of the Earth*, trans. Constance Farrington (New York: Grove, 1963), 38.

22 Derrida, *On Cosmopolitanism and Forgiveness*, trans. Mark Dooley and Michael Hughes (New York: Routledge, 2001).

23 Witzgall, "Can We Be Too Fragile for Real Contact?" 107.

24 See Michel Serres, *The Parasite*, trans. Lawrence R. Schehr (Minneapolis: University of Minnesota Press, 2007); and Bonnie Honig, *Democracy and the Foreigner* (Princeton, NJ: Princeton University Press, 2001).

25 Lorenz Khazaleh, "An Alternative to the Classical Eurocentric Way of Thinking," University of Oslo: Department of Social Anthropology, October 3, 2014, sv.uio.no/sai/english/research/projects/overheating/news/2016/van-haesendonck.html.

26 Brent Hayes Edwards, "Review: The Ethnics of Surrealism," *Transition* 78 (1998): 93.

27 Brian Wallis, "Black Bodies, White Science: Louis Agassiz's Slave Daguerreotypes," *American Art* 9, no. 2 (1995): 45.

28 Molly Worthen, "Memorize that Poem!," Opinion, *New York Times*, August 26, 2017, nytimes.com/2017/08/26/opinion/sunday/memorize-poems-poetry-education.html.

29 Muriel Rosemberg, "Édouard Glissant's Geopoetics, A Contribution to the Idea of the World as the World," *L'Espace Géographique* 45:4 (2016): 321–34, cairn-int.info/article-E_EG_454_0321--edouard-glissant-s-geopoetics-a.htm#no28

30 Khazaleh, "An Alternative." See also, Édouard Glissant, *Poetics of Relation*, trans. Betsy Wing (Ann Arbor: University of Michigan Press, 1997).

31 Enwezor, "Introduction," *Intense Proximity: An Anthology of the Near and the Far* (exhibition catalogue) (Paris: Centre national des arts plastiques, 2012), 18.

32 André Breton, *Manifestoes of Surrealism* (Ann Arbor: University of Michigan Press, 1969), 26.

33 Enwezor, "Okwui Enwezor: 'I Always Had . . . a Change Agenda.'"

34 For now, I pose this question rhetorically and defer exploring the topic of visualizing abolition and the making of afterworlds for another time.

35 Ruth Wilson Gilmore, "Making Abolition Geography in California's Central Valley," *The Funambulist* 21 (2019): 14.

ENWEZOR'S MODEL
and Copenhagen's Center for Art on Migration Politics

Sabine Dahl Nielsen and
Anne Ring Petersen

One of the most remarkable signs of the importance and adaptability of Okwui Enwezor's work is the way in which the transformative models for exhibition making that he developed in the contexts of mega-events, such as Documenta11 in 2002 and the Biennale di Venezia in 2015, have found their way into radically different, small-scale institutional spaces and extra-institutional contexts. Resourceful curators across the world have successfully translated his models into critical formats and inventive ways of producing social and political knowledge, carefully adjusted to local contexts and needs.[1]

The aim of this study is to trace the influential postcolonial "platforms model" that Enwezor conceptualized for Documenta11 to a small but internationally acclaimed gallery in Copenhagen, the Center for Art on Migration Politics (CAMP).[2] The article falls into three parts. The first part introduces CAMP and the Danish context for migration before we discuss core elements of Enwezor's exemplary transformation of curating into the creation of platforms for political interventions at his Documenta exhibition. The second part seeks to answer three questions: What was the curatorial strategy and multisited structure that Enwezor and his team developed? How did their decolonizing approach help create inclusive, discursive, and curatorial spaces that contested the binaristic perception of the West as the center and the non-West as periphery and

Journal of Contemporary African Art · 48 · May 2021
DOI 10.1215/10757163-8971314 © 2021 by Nka Publications

Dady de Maximo, *If the Sea Could Talk*, 2014. Political fashion show during the opening of *Camp Life: Artistic Reflections on the Politics of Refugee and Migrant Detention*, CAMP / Center for Art on Migration Politics, Copenhagen, April 17, 2015. © CAMP. Photo: Alba Oren

Professor of Law Eva Smith leads the debate meeting "Are Human Rights Being Violated in Denmark's New Asylum Institutions," 2016, curated by CAMP / Center for Art on Migration Politics at Trampoline House, Copenhagen. © CAMP. Photo: Britta Thomsen

offered a vision of the (art) world as profoundly entangled and plurivocal? Furthermore, how has the organization of Documenta11 as a globally distributed network of discursively and conceptually interconnected platforms contributed to restructuring the exhibition venue and to rethinking the interrelationship between the exhibition itself, as it is traditionally understood as the very core of an art event, and exhibition-related events perceived as collateral, sometimes even dispensable, activities? The third part of the article returns to CAMP to explore the specific translation of Enwezor's legacy into a small-scale, local art space. It outlines the development of CAMP's exhibition program since the opening in 2015 and homes in on two exhibitions from CAMP's program, State of Integration: Artistic Analyses of the Challenges of Coexistence (2018–20).

We turn to Enwezor for theoretical support—in particular, to his curatorial working principles of "transculturality" and "extraterritoriality"—as well as draw on the notion of the *curatorial* developed in British curatorial studies.[3] We adopt the categories of "space" and "public," and unpack the idea of *postmigrant public spaces* to examine how CAMP created a transcultural contact zone and addressed not just an (art gallery) audience but a plurality of publics. Our understanding of the postmigrant is indebted to recent German postmigrant thinking that has reopened the debate on the long-term effects of migration on European societies.[4] It is a critical, conflict-sensitive discourse that aims to recode migration and sociocultural diversity as a state of normalcy as opposed to the widespread obsession with migration as "crises"—a discourse that resonates with Enwezor's agendas and visions.

CAMP, Trampoline House, and Danish Migration Politics

From 2015 until 2020, CAMP was uniquely housed inside the community center, Trampoline House, a meeting place for refugees, asylum seekers, volunteers, and citizens of Copenhagen.[5] Five days a week the house offered various activities and classes, legal counseling, job training, a children's club, and, importantly, a space for conviviality. By creating a hospitable zone of contact, the community center helped to break the isolation and alleviate the sense of powerlessness that many refugees and asylum seekers experience during their months and years of waiting in the Danish asylum system while their asylum application is being processed.[6] Thanks to CAMP, Trampoline House also became a place where nongovernmental organization representatives, activists, scholars, educators, artists, and curators came together within the framework of the center's program of art exhibitions and politically mobilizing exhibition-related events, which were often woven into the fabric of regular activities of the community center and its multicultural community of refugees, asylum seekers, volunteers, staff, and other citizens of Copenhagen.

The founders of CAMP are Frederikke Hansen and Tone Olaf Nielsen, alias the curatorial team Kuratorisk Aktion (Curatorial Action). Their approach to curating resonates with that of other collectives such as the one explored by ruangrupa, a Jakarta-based collective established in 2000. Kuratorisk Aktion has collaborated with ruangrupa on several projects such as *Rethinking Nordic Colonialism: A Postcolonial Exhibition Project in Five Acts* (2006) and—important in relation to the legacy of Okwui Enwezor—the upcoming documenta fifteen (2022). In effect, the closing of the physical gallery space of CAMP in 2020 coincided with Kuratorisk Aktion's increasing engagement in the preparations for documenta fifteen.[7]

That the curators have had the perseverance to keep a gallery dedicated to migration politics going for six years in Denmark is an extraordinary achievement in itself. This country has some of the toughest laws on asylum and immigration in Europe and within the European Union (EU) with its dubious border regime, the slow violence of its asylum centers, and its proliferating range of old

and new forms of racism and fascism. Historically, Denmark has been held up as a liberal forerunner with respect to the protection of refugees. In recent decades, however, Denmark has imposed a series of restrictive policies concerning both asylum and immigration. For instance, 2015 saw the introduction of a new tertiary protection status, "temporary protection status," for those fleeing general violence and armed conflict. The year after, access to family reunification for those granted temporary protection status was also removed during the first three years of residence unless special considerations apply. Following the surge in the number of primarily Syrian asylum seekers in the summer of 2015, Denmark also ran an antirefugee ad campaign in Arabic-language newspapers warning refugees about the plights that asylum-seekers and refugees will have to endure in Denmark. Such forms of indirect deterrence can be characterized as a form of "negative nation branding" intended to discourage refugees and irregular migrants from arriving in the territory and accessing the asylum system. While other EU countries have increasingly followed suit and adopted similar policies to stem the tide of refugees and irregular immigrants from Africa and the Middle East, Denmark and some other countries have also sought to brand themselves as "hard-liners." Professor in Migration and Refugee Law Thomas Gammeltoft-Hansen has thus rightly pointed out that "Denmark has long openly justified its more restrictive asylum policies with reference to its desire to avoid asylum-seekers."[8]

This tightening of the laws on asylum is obviously permeated by racism. As the German social scientist Naika Foroutan has observed, many of the conflicts at the heart of European plural democratic societies—such as the struggles for equality, freedom, security, and democratic rights—are fought, in an emblematic way, in relation to migration.[9] Regarding the European struggles against racism, they are inseparable from the critique of the highly racialized border control measures generated by European refugee and asylum policies. As refugee studies scholar Martin Lemberg-Pedersen has remarked, "the racialized fears of being demographically swamped by black majorities" at the core of European border control systems can be traced back to colonial times, when the white Caribbean

plantation elites were split between "the desire for profit maximization" and the fear of suppressed Black majorities overpowering them on what the European colonizers regarded as their territories.[10]

It could thus be argued that, in a Danish context, the activist and political struggle against unjust and debilitating asylum policies cannot be separated from the struggle against racism.[11] Accordingly, CAMP's critical interrogation of asylum and migration politics can be seen as a local variant of the worldwide antiracist struggle and thus linked to the protests against police brutality against African Americans specifically and systemic racism in general, which exploded in the United States after the police killing of George Floyd on May 25, 2020, and then spread like wildfire across the Western world, thanks to the transnational Black Lives Matter movement.

Documenta11: A Multiplicity of Platforms for Political Interventions

As Anthony Gardner and Charles Green have noted in their book *Biennials, Triennials, and Documenta*, Documenta11 is widely considered to be one of the most important exhibitions in recent decades, recognized for its postcolonial agenda, its sensitivity to the geographic dispersion of contemporary art in the so-called Global South, as well as its experimentation with collective modes of curatorship.[12] Enwezor organized Documenta11 with a group of six cocurators: Carlos Basualdo, Ute Meta Bauer, Susanne Ghez, Sarat Maharaj, Mark Nash, and Octavio Zaya. As this curatorial team comprised professionals with various Western and non-Western backgrounds, it countered the dichotomous perception of the West as the center and the non-West as periphery on an institutional level and suggested that the art world is profoundly entangled and culturally pluralized.[13]

In the following, we will primarily concentrate on one key aspect underpinning the conceptualization of Documenta11, namely, the creation of a series of interconnected platforms for political intervention, which Enwezor himself referred to as "interlocking constellations of discursive domains, circuits of artistic knowledge production, and research modules."[14] Instead of solely staging a show in Documenta's home city Kassel, Germany, Enwezor chose to disperse the significantly expanded range of the exhibition-related discursive activities encompassing conferences, debates, and workshops. These activities were conceived as interventions into current theoretical and political debates, and they were far more comprehensive than the type of events program that has traditionally accompanied major international exhibitions and biennales. Documenta11's discursive activities were distributed across five connected forums, or platforms, as Enwezor called them. Taking place successively over the course of one year, these platforms facilitated a durational approach to curating.[15] Furthermore, the platforms were spread across the globe, each located in a different nation. Platform One, titled *Democracy Unrealized*, took place in Vienna, Austria, from March 15 to April 20, 2001, and later in Berlin, Germany, from October 9 to October 30, 2001. Platform Two, *Experiments with Truth: Transitional Justice and the Processes of Truth and Reconciliation*, materialized in New Delhi, India, from May 7 to May 21, 2002. Platform Three, *Créolité and Creolization*, was held on the West Indian island of St. Lucia in the Caribbean from January 12 to January 16, 2002. Platform Four, *Under Siege: Four African Cities—Freetown, Johannesburg, Kinshasa, Lagos*, took place in Lagos, Nigeria, from March 15 to March 21, 2002; and Platform Five, the final platform in the form of the exhibition in Kassel, was shown from June 8 to September 15, 2002. Together with his curatorial team, Enwezor sought to decentralize the exhibition format. As noted by Gardner and Green, Documenta11 thus painted a picture of contemporary art as a network in which metropoles of the Global South and the Global North were more or less equally important to the contemporary canon and similarly crucial to our understanding of contemporaneity, as opposed to some centers being perceived as exotic margins and others as more genuinely cosmopolitan and contemporary art scenes.[16]

By partly replacing Documenta's historical context in Kassel with other geopolitical contexts, and by employing that which Enwezor termed a strategy of "extraterritoriality," Documenta11 advanced a narrative of postcoloniality.[17] Already, as the curator of *Trade Routes: History and Geography*, the title of the Second Johannesburg Biennale (1997), Enwezor had explored a similar method. In Johannesburg,

Sandra Johnston, performance during the discussion event "War Images: How to Show That Black Lives Matter," 2017, Trampoline House, Copenhagen, part of the CAMP / Center for Art on Migration Politics exhibition *We Shout and Shout, but No One Listens: Art from Conflict* Zones. © CAMP. Photo: Britta Thomsen

he presented multiple exhibitions co-organized by a group of curators, a film program, and a symposium as an "open network of exchange," seeking to collectively produce knowledge about the sociopolitical processes of globalization.[18] Moreover, in terms of focusing attention on how contemporary globalization relates politically to historical colonialism, *Trade Routes: History and Geography* can be said to have laid the ground for Documenta11's emphasis on the colonial origins of contemporary developments in global history and art. Thus, neither the curatorial method of conceptualizing a series of interconnected exhibition venues dispersed in time and space, nor the explicated agenda of exploring the historically rooted asymmetrical power relations between the Global South and the Global North,

were entirely unprecedented in Enwezor's curatorial practice. The more robust institutional and financial foundation of Documenta11 did, however, enable him to develop the platforms model further and on a far larger geographical scale.

The Curatorial as Transgression of Traditional Boundaries

At the five platforms, participants from many different corners of the world contributed to the transdisciplinary production of knowledge and the articulation of critical discourses. More than eighty participants from different disciplines such as writers, political scientists, philosophers, artists, architects, lawyers, political activists, researchers, and other cultural practitioners engaged in lectures,

debates, and panel discussions. It is important to note that Enwezor's stated intention of employing an "extraterritorial" strategy not only entailed a dispersal in terms of geopolitical territories, it also referred to a conscious attempt to destabilize and decentralize traditional notions of institutional frameworks and disciplinary boundaries. As Enwezor explained, "extraterritoriality" was enacted "firstly, by displacing its historical context in Kassel; secondly, by moving outside the domain of the gallery space to that of the discursive; and thirdly, by expanding the locus of the disciplinary models that constitute and define the project's intellectual and cultural interest."[19]

Importantly, in this context, the knowledge-producing activities of the first four platforms did not function as mere add-ons to the subsequent mega-exhibition in Kassel or as preparatory discursive programs leading up to the actual curatorial event (even though each of them was either attended by audiences of insignificant size or by invitees only).[20] Nor were the conference books, which were published after the exhibition, viewed as mere documentations or as commodifiable end products. Rather, all the platforms were perceived by Enwezor as integral to and equally important components of the Documenta11 exhibition project. In this way, by conceptualizing Documenta11 as "a constellation of disciplinary models" and as a nonhierarchical network of discursively and conceptually interconnected platforms for knowledge production, spanning locations around the globe and taking place successively over the course of a whole year, Enwezor's curatorial practice effectively contributed to restructuring the exhibition venue and the interrelationship between exhibition and exhibition-related events in dynamic and explorative ways.[21]

Enwezor's curatorial approach resonates with more recent theories on curating as an active form of knowledge production. As curatorial theorist Simon Sheikh notes, curatorial practice does not necessarily take on the form of a traditional exhibition but employs "the thinking involved in exhibition-making and researching."[22] In this way, curatorial practice is not merely perceived as a means of "putting on exhibitions" and "displaying works of art," as cultural theorist Irit Rogoff has termed it; rather, a shift of attention can be located toward the expanded

notion of the curatorial.[23] In their seminal anthology *The Curatorial: A Philosophy of Curating*, Rogoff and Jean-Paul Martinon argue for a distinction between *curating* and *the curatorial*: "If 'curating' is a gamut of professional practices that had to do with setting up exhibitions and other modes of display, then 'the curatorial' operates at a very different level: it explores all that takes place on the stage set-up, both intentionally and unintentionally, by the curator and views it as an event of knowledge."[24] The curatorial, then, is viewed as an analytical tool and a mode of critical knowledge production that may or may not involve the curating of exhibitions. As Sheikh has noted, it will, however, always include the modes of thinking and making curatorial constellations that can be drawn from the historical forms and practices of curating.[25] It might also be added that curating always involves research processes and knowledge production, albeit often of a somewhat different kind.[26] The notions of *curating* and *the curatorial*, therefore, we will argue, should not be viewed as oppositional categories that are mutually exclusive. Rather, they appear as related approaches that differ in degree with regard to the emphasis put on discursive practices, the expansion of formats, and the knowledge-producing events generated by curatorial agents, both intentionally and unintentionally.

Enwezor's curatorial projects such as *Trade Routes: History and Geography*, Documenta11, and, one might add in this context, *All the World's Futures*: 56th Biennale di Venezia (2015) were projects that sought to transgress traditional boundaries in terms of changing the norms of institutions, publics, exhibition venues, and forms of artistic practice. It should be noted, however, that Enwezor, in the two last-mentioned cases, operated from within the highly institutionalized contexts of mega-exhibitions, thus contributing to the booming of the global art industry and benefitting from substantial budgets, large audiences, and extensive media attention, as well as from the support of an established art world that was becoming increasingly preoccupied at this specific time in history with the postcolonial theories being circulated within academic fields.[27] Enwezor's curatorial projects were thus carried out as instances of criticality, embedded in the very same institutional structures he sought

to transgress. Notwithstanding these reservations, Enwezor's curatorial projects clearly succeeded in setting up venues for wide-reaching, transculturally networked, and cross-disciplinary forms of knowledge production. In his own writing, Enwezor also reflected on his curatorial projects not solely as exhibitions but as unbounded practices seeking to experiment with various forms of public address and congregation:

> Documenta11 was conceived not as an exhibition but as a constellation of public spheres. The public sphere of the exhibition gesture is rearticulated here as a new understanding in the domain of the discursive rather than the museological. Documenta11's paradigm is shaped by forces that seek to enact the multidisciplinary direction through which artistic practices and processes come most alive, in those circuits of knowledge produced outside the predetermined institutional domain of Westernism, or those situated solely in the sphere of artistic canons.[28]

As the quote indicates, Enwezor sought to expand the practices of curating as well as contest notions of the West as center. Concerning the first aspiration, his projects have clearly contributed to paving the way for more expansive, explorative, and knowledge-producing practices within the field of the curatorial. As for the last aspiration, however, Enwezor's postcolonial attempts to deconstruct Western-centric notions of art and curating have been both celebrated and subjected to severe criticism. Chin-tao Wu, for example, has taken a critical stance and argued that although the art projects staged at the Kassel exhibition in connection with Documenta11 were clearly intended to contest notions of the West as center, a surprisingly large number of the artists presented were from Europe and the United States.[29] Following this line of thought, Kobena Mercer has noted that Documenta11, despite its stated ambition to effectively decenter the art event, upon closer scrutiny turned out to rely first and foremost on familiar names from the international biennale circuit in order "to uphold what is by now a fairly conventional conception of global *mélange*."[30] Applying a more confrontational rhetoric, Sylvester Okwunodu Ogbechie has likewise argued that Enwezor advanced a very self-referential mode of curatorial practice "using limited numbers of artists recycled in closed-loop exhibitions."[31]

Furthermore, Ogbechie accuses Enwezor of giving priority to African artists living and working in the West, thus locating Africa in the diaspora and producing ahistorical and decontextualized interpretations of contemporary African art. Africa, he states in his critique of Documenta11, "is everywhere but nowhere, essentially described in the discourse as a *non-location*."[32] Similar criticisms have been raised by Peter Schjeldahl, Anthony Downey, and Oliver Marchart, among others.[33] They have, in different ways and from various vantage points, remained skeptical of Enwezor's capacity to counter hegemonic perceptions of center and periphery without subsuming, misrepresenting, and excluding artists from the Global South and turning postcolonial critique into mere spectacle and so-called festivalism.

These criticisms testify not only to the skepticism surrounding sponsored mega-events, but also to the fact that Documenta11 has been inscribed in exhibition history as a "postcolonial" event and thus linked to a critical tradition that has been seen by later decolonial theorists as a critical tradition spearheaded primarily by critical thinkers of non-Western backgrounds based within the West itself.[34] An illustrative example of this historicization is curator Maura Reilly's description of Documenta11 as the first Documenta "to employ a postcolonial curatorial strategy."[35] Similarly, Gardner and Green have summarized the "double perspective" of Documenta11 "in two words: postcolonialism and globalization," and curator Naomi Beckwith has added the overarching observation that, for Enwezor, "post-colonialism was an ethical position."[36] Some of these criticisms reflect the fact that what in 2002 was perceived as a new ground-breaking "postcolonial" form of critique of the deep-seated colonial power structures of the art world and its institutions has since then become the object of a more radical type of critique that calls for profound *epistemological* and *durational* change—a liberating *decolonization*.[37] As will be explained in greater detail below, CAMP's practice can be seen as an attempt to further develop Enwezor's curatorial strategy into exactly this type of profound and durable institutional change.

Without subscribing to the somewhat harsh criticism and envisioning Documenta11 as just another example of festivalism "mixing entertainment and

soft-core politics," we acknowledge that curatorial work in a well-established, large-scale institution such as Documenta poses certain challenges in terms of having to negotiate potentially conflicting interests with funding bodies, marketing departments, et cetera.[38] Moreover, we concur with the assessment that changing not just the content but the very terms of exhibition making, that is, the rules of the game, requires a decolonization of the exhibitionary complex and the epistemological foundations of the institutionalized mega-exhibitions that have recalibrated the terms of production, distribution, and curating of contemporary art since the "biennale boom" of the 2000s. According to Gardner and Green, the curatorial team of Documenta11 sought to achieve exactly this. Incorporating the discursive shift in critical terms from "postcolonial" to "decolonial," Gardner and Green in 2017 concluded that the curatorial team "advanced *a narrative of decolonization* over other narratives about the global, and Documenta11 did so thoroughly enough to have a genuinely historic impact on both artistic and curatorial practice."[39]

At this juncture it should be noted that despite, or perhaps precisely because of, his collaboration with big institutions, several scholars and curators have ascribed to Enwezor an intent to do activist work *within* the institutions. The clearest example is probably Reilly. In her book *Curatorial Activism: Towards an Ethics of Curating,* she uses the term *curatorial activists* to define the work of professionals such as Enwezor and mentions both Documenta11 and *All the World's Futures* among her key examples. As our analysis of Documenta11 suggests, the character of Enwezor's curatorial work is captured well by Reilly's definition of curatorial activists as "people who have dedicated their curatorial endeavors almost exclusively to visual culture in, of, and from the margins: that is, to artists who are non-white, non-Euro-US, as well as women-, feminist- and queer-identified. These curators, and others in similar fields, have committed themselves to initiatives that are leveling hierarchies, challenging assumptions, countering erasure, promoting the margins over the center and the minority over the majority, inspiring intelligent debate, disseminating *new* knowledge, and encouraging strategies of resistance—all of which offers hope and affirmation."[40]

CAMP: Anchoring the Platforms Model in the Local

Although we recognize that curators always work within certain financial, structural, and political constrictions, we propose that the Western institutional circumscription of their work is not always so tight where small-scale, (semi-)independent art spaces are concerned. Whereas museums and large-scale exhibitions such as biennials, triennials, and Documenta tend to gain extensive media attention and reach large international audiences, they often also—partly because of these very effects—end up being restricted by local politicians, sponsors, and marketing departments trying to avoid dealing with explicitly political, and therefore potentially divisive, issues such as asylum, immigration, integration, displacement, and forced deportation. Small-scale institutions and art spaces working with lower budgets, smaller audiences, and less political attention can, on the other hand, experience a comparatively higher degree of curatorial freedom when seeking to address such conflict-sensitive issues. This may provide them with a greater scope for contesting the boundaries and limitations of Western systems, and they may, therefore, offer curators a more fertile ground for implementing Enwezor's vision of curating as an unbounded practice that enables cultural producers to experiment with different forms of public address and congregation, which may but do not have to be linked to exhibition making.

In what follows, we will test and substantiate this claim by examining CAMP.[41] Although there are no direct links between Enwezor and CAMP, we submit that, as a nonprofit institution operating on a significantly smaller scale, CAMP succeeded in radically developing the kind of critical curatorial model envisioned by Enwezor by linking it to activism, prolonging its duration in order to create more sustainable infrastructures for those involved, and embedding it in politically engaged community work. Furthermore, as a postmigrant public space, CAMP has a strong precedent in Enwezor's conceptualization of Documenta11 as "a constellation of public spheres" and his idea of the exhibition as "a forum of public discovery of art's potential in the face of difficulty and the inscrutable."[42] As a space for critical engagement with the world (rather than a space of autonomy and withdrawal), the exhibition

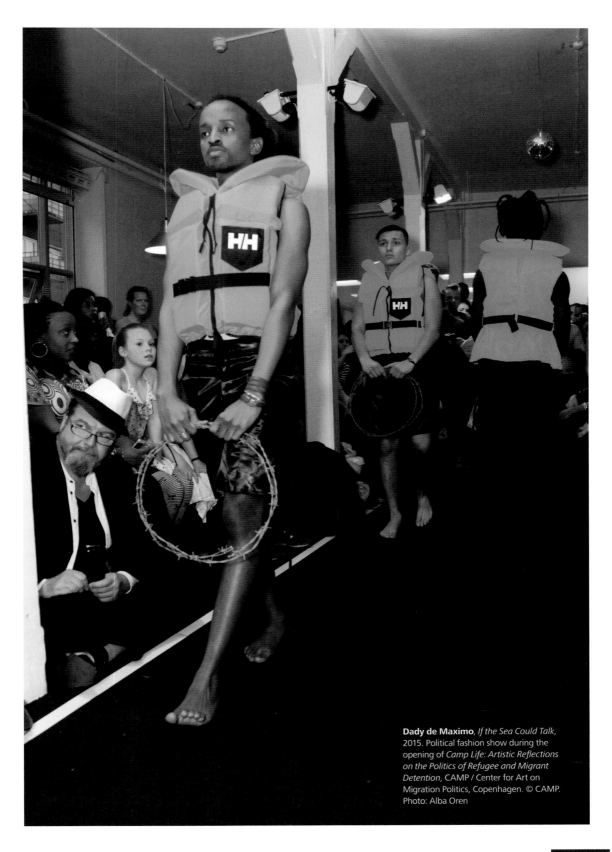

Dady de Maximo, *If the Sea Could Talk*, 2015. Political fashion show during the opening of *Camp Life: Artistic Reflections on the Politics of Refugee and Migrant Detention*, CAMP / Center for Art on Migration Politics, Copenhagen. © CAMP. Photo: Alba Oren

is, Enwezor argues, embedded in the world as "a space of public discourse," and it "can no more assert a distance from its cultural context than it can repress the very social condition that brings it into dialogue with its diverse publics."[43]

We would like to suggest that Kuratorisk Aktion actively used their situatedness in Denmark. They used it as an incentive to found a themed-based exhibition venue dedicated to showing artworks that articulate radical critiques of Western immigration, refugee, and asylum politics—a place that reflects on the experience of forced migration while also seeking to stimulate sympathetic encounters and greater understanding between displaced people and the Danish public(s).[44] As the curators stated: "The objective is, through art, to stimulate greater understanding between displaced people and the communities that receive them—and to stimulate new visions for a more inclusive and equitable migration, refugee, and asylum policy."[45]

This curatorial mission was effectively communicated ever since CAMP's inaugural exhibition in April 2015, *Camp Life: Artistic Reflections on the Politics of Refugee and Migrant Detention*. It opened with Rwandan activist, artist, and fashion designer Dady de Maximo's political fashion show *If the Sea Could Talk* (2014), a tribute to the thousands of migrants and refugees who have drowned in the Mediterranean Sea, or died elsewhere, trying to reach safety. The mixed audience of gallerygoers, artists, intellectuals, and activists, along with refugees, asylum-seekers, regular users, volunteers, and staff of Trampoline House, were confronted with a show presenting grand dresses sewn of rice bags from United Nations refugee camps, men's outfits combining satin and life jackets, and accessories made from barbed wire and bast. De Maximo's thought-provoking use of the language of fashion conjured up the friction of multiple, conflicting associations, spanning the drama of rescue and survival to the kinds of societal and environmental crises that necessitate humanitarian aid and refugee camps; to the debilitating wait in asylum centers fenced-off from society; and to the dream of a good life, safety, and affluence that may help refugees and asylum seekers overcome the ordeal they are going through.[46] The intimate connection between the mission of the art space and the purpose of the community center was obvious from the start.

The history of Trampoline House indicates how this unusual combination of spaces, functions, and objectives came into being. The house was founded in 2009–10, as a critical response to Danish refugee and asylum policies, by artists Joachim Hamou and Morten Goll (who later channeled and transformed his artistic and activist skills into his work as the executive director of Trampoline House), together with curator Tone Olaf Nielsen and a large group of asylum seekers, art students, activists, and volunteering professionals.[47] The initiative thus came from "artivists," and thanks to Nielsen's participation, Kuratorisk Aktion had been involved already in the early development of the house.

Camp Life marked the beginning of the center's two-year exhibition program Migration Politics, which presented a series of six exhibitions between 2015 and 2017 that were both locally relevant and internationally significant. The program included a range of artistic responses to displacement, migratory routes, border politics, refugee and migrant detention, undocumented migration, deportation, and visions for alternative migration and asylum policies.[48] The works were created by artists, artist groups, and social networks that originated from many different countries and in many cases had firsthand experience of displacement, migration, and asylum seeking.[49]

In 2017, Kuratorisk Aktion produced its first pop-up project (with homeless migrants) in collaboration with the Copenhagen-based community radio, the Bridge Radio, for the annual Roskilde Festival, in Denmark, one of the largest music festivals in Europe.[50] The year before, the collective had entered into an agreement with another major cultural institution when it "exported" a constellation of three of its exhibitions to the Statens Museum for Kunst (SMK), the National Gallery of Denmark, thereby reaching audiences other than those who found their way to Trampoline House. Besides the opening show *Camp Life*, the SMK exhibition comprised *The Dividing Line: Film and Performance about Border Control and Border Crossing* (2016) and *From the Mountains to the Valleys, From the Deserts to the Seas: Journeys of Historical Uncertainty* (2015), a solo exhibition by Tiffany Chung (Vietnam). The latter was originally shown at CAMP in the autumn of 2015, coinciding with Enwezor's inclusion of

Chung's *The Syrian Project* (2011–15) in his exhibition *All the World's Futures* at the Biennale di Venezia of that year, an exhibition that shared CAMP's focus on refugees and humanitarian crises caused by large-scale forced displacements. Chung's 2015 exhibition at CAMP also included works from *The Syrian Project,* in which Chung had meticulously gathered statistics about the then rising numbers of war casualties and internationally displaced Syrians and translated these data into delicately painted and embroidered maps, wherein the size and the colors of dots indicated the extend of the crisis.[51]

In 2018, Kuratorisk Aktion initiated a new two-year exhibition program, State of Integration: Artistic Analyses of the Challenges of Coexistence (2018–20), which reflected three important changes in their curatorial practice. First, there was a shift of emphasis away from the politics and experience of migration toward those of integration and other long-term effects of migration. Second, they entered into collaboration with internationally renowned figures such as curator and art historian Temi Odumosu (United Kingdom/Sweden) and visual culture theorist and activist Nicholas Mirzoeff (United States). The second program thus comprised a mixture of ambitious guest-curated group shows and small solo exhibitions in which Kuratorisk Aktion spotlighted emerging practitioners, mostly with migrant or refugee experience. Third, to further strengthen and develop their existing educational activities, Kuratorisk Aktion established CAMP education!, a platform of knowledge dissemination geared toward producing educational material for school teachers and other educators as well as continuing the existing gallery guide education program to enable asylum seekers, migrants, refugees, and minority ethnic Danes to become part of CAMP's guide team.[52] The educational focus reflects the proximity of CAMP's mission to Enwezor's vision: State of Integration can be seen as an emphatically local, context-sensitive implementation of Enwezor's vision of curating as a flexible form of knowledge production that enables cultural producers to use different forms of public address and congregation.

The exhibitions presented within the framework of CAMP spanned a wide variety of formats, aesthetic sensibilities, and modes of address. We have selected two group exhibitions that are emblematic of these differences: *Decolonizing Appearance* and *Threshold(s)*, curated, respectively, by Mirzoeff and Odumosu as part of the exhibition program State of Integration.

Decolonizing Appearance: Curating as a Partisan and Politically Mobilizing Practice

Thematically, Mirzoeff's *Decolonizing Appearance* (2018) focused on how appearance is used to classify, segregate, and rule human beings on a hierarchical scale in today's colonially structured world, as well as on how this regime can be actively challenged. Through photography, video, installation, and text, the exhibition created constellations of art projects reflecting on the issue of appearance within the power matrix of "the colonial": for example, in the case of Jane Jin Kaisen's staged family portrait *The Andersons*, the dynamic within the transnational adoptive family is reversed by portraying a supposedly Asian American couple with their nine-year-old Danish-born daughter. Other examples included Carl Pope's poster installation *The Bad Air Smelled of Roses*, which reflects on Black pride and queer identity, and Dread Scott's performance still *I Am Not a Man*, which paraphrases the 1968 Memphis sanitation workers' strike in the United States, where the iconic "I Am a Man" sign originated, to comment critically on the advances of the civil rights movement in today's racialized societies.

Decolonizing Appearance addressed the power-related issues of appearance not only by presenting art projects in the exhibition space of CAMP, but also through the conversations and discussions instigated by the projects. In addition, Mirzoeff and CAMP experimented with discursively oriented and activist approaches to curating in a series of politically mobilizing exhibition-related events conducted in Trampoline House, which enabled these events to create so-called *spillovers*, as Kuratorisk Aktion has termed it, into the social contact zone of the community center.[53] For example, the *Decolonizing Assembly* was organized and led by Amin Husain and Nitasha Dhillon of the New York-based MTL Collective, which joins research and activism with artistic practice.[54] MTL created a forum for asking politically mobilizing questions such as, How can the colonized have the right to

Installation view from the exhibition *Decolonizing Appearance*, CAMP / Center for Art on Migration Politics, Copenhagen, 2019. Works by **Jeannette Ehlers**, **Marronage**, **MTL Collective**, and **Carl Pope** are pictured. © CAMP. Photo: Mads Holm

look, the right to be seen—in short, the right to appear? What would happen when appearance is decolonized? What has to happen for decolonizing to take place where you live? The last question was emblematic of how *Decolonizing Appearance*, and in particular MTL's assembly, sought to address its public. The "you" being addressed is a virtual "you" that could be inhabited by persons with different positionalities. Crucially, on that particular day, it implicated a heterogeneous mix of people participating in the assembly on the history of colonialism and the current call for decolonization that included those who declared themselves as sympathizers, those critically inclined toward the activist approach of MTL Collective, and those situated somewhere in between these positions.[55] MTL Collective's assembly thus anticipated and called forth a heterogeneous public of different national

backgrounds and political positionalities in a way that resonated with many of the other components of the exhibition. What the participants had in common was a willingness to actively respond to the exhibition's proposition of how we are all entangled in the unfinished history of colonial relations and regimes of appearance. Similarly, partisan approaches to art and politically mobilizing modes of address characterized many of the other exhibition-related events such as the collaborative production of banners initiated by MTL Collective; the happening *We Are Here—Marronage Is Resistance*, performed by the decolonial feminist collective Marronage; and the workshop Naturalizations: Facial Politics and Decolonial Aesthetics, conducted by artist and Duke University Professor Pedro Lasch. *Decolonizing Appearance* can thus be said to present a turn toward what political theorist Oliver Marchart has

Installation view from the exhibition *Decolonizing Appearance*, guest curated by Nicholas Mirzoeff, CAMP / Center for Art on Migration Politics, Copenhagen, 2019. Works by **Pedro Lasch** and **Dread Scott** are pictured. Photo: Mads Holm

termed *activist art*, which he understands to be art that employs strategies of political activism in the attempt to stage counter-hegemonic struggles, leave the art institution behind, and form new alliances of solidarity.[56]

Threshold(s): Curating the Politics and Poetics of Relation

Marchart distinguishes activist art from *critical art*, that is, art that seeks to critique and to instigate hegemonic shifts of critical practices from a position within the very structures and constrictions of art institutions. In contradistinction to art activism, critical artists consider these institutions to be platforms for intervening in dominant discourses, or, in Marchart's words, "potentially powerful *counterhegemonic* machines whose symbolic efficacy must not be underestimated."[57] This category offers

a more accurate description of the type of criticality and aesthetics represented in Temi Odumosu's *Threshold(s)* (2019–20). This exhibition with five Nordic artists of color explored female experiences of displacement and exile, in particular, how memories and the residual effects (and affects) of colonialism "travel" with migrants or are transferred intergenerationally as "postmemory," an embodied and also mediated heritage that crosses national and temporal boundaries to inhabit contemporary bodies, identities, languages, cultures, and everyday life.[58] In *Threshold(s)*, the emphasis was on neither the journey nor the arrival but on the state of being in-between polarities and what it entails to produce critical art from that positionality, fueled by the dynamics of postcolonial agony, emotional ambivalence, and complex diasporic relations to places both in and beyond the Nordic countries. As

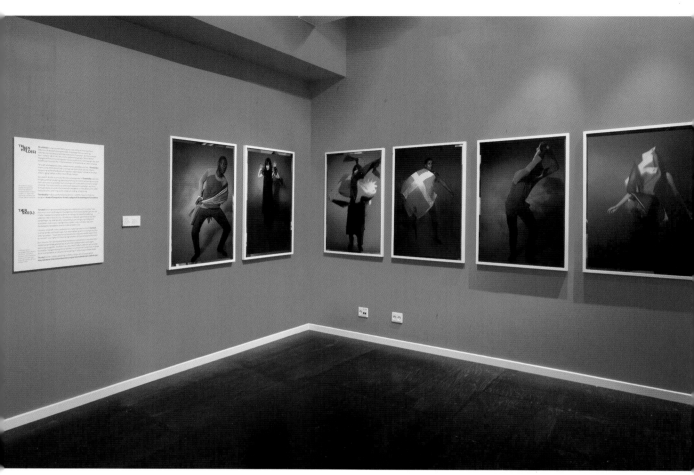

Michelle Eistrup, *BeLONGING Vexillum*, 2019. Six framed color photographs, 74 x 109 cm. Part of the exhibition *Threshold(s)*, guest curated by Temi Odumosu, CAMP/Center for Art on Migration Politics, Copenhagen, 2019–20. © CAMP. Photo: Mads Holm

Odumosu explained in the catalogue, the exhibition was an invitation to consider "how a modern body can also be a colonial document" and to explore "the politics and poetics of relation."[59] In this case, the institutional platform of the gallery served as a "counterhegemonic machine," providing female artists of color with the necessary public space and visibility for their critique of "inter-racial" relations in Scandinavia to enter into the public discourse on racialization, racism, and racist violence in which the local Danish problems are usually minimized and their very existence sometimes denied.[60]

Odumosu's objectives mark the other end of the curatorial spectrum at CAMP. As Mathias Danbolt has pointed out, "curatorial modes of address can condition and produce alternative forms of publics."[61] The objective of Mirzoeff's confrontational address was to decolonize and inspire antiracist activist mobilization, although Marronage has attacked his exhibition for merely "decolonizing appearance" for "the white gaze," as the majority of art-interested visitors to the gallery were likely to be white Danes.[62] On the contrary, the intended public produced by Odumosu's sensuous, evocative, but not any less critical exhibition address was, we submit, a mixed audience. The exhibition's "entangled herstories" invited empathic, bodily responses from everyone and also offered a plurality of intersecting points of identification for non-white and female visitors.[63] An emblematic example is Swedish Ethiopian Saba Bereket Persson's *THE UNSPOKEN: About Unconscious Discrimination* (2015/2019), an installation of mannequins carrying costumes covered with sacks heavy from the unknown burdens they both conceal and expose. The centerpiece of the installation was a video of dancer Mpululu

Saba Bereket Persson, *THE UNSPOKEN: About Unconscious Discrimination*, 2015/2019. Video 16:58 min., dimensions variable, part of the exhibition *Threshold(s)*, CAMP / Center for Art on Migration Politics, Copenhagen, 2019–20. © CAMP. Photo: Mads Holm

Ntuve dressed in one of the costumes, her contorted movements giving bodily expression to Persson's experiences of living in Scandinavia with a different skin color than white, accompanied by a voiceover that summarizes the results of a scientific survey of common prejudices about Black people in Sweden.

Like *Decolonizing Appearance*, *Threshold(s)* included the staging of discursive and artistic events at "dislocated" platforms embedded in Trampoline House. The most important one was the opening. As usual on Fridays, Trampoline House was crowded with regular users. It is no coincidence that the *Threshold(s)* catalogue includes snapshots documenting the conviviality, the mingling, the mixed community. As the evening's attraction included not only the weekly community dinner followed by a party with disc jockeys and bar but also CAMP's opening event, they were joined by

artists and exhibitiongoers. Navigating through the hallway where children were playing, the newly arrived would pass the kitchen, the smell of freshly cooked food evoking anticipation of the pleasure of eating the treats cooked by Sisters' Cuisine. They would also pass by the open door to the meeting room, where Yong Sun Gullach's performance was to take place, before entering the big multipurpose room, the heart and hearth of Trampoline House that brings the community together. Among other things, this space had a bar and an area with café tables where people could gather to talk to friends and strangers, play chess, and, later that night, have dinner. This was also where Odumosu gave her opening speech, and Maria Thandie and Deodato Siquir performed Afro-fusion music that spread a meditative atmosphere and resonated with the introspective atmosphere of the exhibition. Although

the music was soothing, it did not serve the purpose of repressing frictions and politics but rather extended the reparative work, performed by Odumosu's exhibition, into Trampoline House. Just before the live music started, Tone Olaf Nielsen announced the arrival of the bus that was to take parents and children from the Danish deportation center, Sjælsmark, back to the center. If people did not know already that the rejected asylum seekers living under appalling conditions at Sjælsmark were among those who used the house as a brief respite from camp life, they would learn it at the opening event. The encounters between asylum seekers, local Copenhageners, and the professional art crowd were not devoid of friction, but it is remarkable that CAMP and Trampoline House managed to facilitate the interweaving of such a heterogenous mix of people. Odumosu's exhibition address, with its affective and empathic ways of engaging with the Other as a human being, was finely tuned to connect to, even blend into, this local microcommunity. CAMP's creation of such spaces of coming together can be seen as a response to the need to imagine public spaces anew as, what we have termed, *postmigrant public spaces*. Before unpacking this concept, we must first address the question of extraterritoriality.

Extraterritoriality in the Context of CAMP
Refocusing attention on Enwezor's aforementioned concept of extraterritoriality, it becomes clear that CAMP activated, although in different ways and other contexts, all three aspects of this term. First, a deterritorializing strategy was employed, combining exhibitions at CAMP and various kinds of exhibition-related activities extending into Trampoline House, with the creation of platforms for political interventions at multiple other locations. An example is Castaway Souls of Sjælsmark's contribution to the group exhibition *The Dividing Line* (2016). Here the transnational group of rejected asylum seekers from Sjælsmark not only presented a performance in connection with the opening of the exhibition, but they also conducted so-called meetings of mobilization at CAMP, where the harsh conditions of rejected asylum seekers were debated and collective calls for action were articulated.[64] These meetings resulted in participants contributing to the public campaign For the Right to Have Rights!, which

demanded an end to forced deportations, the closure of asylum camps, a stop to the criminalization of migrants and asylum seekers, and the right to move and to stay. The following year, CAMP also teamed up with the Copenhagen-based community radio project, the Bridge Radio, to produce a sound installation and a live event in close collaboration with homeless migrants who make a living collecting and selling bottles in Copenhagen. As mentioned previously, this project, focusing on the precarious life situations of migrant workers in Denmark, was presented at Roskilde Festival in the summer of 2017, thus relocating the activities of CAMP to a site outside of Copenhagen and addressing different publics than the ones congregating on a more regular basis in and around Trampoline House. As these cases emphasize, CAMP's activities were thus spatially dispersed and activated a multiplicity of platforms over time by means of educational, activist, and installation-based activities, and they were underpinned by a curatorial activist intent, as were those of Enwezor.

Second, CAMP often performed an extraterritorial shift from the domain of the gallery space to that of the discursive. Such discursive programming could, for example, include talks, workshops, seminars, and guided tours of the exhibitions conducted by users of Trampoline House. Third, CAMP's curatorial practice also resonated with Enwezor's attempt to expand "the locus of the disciplinary models" that constitute and define a given project's intellectual and cultural interest.[65] Like Documenta11's platforms, CAMP's various exhibition-related activities drew on participants from a wide spectrum of disciplines. Thus, the discursive programming at CAMP can be said to have transgressed disciplinary boundaries, seeking to set up platforms for wide-reaching, transculturally networked, and cross-disciplinary forms of knowledge production related to contemporary migration politics.

Some of CAMP's events were realized at well-established and large-scale Danish art institutions such as the Statens Museum for Kunst and the Louisiana Museum of Modern Art.[66] Although CAMP's curatorial team has reflected explicitly on the potential dangers of being coopted into such transinstitutional collaborations, it continued to operate within these museological contexts, partly

For the Right to Have Rights!, theater performance by **Castaway Souls of Sjælsmark**, a self-organized group of rejected asylum seekers from the Danish deportation center Sjælsmark, performed during the opening of *The Dividing Line: Film and Performance on Border Control and Border Crossing*, CAMP / Center for Art on Migration Politics, Copenhagen, 2016. Photo: CAMP

because the collaborations provided much-needed possibilities of funding and partly because they enabled CAMP to reach more extensive audiences, thus potentially broadening the scope of the center's curatorially staged political interventions.[67] Concerning the effects of these transinstitutional collaborations, we argue that CAMP's presence at the Statens Museum and the Louisiana Museum has not impacted the museums' institutional practices in any substantial way. Producing such counter-hegemonic effects would have necessitated long-term engagements as well as more active negotiations of the power relations between the institutions. This reservation aside, the collaborations evidently led to new audiences being exposed to CAMP's curatorial projects. The collaboration with the Statens Musueum also enabled the free transfer of museum visitors to the lesser known exhibition site of CAMP,

and vice versa, in connection with singular events such as the opening of *Migration Politics: Three CAMP Exhibitions*. Although collaborations with large-scale museums were initiated, the majority of CAMP's discursive activities still took place at Trampoline House in order to ensure a close intertwinement with the regular activities of the community center and the multicultural mix of users that constituted its microcommunity.

Postmigrant Public Spaces

This constant interweaving of CAMP's activities and those of Trampoline House played a pivotal role in the curatorial production of what we have termed postmigrant public spaces.[68] CAMP's activities materialized in both physical and media spaces and comprised different kinds of aesthetic, social, and intellectual participation; public discourse;

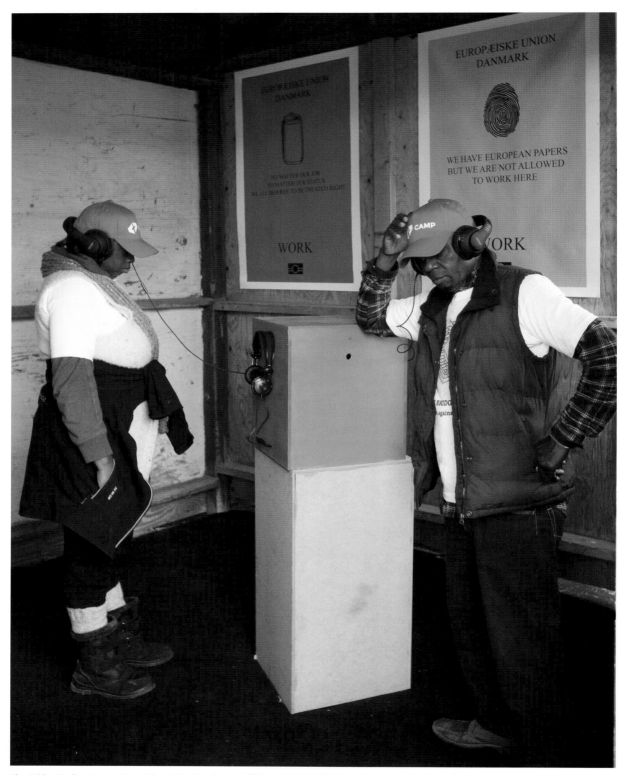

The Bridge Radio, show and installation at Roskilde Festival, 2017, curated by CAMP / Center for Art on Migration Politics, Copenhagen. © CAMP.
Photo: Paula Duvaa

activism; political protest; and acts of solidarity. Taking these spatiotemporal ramifications and the functional diversification into account, we define public space broadly. We call the kind of public spaces generated by CAMP "postmigrant" to indicate that they are plural and sometimes conflictual domains of human encounter, shaped under the impact of former and ongoing (im)migration and by the new and old forms of nationalism that have gained ground under the combined pressures of global capitalism, increasing economic inequity, and the rising numbers of migrants and refugees.[69] Unlike the notion of the nation as a public sphere, the designator *postmigrant* does not draw imaginary national borders around a public. On the contrary, it foregrounds transcultural entanglement, which is a further reason why this concept is apt for describing the particularity of CAMP as a public art space existing within a community center that was itself a postmigrant public space, albeit of a different kind.

Our understanding of publics draws on queer and literary theorist Michael Warner's theory of publics and his argument that a public "exists *by virtue of being addressed*"; that is, a public is "a special kind of virtual social object enabling a special mode of address."[70] In the context of this study, it is significant that Warner underscores that a public, in the modern sense of the word, also embraces strangers and outsiders—in fact, anyone who feels the topic of the address "speaks to" them. It should also be noted that Enwezor used the term *public sphere* while we prefer *public space*, first, because we draw on Chantal Mouffe's notion of democratic public spaces as inherently conflictual spaces, and, second, because we are concerned with a specific art space and local community, not the public sphere as a wide-ranging "communication framework of the 'body public,' a sphere of channels of opinion-circulation binding and protecting its constituent publics," to quote communications scholar Slavko Splichal.[71]

The concept of postmigration (das Postmigrantische) is a recent addition to the reservoir of critical terms in the humanities and the social sciences. It holds that Europe has been irreversibly shaped by immigration since the mid-twentieth century; that is, the concept relates to the after- (post-) effects of migration on society, not population movements as such. Postmigrant thinking articulates a realization

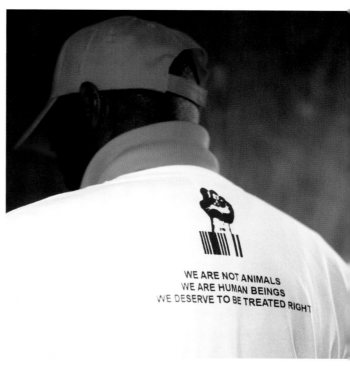

The Bridge Radio, show and installation at Roskilde Festival, 2017, curated by CAMP / Center for Art on Migration Politics, Copenhagen. © CAMP. Photo: Paula Duvaa

that new conceptual frameworks are needed to address this complex historical condition and develop egalitarian, antiracist institutional policies of democratic participation.[72] With regard to the concept of postmigrant public spaces, it designates spaces that have their anchor point within a democratic nation-state where migration has been a crucial trigger for social and cultural transformations. These changes have turned society into what Foroutan has called a "society of negotiation," where structural discrimination, privileges, resources, and norms, along with national identity and the terms of belonging to the imagined community of the nation, are being critically renegotiated. Importantly, according to the proponents of postmigrant thinking, it is not only immigrants and their descendants, but also the well-established "elites" who are expected to adjust to and integrate themselves into the new pluralist structure.[73] This aspect of the postmigrant reconstitution of society and the social imaginary came to the fore in Trampoline House and CAMP. As multicultural and multilingual environments that facilitate face-to-face encounters between displaced

people and the receiving communities, they testify to the fact that postmigrant public spaces can never be confined to "the nation" as a public sphere. Such spaces always exist in a dynamic, transcultural relationship with people, discourses, and cultures that hail from places beyond the nation-state.

As explained above, Enwezor conceived Documenta11 "not as an exhibition but as a constellation of public spheres" whose activities unfold within "the domain of the discursive rather than the museological."[74] The same could be said about CAMP. In both cases, the curatorial activities aimed at generating *publics* rather than audiences of art spectators, although the exhibitions also did just this.[75] This ambition is almost programmatically reflected in the first four Documenta11 platforms, which did not include works of art or reach publics beyond those who attended the local events until the conference books were disseminated through international book distribution channels. The ambition to produce publics and to "activate moments of communal publicness" was also evident in the way in which Kuratorisk Aktion worked from a position of embeddedness and solidarity.[76] They consciously orchestrated CAMP's activities in Trampoline House to attract and interweave different kinds of people. In doing so, CAMP succeeded in engendering postmigrant public spaces that were relatively open forums, providing the indefinite publics that emerged within them with a place to thematize, discuss, and act on issues related to forced migration, asylum seeking, and integration, as well as exploring how art can stimulate engagements with these issues and foster solidarity among people.

How did CAMP negotiate latent conflicts and enhance the potential for bridge building among the heterogeneous mix of individuals who constituted the gallery's public(s)? As already suggested in the outline of CAMP's activities, the public spaces generated at CAMP had a distinctive local quality, since the center's regular visitors mainly lived in the Copenhagen area. CAMP's strategy of public engagement thus relied on the possibility of face-to-face interaction and on addressing, in a politically active way, migration and integration issues that were of interest to the refugees and asylum-seekers of Trampoline House, who remained the primary *intended* audience for CAMP's exhibitions, despite the fact that it was mostly the art audience that set foot in the exhibition space. Nevertheless, the persistent insistence on catering for the Trampoline House community is significant. Although it has proved difficult to entice the majority of Trampoline House users to enter the "other space" of the gallery, CAMP found ways to reach out to them and get different groups to mingle. This was done by consciously seeking to present art projects that did not exclude the users of Trampoline House due to language barriers or to excessive use of codifications specifically related to the art world. As Kuratorisk Aktion has stated, "We look for artworks that do not involve too much language and that are not too conceptual, because we're not just talking to a professional art audience, we also address people in the house who have no training or maybe a different training in understanding contemporary art. While English is the most commonly used language in the international art world, this might be only the fourth or fifth language to some of our audiences."[77]

Creating a heterogeneous contact zone where Trampoline House users and art audiences could intermingle was also achieved by launching the educational program Talking about Art. By means of this program, members of the community of Trampoline House who were interested in learning how to become gallery guides were recruited and participated in self-organized workshops, studied the exhibitions about to be mounted, and coauthored guide manuscripts that they subsequently performed in duos throughout the exhibition periods.[78] In this way, encounters were staged within the exhibition space that effectively challenged the binaries of inclusion and exclusion, guest and host. Last but not least, getting different groups to come into contact within the curatorial framework of CAMP was made possible by coorganizing performances, film screenings, and public debates and opening events in the familiar environment of Trampoline House, which its users regarded as *their* space.[79] These events offered platforms for democratic participation, aesthetic experience, and raising and sharing sensibilities while discussing (or listening to discussions), as well as for informal conversations and sociability. It could thus be argued that the art events in Trampoline House, and the guided tours of the exhibitions by refugees and asylum seekers,

constituted the crucial contact zones where art and curating facilitated transcultural exchange between refugees, asylum seekers, local Copenhageners, and (inter)national art audiences.

Returning to the question of how CAMP imagined public space otherwise, that is, as a contact zone for local Copenhageners (privileged) and asylum seekers (subaltern), it is important to stress that this contact zone was not primarily a space for rational-critical debate, although the premises sometimes fulfilled this purpose, but rather a space of coming together that made possible intersubjective encounters that would leave affective traces; provoke reflection; and might even sow the seeds of sympathy, solidarity, and pro-asylum seeker and antiracist activism. Drawing on Jürgen Habermas's, Chantal Mouffe's, and Michael Warner's theorization of the public sphere, art historian and curator Alpesh Kantilal Patel submits that there is a need for "a public sphere (whether agonistic or counter)" that assigns a defining part to embodied, affective sociability in public dialogue. Importantly, Patel suggests that in such spaces of coming together, the artistic practices (and, we may add, the curatorial practices by which artworks are usually mediated) "can be envisioned as making felt—if only transient—connections among different, perhaps conflicting, counterpublics or subjects."[80]

Although CAMP's discursive events had a strong oral and local component, they were also communicated and expanded through the use of the center's website, exhibition catalogues (both printed and online), social media, and, sometimes, news media. In order to better grasp the implications of Kuratorisk Aktion's work, however, we need to look beyond CAMP. In 2011, Paul O'Neill and Claire Doherty identified a "durational approach" in public art, based on case studies of temporally extended art projects that prioritize spatial and public forms of expression and knowledge production and develop methods of working that dissolve the boundaries between artistic and curatorial modes of thinking, researching, and organizing.[81] Because of their long timespan, O'Neill observes, such enduring projects engender "a complex set of interactions." This suggests that they are capable of creating and sustaining "a certain connectivity" among their participants and publics, that is, a deeper form of engagement that "aspires to create an ethos of patience, perseverance and attentiveness" at odds with the usual grind of globalized exhibition making and the fleeting encounters between audiences and artworks in transit between venues.[82] As Andrea Baldini submits, "enduring artworks"—and curatorial projects, we might add—"are important since they provide the opportunity to engage members of public-art publics in a more sustained and intense way, thus promoting more structured forms of discussions."[83] As a long-term thematic curatorial project, CAMP operated along similar lines, generating different and repeated forms of coming-together that engaged many different actors in "an exchange of ideas as part of an initiated process of potential transformation."[84] Such open-ended processes permitted conflicts and tensions to surface, but they also allowed for the building of solidarity and what Foroutan has termed *postmigrant alliances*, that is, strategic bridge building between migrant and nonmigrant actors who pursue a common goal. By bringing together different people based on a shared experience (for example, of migration, racism, or discrimination) or a common ethical stance on migration and diversity, postmigrant alliances enable new interest-based relationships to develop "beyond homogenous peer groups." By blurring the boundaries, these alliances between people of different heritage and citizenship status have the potential to restructure the understanding of identity and belonging because "other nonethnic principles are promoted in order to undermine the legitimacy of ethnic, national, or racial boundaries."[85]

We would like to conclude this tracing of Enwezor's legacy from Documenta11 to CAMP in Trampoline House with a glimpse of the future and a possible closing of the circle of curatorial inspiration. As mentioned in the introduction, Kuratorisk Aktion's participation in the preparation of documenta fifteen resulted in the closure of CAMP, but this is not the end of the story. While Frederikke Hansen joined ruangrupa's curatorial team in 2019, Tone Olaf Nielsen chose to stay in her program director position at Trampoline House, partly to program the house, partly to coordinate Trampoline House's contribution to documenta fifteen in collaboration with a group of Trampoline House representatives.[86] Despite Trampoline House's un-

fortunate closure at the end of 2020, the house will remain in documenta fifteen and use it as a platform to communicate the history, knowledges, and methods of the house; create a temporary solution for Trampoline House's users; create awareness of discriminatory migration policies; and develop a plan for a new more sustainable Trampoline House. What further transmutations of Enwezor's legacy will result from this folding of CAMP and Trampoline House into Documenta remains, at the time of writing, an open question.

This study of the legacy of Okwui Enwezor has pursued the idea that small-scale art spaces may offer more fertile conditions for making Enwezor's vision materialize and for transforming curatorial initiatives into political platforms. We have demonstrated how the participation of CAMP's audiences and the users of Trampoline House diverged from that of traditional visually oriented spectatorship and, instead, approximated a form of civil practice enacted by individuals as citizens or denizens. The durational character of this small-scale institution's curatorial engagement with migration, that is, its long-term commitment to the development of solidarity, accountability, and sustainable institutional structures, including the setting up of so-called support systems for participants, plays an important part in this shift. It enabled CAMP to experiment with varying forms of public address and congregation embedded in politically engaged community work, sometimes linked to activism. Crucially, it was the relationship between the different projects and events in the same place across time that enabled the activities to cohere synergistically as their effects accumulated and produced transitory constituencies that supported CAMP's continual work toward more equitable migration, refugee, and asylum policies.

Sabine Dahl Nielsen is a postdoc at the Department of Arts and Cultural Studies, University of Copenhagen, Denmark. Anne Ring Petersen is a professor of modern culture and contemporary art at the University of Copenhagen.

Notes

We would like to thank editors Jane Chin Davidson and Alpesh Kantilal Patel for constructive and insightful comments on an earlier version of this essay and extend our gratitude to the Novo Nordisk Foundation's Committee on Research in Art and Art History for supporting the research on which this article is based (grant NNF 19OC0053992). An earlier version of the section on postmigrant public spaces was published in *CAMP Status! Seven Years of Engaging Art on Migration Politics,* ed. Frederikke Hansen and Tone Olaf Nielsen (Copenhagen: CAMP/Center for Art on Migration Politics, 2020). Last, but important, a warm thank you to Frederikke Hansen and Tone Olaf Nielsen for giving an interview and for generously allowing us to use images from CAMP.

1 There are many examples of such small-scale institutional spaces and extra-institutional contexts in which curatorial agents are currently experimenting with practices characterized by geographic dispersal, deconstruction of Western-centric notions of art, and the collective production of social and political knowledge. With respect to the European context under study in this essay, one could mention SAVVY Contemporary in Berlin, the Showroom in London, as well as the Silent University in Stockholm, Sweden; Hamburg, Germany; and Ruhr, Germany. At the time of writing, the most recent example is Sonsbeek, in Arnhem, Netherlands, a quadrennial for art in public spaces. Its upcoming twelfth edition will include so-called Sonsbeek Councils, a series of international encounters curated by the Sonsbeek team in dialogue with local cultural workers in multiple locations worldwide that is "inspired by Okwui Enwezor's Documenta11 platforms." See "Sonsbeek," e-flux, June 8, 2020, e-flux.com/announcements/315543/sonsbeek20-24force-times-distance.

2 Enwezor used the term *platform*. Chika Okeke-Agulu and Okwui Enwezor, "Interview with Okwui Enwezor, Director of the 56th Venice Biennale," Huff Post, December 6, 2013, huffpost.com/entry/interview-with-okwui-enwe_b_4380378.

3 Okwui Enwezor, "The Black Box," in *Documenta11_Platform 5: Exhibition Catalogue,* ed. Heike Ander and Nadja Rottner (Berlin: Hatje Cantz, 2002), 42–55. Regarding the *curatorial*, see Irit Rogoff, "'Smuggling'—An Embodied Criticality," European Institute for Progressive Cultural Politics, August 2006, xenopraxis.net/readings/rogoff_smuggling.pdf; Simon Sheikh, "Curating and Research: An Uneasy Alliance," in *Curatorial Challenges: Interdisciplinary Perspectives on Contemporary Curating,* ed. Malene Vest Hansen, Anne Folke Henningsen, and Anne Gregersen (New York: Routledge, 2019), 97–107.

4 See Naika Foroutan's seminal book *Die postmigrantische Gesellschaft: Ein Versprechen der pluralen Demokratie* (Bielefeld: transcript, 2019). See also, *Postmigrantische Perspektiven: Ordnungssysteme, Repräsentationen, Kritik,* ed. Foroutan, Juliane Karakayali, and Riem Spielhaus (Frankfurt: Campus, 2018); and *Postmigrantische Visionen: Erfahrungen – Ideen – Reflexionen,* ed. Marc Hill and Erol Yildiz (Bielefeld: transcript, 2018). Most of the key sources are in German, but an English-language discussion of, and contribution to, postmigrant thought and postmigrant debates is found in *Reframing Migration, Diversity and the Arts: The Postmigrant Condition,* ed. Moritz Schramm, Sten Pultz Moslund, and Anne Ring Petersen (New York: Routledge, 2019).

5 A few days before New Year's Eve 2020, Trampoline House sent out a press release explaining that the house would close after ten years (2010–20), due to the lack of funding. It has been impossible to get financial support during the pandemic. As the house is now closed, we have changed present tense to past tense in the following text. See also note 7.

6 See Trampoline House, "Weekly Program," trampolinehouse.dk/program; and Trampoline House, "It's Your House," trampolinehouse.dk/activities (accessed June 30, 2020). See also the annual report, Morten Goll, "Trampolinhuset 2018," (Copenhagen:

Trampolinhuset, 2019), n.p; and Frederikke Hansen and Tone Olaf Nielsen, *Migration Politics: Three Camp Exhibitions at the SMK* (Copenhagen: SMK, 2016), 11, 43.

7 CAMP / Center for Art on Migration Politics, "Camp's Founders and Trampoline House Will Be Part of the Next *Documenta*—and CAMP Will Close," newsletter, June 19, 2020, campcph.org/news/1962020. Trampoline House closed in December 2020 due to lack of funding.

8 Thomas Gammeltoft-Hansen, "Refugee Policy as 'Negative Nation Branding': The Case of Denmark and the Nordics," in *Danish Foreign Policy Yearbook* 2017: 99, 105–6, 109.

9 Naika Foroutan, *Die postmigrantische Gesellschaft: Ein Versprechen der pluralen Demokratie* (Bielefeld, Germany: transcript, 2019), 13–14.

10 Martin Lemberg-Pedersen, "Manufacturing Displacement: Externalization and Postcoloniality in European Migration Control," *Global Affairs* 5, no. 3 (2019): 247–71, 260.

11 Our use of the term *debilitating* draws on queer theorist Jasbir Puar's understanding of the systematic enactment of "debilitation" as a political form of state violence based on the targeting of the unwanted or suppressed in order to debilitate their existence through a protracted process of wearing people down physically and mentally. Jasbir K. Puar, *The Right to Maim: Debility, Capacity, Disability* (Durham, NC: Duke University Press, 2017), xiv–xv.

12 Anthony Gardner and Charles Green, *Biennials, Triennials, and Documenta: The Exhibitions That Created Contemporary Art* (Chichester, UK: Wiley Blackwell, 2016), 183.

13 Regarding the diverse backgrounds of the curators in question, Susanne Ghez is from the United States; Mark Nash was born in the United Kingdom; Carlos Basualdo was born in Argentina and is currently living and working in the United States; Ute Meta Bauer was born in Germany and has since the beginning of the millennium been working in the United Kingdom, Austria, the United States, and Singapore; Sarat Maharaj was born in South Africa and educated there and in the United Kingdom, where he is currently based; and Octavio Zaya was born on the Canary Islands and has been living in the United States since 1978.

14 Enwezor, "The Black Box," 42.

15 Paul O'Neill and Claire Doherty, "Introduction, Locating the Producers: An End to the Beginning, the Beginning of the End," in *Locating the Producers: Durational Approaches to Public Art*, ed. O'Neill and Doherty (Amsterdam: Valiz, 2011), 2–14.

16 The much-debated concept of *contemporaneity* has been shaped by the understandings developed by Peter Osborne and, especially, Terry Smith. The term refers to the prioritization of the present pervading the globalized art world. Smith acknowledges that "our present contemporaneity shares much with the self-evident facts of what it has always been like to be contemporary: immediacy (it is happening now), simultaneity (at the same time as something else), and coincidence (to more than one person, thing, situation)." At the same time, Smith insists on a distinction between mere "presentism" and contemporaneity as a more acute consciousness of the particularity and increasing urgency of our present condition. Contemporaneity thus entails an awareness that "unlike every earlier period," the world population needs to find "our futures entirely within the resources available to us now." Recapitulating his own definition from 2008, Smith explains: "Contemporaneity consists precisely in the acceleration, ubiquity, and constancy of radical disjunctures of perception, of mismatching ways of seeing and valuing the same world, in the actual coincidence of asynchronous temporalities, in the jostling contingency of various cultural and social multiplicities, all thrown together in ways that highlight the fast-growing inequalities

within and between them." Terry Smith, *Art to Come: Histories of Contemporary Art* (Durham, NC: Duke University Press, 2019), 4. See also, Smith, "Rethinking Modernism and Modernity Now," in Aleš Erjavec and Tyrus Miller, Modernism Revisted, special issue *Filozofski Vestnik* 35, no. 2 (2014): 271–319; and Peter Osborne, *Anywhere or Not at All: Philosophy of Contemporary Art* (London: Verso, 2013). In regard to the debate on contemporaneity and contemporary art, see *Contemporary Art: 1989 to the Present*, ed. Alexander Dumbadze and Suzanne Hudson (Chichester, UK: Wiley-Blackwell, 2013). For a development of Smith's thoughts into an understanding of contemporaneity as a temporality characterized by "a lack of futurity," in contradistinction to the linear, future-oriented temporality and teleological narrative of modernity, see Jacob Lund, *The Contemporary Condition: Anachrony, Contemporaneity, and Historical Imagination* (Berlin: Sternberg Press, 2019), 18. See also Gardner and Green, *Biennials, Triennials and Documenta*, 193.

17 Enwezor, "The Black Box," 42.

18 Enwezor, "Introduction: Travel Notes: Living, Working, and Travelling in a Restless World, " in *Trade Routes: History and Geography: 2nd Johannesburg Biennale*, ed. Okwui Enwezor (Johannesburg: Greater Johannesburg Metropolitan Council; Den Haag, Netherlands, Prince Claus Fund for Culture and Development, 1997), 7–12.

19 Enwezor, "The Black Box," 42.

20 Enwezor, "The Black Box," 42.

21 Enwezor, "The Black Box," 49.

22 Sheikh, "Towards the Exhibition as Research," in *Curating Research*, ed. Paul O'Neill and Mick Wilson (London: Open Editions; Amsterdam: De Appel, 2015), 33–34.

23 Rogoff, "'Smuggling'—an Embodied Criticality," 3.

24 Jean-Paul Martinon and Irit Rogoff, "Preface," in *The Curatorial: A Philosophy of Curating*, ed. Jean-Paul Martinon (London: Bloomsbury Academic, 2013), ix.

25 Sheikh, "Curating and Research," 99.

26 In a different context, Simon Sheikh has reflected critically on the different modalities of research that can be said to be conducted through curatorial practices. He distinguishes between two notions of research: *Recherché* and *Forschung*. The first one is to be understood mainly in terms of journalistic research, that is, as an endeavor that uncovers the truth or investigates a topic by examining the facts. *Forschung*, on the other hand, implies a more scientific model of research that, contra to journalism, operates with hypothesis and propositions, treating its findings as uncertainties that need to be defined and may end up contradicting the preemptive thesis about them. Relating these two notions of research specifically to the curatorial field, Sheikh states that "while it is obvious that almost any exhibition employs *Recherché* to a lesser or greater extent, not all exhibitions can truly be thought of as *Forschung*, since they can lack a thesis, proposition, or laboratory." Sheikh, "Curating and Research," 100–101.

27 As an example, one could mention that the curatorial team involved in the conceptualization of Documenta11 was closely connected to a small-scale art institution in London that embodied the growing interest for working at the intersection between academia and curatorship: Institute of International Visual Arts (Iniva). Since its founding in 1994, this institution has become widely known for producing exhibitions, publications, and discursive events specifically related to postcolonial thinking. Several of Iniva's internal staff members and external collaborators were also linked to the influential London-based journal *Third Text* that was founded in 1987 by the artist and theorist Rasheed Araeen and became a powerhouse for the development and distribution of

postcolonial thinking in the 1990s and 2000s.

28 Enwezor, "The Black Box," 54.

29 Chin-tao Wu, "Biennials without Borders," *New Left Review*, no. 57 (2009): 113–14.

30 Kobena Mercer, "Documenta11," *Frieze* 69, September 9, 2002, frieze.com/article/documenta-11-2.

31 Sylvester Ogbechie, "The Curator as Culture Broker: A Critique of the Curatorial Regime of Okwui Enwezor in Contemporary African Art," *Art South Africa* 9, no. 1 (2010): 34–37.

32 Ogbechie, "The Curator as Culture Broker," 36.

33 Peter Schjeldahl, "The Global Salon: European Extravaganzas," *New Yorker* 78, no. 17, June 24, 2002; Anthony Downey, "The Spectacular Difference of Documenta XI," *Third Text* 17, no. 1 (2003): 85–92; Sylvester Okwuwunodu Ogbechie, "Ordering the Universe: Documenta11 and the Apotheosis of the Occidental Gaze," *Art Journal* 64, no. 1 (2005): 88–89; Oliver Marchart, "The Globalization of Art and the 'Biennials of Resistance': A History of the Biennials from the Periphery," in *Conflictual Aesthetics: Artistic Activism and the Public Sphere* (Berlin: Sternberg, 2019), 155–73.

34 Walter D. Mignolo, *The Darker Side of Western Modernity: Global Futures, Decolonial Options* (Durham, NC: Duke University Press, 2011), xxiii–xxvii.

35 Maura Reilly, *Curatorial Activism: Towards an Ethics of Curating* (London: Thames and Hudson, 2018), 140.

36 Anthony Gardner and Charles Green, "Post-North? Documenta11 and the Challenges of the 'Global' Exhibition," *OnCurating* 33 (2017): 111; Naomi Beckwith, "What We Can Learn from Okwui Enwezor's Post-Colonial Ethics," *Frieze* 203 (2019): n.p., frieze.com/article/what-we-can-learn-okwui-enwezors-post-colonial-ethics, (accessed June 25, 2020).

37 Catherine E. Walsh and Walter D. Mignolo, *On Decoloniality: Concepts, Analytics, Praxis* (Durham, NC: Duke University Press, 2018).

38 Schjeldahl, "The Global Salon."

39 Gardner and Green, "Post-North," 109. Emphasis added.

40 Reilly, *Curatorial Activism*, 21–22. See also 54–56, 140. For an overview of Enwezor's sustained curatorial efforts to spotlight the centrality of art from Africa, see Brian Wallis, "Okwui Enwezor Pioneered a New Kind of Global Exhibition," *Aperture*, March 20, 2019, aperture.org/blog/okwui-enwezor-remembrance.

41 Our study is empirically based on our long-term interests *in* and engagements *with* CAMP's curatorial activities. We have both viewed the presented exhibitions; attended various talks, workshops, and opening events; as well as participated in guided tours of the exhibitions conducted by representatives from CAMP's gallery guide educational program for refugees. It should be mentioned that Anne Ring Petersen has attended, as a participant-observer, the openings of CAMP's inaugural exhibition and Temi Odumosu's *Threshold(s),* as well as MTL Collective's *Decolonizing Assembly*. Furthermore, we have researched a broad spectrum of photographs and video-documentations published on CAMP's official website and conducted an in-depth interview on-site with Kuratorisk Aktion on December 13, 2019. We have not conducted interviews with the users of Trampoline House, because the ethical guidelines of the house state that permission to do so is only given if the interviewer works as a volunteer in the house for twenty to twenty-five hours a week for six months, as explained by Tone Olaf Nielsen in CAMP and Nora El Qadim, "On CAMP, Copenhagen: The Politics of Curating Art on Migration: A Conversation between Frederikke Hansen, Tone Olaf Nielsen, and Nora El Qadim," *Parse* 10 (2020): n.p.

42 Enwezor, "The Black Box," 54; and Enwezor, "The State of

Things," in *All the World's Futures: La Biennale Di Venezia, 56 Esposizione Internazionale D'arte*, ed. Okwui Enwezor and Monica Rumsey (exhibition catalogue) (Venice: Marsilio Editori, 2015), 17.

43 Enwezor, "The State of Things," 16–21, 17–18.

44 On sympathy as a precondition for solidarity, see Paul Gilroy, "Agonistic Belonging: The Banality of Good, the 'Alt Right,' and the Need for Sympathy," *Open Cultural Studies* 3, no. 1 (2019): 1–14.

45 "About," CAMP Center for Art on Migration Politics, camp-cph.org (accessed June 30, 2020).

46 Hansen and Nielsen, *Migration Politics*, 36–37.

47 Hansen and Nielsen, *Migration Politics*, 121.

48 Hansen and Nielsen, *Migration Politics*, 19.

49 Marianne Torp and Tone Bonnén, "Introduction," in *Migration Politics*, 7.

50 For CAMP's project description, see "The Bridge Radio at Roskilde Festival," CAMP Center for Art on Miration Politics, campcph.org/past/2962017 (accessed September 7, 2020). This project was later transformed into an exhibition/sound installation at CAMP. See "Economy of Migrant Labor—for the Right to Work," CAMP Center for Art on Migration Politics, campcph.org/past/2292017 (accessed June 30, 2020).

51 Sylvia Tsai, "Tiffany Chung: To Be Remembered," *ArtAsiaPacific* 100 (2016): 128–37.

52 "CAMP 2018–2020. Præsentation, strategi og handlingsplan" ("Presentation, Strategy and Action Plan"), CAMP / Center for Art on Migration Politics (Copenhagen: CAMP / Center for Art on Migration Politics, 2017), 16–17. See also "Talking about Art," CAMP / Center for Art on Migration Politics, campcph.org/guide-program; and "Migrationspolitik & Kunst—et undervisnings-tilbud," CAMP / Center for Art on Migration Politics, campcph.org/migrationspolitik-kunst-et-undervisningstilbud (accessed June 30, 2020).

53 The curatorial intention of creating *spillovers* between CAMP and Trampoline House is mentioned in our interview with Kuratorisk Aktion on December 13, 2019.

54 Tone Olaf Nielsen and Yannick Harrison, eds., *Decolonizing Appearance* (Copenhagen: CAMP / Center for Art on Migration Politics, 2018), 54–55, 65–67; "Decolonizing Appearance," CAMP / Center for Art on Migration Politics, campcph.org/events/2392018 (accessed October 2, 2020).

55 Marronage, "The White Gaze within the Structure," in *Actualise Utopia: From Dreams to Reality*, ed. Ninos Josef (Oslo: Kulturrådet, 2019), 99–136.

56 Oliver Marchart, *Conflictual Aesthetics: Artistic Activism and the Public Sphere* (Berlin: Sternberg Press, 2019), 26.

57 Marchart, *Conflictual Aesthetics*, 26.

58 Marianne Hirsch, "The Generation of Postmemory," *Poetics Today* 29, no. 1 (2008): 103–28.

59 Temi Odumosu, "That Place Beyond," in *Threshold(s)*, ed. Frederikke Hansen, Temi Odumosu, and Lan Yu Tan (Copenhagen: CAMP / Center for Art on Migration Politics, 2020), 7.

60 With regard to "counterhegemonic machine," see Marchart, *Conflictual Aesthetics*, 26.

61 Mathias Danbolt, "Exhibition Addresses: The Production of Publics in Exhibitions on Colonial History," in *Curatorial Challenges*, 65.

62 Marronage, "The White Gaze within the Structure," 117. Marronage understands "the white colonial mentality" to be integral to "the white gaze" as a "pervasive" phenomenon that has surfaced in recent curatorial initiatives taken by Danish art institutions, among others CAMP. Unfortunately, Marronage does not unpack their concept of *the white gaze*. This scopic practice and mental phenomenon is only evocatively linked by a discursive

chain of equivalence to "*white fragility:* white people's reduced ability to tolerate racial criticism as a result of their racial privileges": Marronage, "The White Gaze within the Structure," 101. Emphasis in the original text. Moreover, Marronage also fails to mention that Kuratorisk Aktion has always sought to transform audience relations by inviting the users of Trampoline House to CAMP's events. As Frederikke Hansen, CAMP co-funder and creative director of programming, explains in an email to the authors on September 4, 2020: "We have always done a lot to make our events open and accessible, and the users of the house have been a significant target group. When it was not possible to schedule CAMP events for days when the house was open and people from the camps [that is, asylum centers near Copenhagen] got tickets through their internship in the house, we would either rent a bus or compensate people for the cost of tickets, so they had the opportunity to attend."

63 On "entangled herstories," see Odumosu, "That Place Beyond," 4.

64 Hansen and Nielsen, *Migration Politics*, 14–15, 122–25.

65 Enwezor, "The Black Box," 42.

66 Examples hereof include *Migration Politics: Three CAMP exhibitions at the SMK* (2016) and *Spaces of Disappearance*, a literature and film event at the Louisiana Museum of Modern Art, Humlebaek, Denmark, September 9, 2019.

67 The above-mentioned reflections on the potential dangers of becoming coopted when engaging with mainstream art museums; the pragmatic necessity of securing funding in this way to run an alternative, small-scale institution such as CAMP; as well as the political importance of trying to reach new publics by means of cross-institutional collaborations have been discussed at various public events, for example, when Tone Olaf Nielsen presented CAMP's curatorial practice at the conference *Politics: Orientations and Possibilities of the Present*, Copenhagen University, October 30, 2019. The advantages and disadvantages of engaging with large-scale institutions such as SMK and Louisiana Museum of Modern Art was also touched upon in our above-mentioned interview with Kuratorisk Aktion on December 13, 2019.

68 In the following, we build and elaborate on the definition of *postmigrant public spaces* proposed in Anne Ring Petersen, "The Square, the Monument, and the Reconfigurative Power of Art in Postmigrant Public Spaces," in *Postmigration: Art, Culture, and Politics in Contemporary Europe*, ed. Anna Meera Gaonkar, Astrid Øst Hansen, Hans Christian Post et al. (Bielefeld, Germany: transcript, forthcoming).

69 For more on "global capitalism," see Nicki Lisa Cole, "5 Things That Make Capitalism 'Global,'" *ThoughtCo*, April 22, 2018, n.p., www.thoughtco.com/global-capitalism-p2-3026336.

70 Michael Warner, *Publics and Counterpublics* (New York: Zone, 2005), 67, 55.

71 Chantal Mouffe, "Artistic Activism and Agonistic Spaces," *Art and Research: A Journal of Ideas, Contexts and Methods* 1, no. 2 (2007), 1–5; Mouffe, "Art and Democracy: Art as an Agonistic Intervention in Public Space," *Open! Platform for Art, Culture and the Public Domain*, no. 14 (2007): 1–7, www.onlineopen.org/art-and-democracy (accessed October 25, 2018); and Slavko Splichal, "Eclipse of 'the Public': From the Public to (Transnational) Public Sphere. Conceptual Shifts in the Twentieth Century," in *The Digital Public Sphere: Challenges for Media Policy*, ed. Jostein Gripsrud and Hallvard Moe (Gothenburg, Sweden: Nordicom, 2010), 33.

72 Foroutan, *Die Postmigrantische Gesellschaft*; Foroutan, Coşkun Canan, Benjamin Schwarze et al., *Deutschland Postmigrantisch II. Einstellungen von Jugendlichen und jungen Erwachsenen zu Gesellschaft, Religion und Identität* (Berlin: Humboldt-Universität, 2015); Foroutan, Karakayali, and Spielhaus, *Postmigrantische*

Perspektiven; Hill and Yildiz, *Postmigrantische Visionen*; and Schramm, Moslund, and Petersen, *Reframing Migration*.

73 Foroutan et al., *Deutschland Postmigrantisch II*, 3.

74 Enwezor, "The Black Box," 54.

75 Our understanding of a/the public is based on Michael Warner's theory of publics in *Publics and Counterpublics*. It should be noted that the terms *public* and *public space* tend to bleed into each other. Although they cannot be neatly disentangled, a distinction should be made. We draw on Splichal's distinction between a *public sphere* and a *public*, according to which a public is "a social category, whose members (discursively) act, form, and express opinions," and a public sphere is "its infrastructure." Splichal, "Eclipse of 'the Public,'" 28. As Splichal observes, "A public sphere cannot act, it cannot communicate, but a/the public can. The public sphere is a necessary but not sufficient condition for a/the public to emerge, an infrastructure that enables the formation of the public as the subject, the bearer of public opinion": Splichal, "Eclipse of 'the Public,'" 28. As publics are not coterminous with (postmigrant) public spaces, we suggest that they are best understood to be the malleable formations of participants that exist, and coexist, within them.

76 O'Neill and Doherty, "Introduction," 12.

77 El Qadim, "On CAMP, Copenhagen," 5.

78 For more information on the Talking about Art program, see El Qadim, "On CAMP, Copenhagen," 7.

79 The here-mentioned challenges of enticing Trampoline House users to enter CAMP's exhibition space, and vice versa, have been reflected on by Kuratorisk Aktion in an interview with the authors on December 13, 2019.

80 Alpesh Kantilal Patel, *Productive Failure: Writing Queer Transnational South Asian Art Histories* (Manchester, UK: Manchester University Press, 2017), 173. Patel refers to Jürgen Habermas, *The Structural Transformation of the Public Sphere: An Inquiry into a Category of Bourgeois Society*, trans. Thomas Burger and Frederick Lawrence (Cambridge, MA: MIT Press, 1989); and Hal Foster and Jürgen Habermas, "Modernity—An Incomplete Project," *The Anti-Aesthetic: Essays on Postmodern Culture* (Port Townsend, WA: Bay Press, 1983), 3–15. Like our article, Patel draws on Michael Warner's *Publics and Counterpublics*, as well as several essays and chapters on art, agonism, and the public sphere by Chantal Mouffe, including "Artistic Activism and Agonistic Spaces," which we have mentioned above. Patel references further sources by Mouffe in *Productive Failure*, 184 [N91, 92].

81 O'Neill and Doherty, "Introduction," 10–11.

82 O'Neill, "The Blue House (Het Blauwe Huis)," 51, 55.

83 Andrea Baldini, "The Public-Art Publics: An Analysis of Some Structural Differences among Public-Art Spheres," *Open Philosophy* 2, no. 1 (2019): 19.

84 O'Neill, "The Blue House," 55.

85 Andreas Wimmer, quoted in Foroutan, *Die Postmigrantische Gesellschaft*, 199.

86 Tone Olaf Nielsen, e-mail message to authors, January 10, 2021. See also "CAMP's Founders and Trampoline House Will Be Part of the Next *documenta*—and CAMP Will Close," CAMP / Center for Art on Migration Politics, campcph.org/news/1962020 (accessed October 3, 2020).

ETHNIC ENVY
and Other Aggressions in the Contemporary "Global" Art Complex

Amelia Jones

Curate, as many curatorial studies scholars have pointed out, is derived from the Latin *cura*, which means "to care" (the original curators in Europe were caring for arrays of objects in cabinets of curiosity and other personal collections before the development of municipal or national art and natural history museums). Far from existing as an inherently caring profession, however, even when well intended, curatorial work over the past decades has most often aided and abetted the forces of the "global" art complex. Under the guise of the "global," glamorous international art fairs and events are peddled. Yet, they are most often sponsored either by dictatorial governments that seek to gloss over their violence and reactionism or by private corporations that monetize art while simultaneously touting its supposedly ethereal and transcendent values. The art that they present is almost always produced by people identifying as artists in the Euro-American sense, trained usually in Euro-American art schools. How "global" (in scare quotes, for reasons that will become obvious) is this kind of so-called art (itself an English word, a European conceit)? We can see the exposed structures of the "global" art complex very clearly now that it has been stopped overnight by quarantines and the termination of international air travel.

Journal of Contemporary African Art · 48 · May 2021
DOI 10.1215/10757163-8971328 © 2021 by Nka Publications

David Hammons, installation view of tents for *David Hammons* exhibition, Hauser and Wirth, Los Angeles, 2019, below **Martin Creed,** "Everything Is Going to Be Alright, neon, 2019. Photo: Amelia Jones

Most curators who sign up to produce "global" exhibitions are forced to participate (or do not realize they are participating) fully in the global commodification of world visual culture—the neoliberal joining of disparate works from around the world as art, contributing to the flourishing of tourism—through an entirely European system and Euro-American standards and values. Art is not incidental to the success of Europe's violent subjugation of colonized and enslaved peoples, and this constructed system of values in relation to art has had concrete effects. From the beginning, it was built into European education, architecture, all forms of culture, and the fabric of burgeoning early modern and modern urban centers in and beyond Europe. Thus, following this logic, European cities founded art museums in the late eighteenth and nineteenth centuries to house objects hallowed as works of art. They established museums of natural history during the same period to contain and display objects considered to be artifacts. The spaces European and US citizens inhabit are literally divided according to this hierarchical logic.

Nevertheless, the world as privileged Euro-Americans imagined it from the Enlightenment through the change of the millennium (with a few

David Hammons, installation view of exhibition *David Hammons*, Hauser and Wirth, Los Angeles, 2019. Photo: Amelia Jones

savage bumps along the way such as WWI and WWII) has arguably come to an end. What seemed like a fairly brisk decay of the sanctity of European values (unless you were a colonized or enslaved other, in which case these values could never have been experienced as anything but hypocritical), starting at least with WWI, has accelerated even more rapidly with the events of the twenty-first century—from 9/11 to the rise of nationalisms across the Western world, to the surge in refugees across the world due to the effects of climate change and political violence, to the economic crashes of 2008 and 2020, to the exposure of the hypocrisy of Euro-American concepts of equality and freedom with the increasingly persistent public and visual evidence of violence against Black and Brown and Asian bodies since the mid-twentieth century. With each catastrophe comes a wave of neoliberal ideology bent on papering over a collapsing system. Art has played a huge role in that papering over. This article addresses the covert toxicity of what I call the "global" art complex.

Enwezor's Challenge

In strong contrast, I focus on a particular curatorial practice that, I argue, intelligently navigated these inescapable racist and colonial and imperial power structures at the base of the "global" art complex—the twenty-year international career of recently departed Nigerian curator Okwui Enwezor, one of the few international-level curators who warned us well of the dangers of the pretenses and hidden violence of the "global" art complex. I then address two hybrid curatorial/artistic practices local to where I live and work in Los Angeles: the David Hammons exhibition installed at Hauser and Wirth (2019), and the work of Crenshaw Dairy Mart in a project called *Care Not Cages* (2020). In line with the ideas I have sketched of the curatorial and of the problem of the "global," I explore these two case studies through the questions of care, caring, and repairing: for whom are they speaking? whom do they serve? what language and sites do they employ? I ruminate briefly, as well, on how these local projects compare to Enwezor's global ambitions: which framework

David Hammons, installation view of exhibition *David Hammons*, Hauser and Wirth, Los Angeles, 2019. Photo: Amelia jones

seems more effective in addressing power structures and inequities in the COVID era?

Enwezor, who left Nigeria to attend college in New Jersey and first worked as a poet in New York, showed great prescience in the beginning of his career as a curator in the late 1990s, grasping the implications of what many were already recognizing as an incipient implosion of Eurocentric illusions of progress and democratic equality. By the early 2000s, he was functioning on the international stage, organizing major "global" shows, such as the hugely influential Documenta11 of 2002, in and beyond the usual site in Kassel, Germany (Enwezor was the first non-European art director of Documenta).[1] Far from unproblematically embracing the global as a shiny packaging mechanism to assign status to his own work or to celebrate a neoliberal economy of shared art values, Enwezor assertively argued throughout his curatorial practice and related scholarship that the global is a *problem* linked to the violence of globalization. As a citizen of Africa and then of the world, Enwezor maintained an oblique and persistently critical perspective on Euro-American institutions, even when he had arguably become part of them. He could see clearly the colonizing force of most curatorial practices claiming to be "global" in their reach, and he worked to counter the Eurocentrism of the most esteemed international exhibitions of contemporary art—not only did he organize one of the most heralded versions of Documenta, he was also chief curator for the 2015 Venice Biennale.

Enwezor exposed power structures inherent to the institutions presenting "global" art as well as the deeper logic of uses of the terms *global* and even *art*. His work—which functioned as noted within the *most* prestigious European "global" art institutions—Documenta and the Venice Biennale—points to the fact that the idea of global art in the 2000s has extended the trajectory of the often lazy multiculturalism of Euro-American art institutions in the 1990s (dominated by a strong tendency to "tick boxes" by adding works by artists of color to preexisting exhibition structures in order to ameliorate the lack of

David Hammons, installation view of exhibition *David Hammons*, Hauser and Wirth, Los Angeles, 2019. © David Hammons. Courtesy the artist and Hauser and Wirth. Photo: Fredrik Nilsen Studio, Los Angeles

David Hammons, graphite on gallery wall, installation view of exhibition *David Hammons*, Hauser and Wirth, Los Angeles, 2019. © David Hammons. Courtesy the artist and Hauser and Wirth. Photo: Fredrik Nilsen Studio, Los Angeles

diversity). This particular kind of multiculturalism is linked to what I call the "ethnic envy" of the art world—the drive to incorporate works by artists of color in order to raise the status of the institution as culturally aware and politically on point. Ethnic envy, which was in full force in US institutions in the 1990s, leads to addition without fundamental change, and this logic worked its way into the celebrations of "global" art networks in the early twenty-first century. If we can assume that Documenta hired Enwezor partly out of ethnic envy, that did not deter him from forcing the entire structure to work toward critical ends.

As an example of the ways in which this lazy multiculturalism extended into the "global" art complex of the twenty-first century, many curators, critics, and art historians in Europe and its former colonies (including the United States, Canada, and Australia), with English as the dominant language, have since the turn of the millennium written about and exhibited so-called global art through a kind of neocolonialist framework. These curators, critics, and scholars (most often privileged white people, once again) traveled the world—arguably in a new version of the "grand tours" of privileged white European gentleman of the eighteenth century, who would travel to "exotic" locales and document their travels through drawings and diaries—often focusing ultimately on Rome as the "origin" site for a particular genealogy of European culture. Paralleling this logic, for example, Terry Smith, a white Australian man now also teaching in the United States,

has over the past two decades lectured internationally and produced scholarship featuring artworks from cities around the world that he selected during his professional travels.[2] Smith presents these in frameworks (the art history survey; the art historical lecture) that, I am arguing, are quintessentially Euro-American in concept and logic. Just as many feminists critical of art institutions and art-historical discourses pointed out in the 1970s and 1980s, nothing inherently changes about the power structures underlying these by simply adding work by women artists to them, so today we must point out that we cannot assume ourselves to be at the cutting edge of cultural production and political progress by simply adding work by artists from Africa or Asia or Latin America to exhibition and scholarship formats that have not fundamentally changed.[3]

Many of these artists will have trained in Euro-American or Westernized art schools. Some of them will not have. Either version is problematic in terms of claiming a true cross-cultural status for the exhibitions featuring their work, given that (for example) the "global" art exhibition or biennial or art fair is fundamentally European in conceit. In this light, it is clear that including work by those *not* trained in Westernized methods is appropriative, but also that including work *only* by those trained in Westernized methods misses the supposed point of the concept of "global" art (expanding art beyond European-based modes of creative expression). What is lacking in this overall logic of tick-box inclusion is an awareness of and criticality about the way in which colonialism has extended Western concepts of art around the world as, arguably, another mode of colonization.

To this end Enwezor insisted, in contrast, on the importance of putting pressure on the very frameworks and value systems through which these supposedly global exhibitions took place, and as art director of Documenta he had enormous power to do so. It was crucial that he worked *within* the very structures he sought to examine, coining the term *Westernism* to encompass the problems of neocolonialism I noted above, as he worked to put pressure on its very premises. In Enwezor's important essay for the main catalogue of his Documenta11 project, "The Black Box," he draws on Frantz Fanon's equally prescient and oblique view in *The Wretched*

Black Lives Matter shrine on the grounds of Hauser and Wirth, Los Angeles, during *David Hammons* exhibition, 2019. Photo: Amelia Jones

of the Earth (1963) of the incipient rot of Western imperialism. Fanon was, like Enwezor, a person of African heritage (originally from Martinique in Fanon's case) who trained in Western schools and became a highly sophisticated theorist of Western oppression. In *The Wretched of the Earth*, Fanon argued that such internal decay will produce calls for the "whole social structure being changed from the bottom up . . . [a] change that is willed, called for, demanded," and that results in a *tabula rasa*.[4] Enwezor, in his text, amplifies Fanon's point, turning his incisive critical capacities to the situation of the world at the time—just after 9/11—arguing that this epochal event marked a turning point and produced a profound void, a *tabula rasa* that was also a literal and figurative "ground zero" in the center of Euro-American modernity or "Westernism." Enwezor goes on to note that, whether in the art world (with our "tendentious claims of radicality")

or beyond, Westernism sums up "that sphere of global totality that manifests itself through the political, social, economic, cultural, juridical, and spiritual integration achieved via institutions devised and maintained solely to perpetuate the influence of European and North American modes of being," asserting itself as "the only viable idea of social, political, and cultural legitimacy from which modern subjectivities are seen to emerge."[5]

Social and political life has everything to do with what artists and art institutions and viewers/interpreters think and do; art and its institutions are intimately connected to the structures of capital and ideologies of Westernism (forged through long histories of colonial domination) that Enwezor identifies. Art and its institutions are not and can never be entirely free from Westernism, given their foundational role in colonization, and, in fact, as I have argued above, they participate centrally in its

constitution and global spread. Enwezor, however, insists that curators and artists and scholars might productively seek to *do something other* than fully accede to the violence of capitalism, imperialism, and colonialism on which Western culture has been built. This is the complex and highly challenging project he embarked on with Documenta11: framing "global" art differently so as to avoid the wholesale commodification that a cyclical event such as Documenta seems inevitably to promote. In order to achieve this goal, his essay takes as its task to explore and outline the particularities of the then current situation, wherein the ground zero of 9/11 begat the ground zero of the post-2000 world, in which "chaos now proliferates inside the former dead certainties of the imperial project of colonialism and Westernism," linked to rapidly decolonizing areas of the Southern hemisphere.[6]

If we spend even a moment dwelling on this line of thought, it is clear how much farther in 2020 the Euro-American sphere and Westernism in general have moved toward chaos and a seemingly endless sparking of ring-wing states of exception (as Giorgio Agamben would put it) as well as forms of "counterhegemonic opposition," even while consolidating toxic reactionary versions of Westernism's most violent and oppressive values in the form of counter-counter opposition (the US's Alt right, Trump's administration, and the increasingly overt consolidation of white supremacist groups, for example).[7] All the anxieties and dangers Enwezor identified around 2000 are more extremely manifested today— and yet, while many of us have worked hard to take a critical stance vis-à-vis resurgent nationalisms, those of us who are white, middle class, and have long been ensconced in the art institutions and their attendant Westernism must acknowledge that what has been exposed through these massive shifts was *not* invisible to prescient thinkers such as Enwezor and many other Black, Indigenous, and People of Color writing and curating from an oblique position to these power structures. The shock of what Americans might now call "11/8" (November 8, 2016, the date of the previous presidential election in the United States, when Donald Trump was elected) was acute for white liberals and allies of (neo-)liberalism in this country and beyond, just as the shock of Brexit and the turn of many European countries toward far-right nationalism has shattered what was left of the European liberal ideal. The trauma of homelessness, of the influx of waves of refugees, and finally of COVID-19's maximization of rapid international travel networks to spread into a truly global pandemic has furthered its destruction.

Nevertheless, as noted, the collapse of an easy belief in the utopian ideals of liberalism has not been a shock for creative workers such as Enwezor, who had long suffered from forms of white supremacy across the globe—whether in its veiled or overt forms. As David Hammons recently put it: "Trump is the truth about America, because America has been like this forever. White people haven't seen it before, but we [African Americans] have."[8] Nor has this collapse been a shock for those living in less Europeanized parts of the world, less touched by "global" art or other forms of neoliberal late capitalist "culture." They have long lived the costs of extractive capitalism, whether or not these are veiled under the guise of "global" art (itself supporting forms of tourism that underlie the precarious economies of many parts of the so-called Global South).[9]

While structural racism is hardly new, Euro-American societies have arguably become more *overtly* racist and class-divided than they have been since the postcolonial and civil rights movements of the immediate post-WWII period. This has become apparent with, for example, the systemic violence against African Americans, finally kept on center screen since the brutal murder of George Floyd in May 2020 by a homicidal Minneapolis police officer. In this light, Enwezor's elaboration of an attentive curatorial project that sought to *activate agency* rather than either superficially illustrate diversity (as with 1990s art world initiatives under the rubric of multiculturalism) or confirm the stale, reactionary, formalist values of the West's art systems is all the more important as a model today. Given this point, it is important to stress that what I am emphasizing is *not* so much the artwork Enwezor included in Documenta11 as the entire logic through which he interrogated the value systems of the "global" art complex. First and foremost, as Enwezor asserts in the catalogue essay, he sought to shift away from the art world's pretense of simply delivering contemporary art in pure form to the public—as most art galleries and museums around the world tend to do.

Instead, Enwezor insists on a broader framework that accounts for and even highlights the ideological force of the discursive and material frames that give art its meaning and value.

Most important, by planning a series of intellectual "platforms" supporting the exhibition and organized around the world, Enwezor literalized the move away from Kassel or Europe as the locus for modernism, the formation of subjectivity, and of art itself. This explicit refusal to contain Documenta within its specified venue and locale at the epicenter of the European art world is a key part of Enwezor's work against Westernism. In the field of art, he notes, Westernism aligns with the concepts of the museum and art history, which "rest on a similar unyielding theology that founds the legitimacy of artistic autonomy, canons, and connoisseurship upon the same interpretive plurality of modernity."[10] Any "diversity" in such an art world—as long as these structures of belief remain unchanged—is illusory, as it maintains the literal center of legitimacy with the same institutions and sets of ideas as always.

Enwezor literalized this interrogation of Europe as the presumed "center" of the art world, and of Documenta. Building the entire event around the premise that "art is the production of knowledge," he worked with an international curatorial team to plan a series of transdisciplinary platforms in 2001 and early 2002 that took place at diverse sites around the world.[11] The platforms involved intensive discussions among diverse international artists and intellectuals that laid the groundwork for the later exhibition in Kassel as well as provided the content for a series of five catalogues. In this way, Enwezor and his team expanded Documenta physically, but also conceptually, beyond Kassel, which became the last of five transdisciplinary "platforms," devoted to the following themes:

· Democracy Unrealized (Vienna and Berlin)
· Experiments with Truth: Transitional Justice and the Processes of Truth and Reconciliation (New Delhi)
· Créolité and Creolization (St. Lucia)
· Under Siege: Four African Cities (Lagos)
· Documenta exhibition (Kassel)

Ultimately, then, Enwezor's Documenta strategy both acknowledged the Westernism built into art and its institutions as we know them (and certainly the legacy of Documenta would make it impossible to do otherwise) and sought to put pressure on the power structures of Westernism by insisting on a multiplication of its cultural forms beyond the material installation of the show itself. The discussions, as noted, led to an opening up of the exhibition to collaborative and politically sharp artistic interventions by a range of artists from around the world, including Tania Bruguera (Cuba), Yinka Shonibare (Nigeria-United Kingdom), and the Raqs Media Collective (India).

The choreography of Documenta11 points to Enwezor's recognition that the interrelated physical and ideological structures of the art world and broader art institutions *on all levels* must be challenged before any mitigation of the violence of Westernism can take place. Enwezor's critical strategies thus worked on a macro level (engaging sites, artists, and thinkers from around the world), but also on a micro level (insisting on interrogating the gaze itself through the commissioning of artists who would activate this critique in their installations). On the micro level, Enwezor thus asserts that the structures of spectatorship are foundational elements to consider in relation to any aspirations of shifting its entrenched systems of value and power, noting in the catalogue that the exhibition and its platforms are meant to acknowledge spectatorship as "central and fundamental to all forms of valuation of the visual content of an exhibition." He continues to assert that "spectatorship can only function productively in a democratic, open system. . . . In the democratic system . . . *one that promotes agency over pure belief*, the demands of citizenship place strong ethical constraints on the artist based on his or her commitment to all 'forms-of-life.' The practice of art presents the artist with the task of making such a commitment."[12] Whether or not we believe Enwezor's optimism about democratic systems still holds, his crucial point articulates through the lens of a Marxist decolonial project my long-developed argument that relational bonds between artists and materialities, and between these manipulated materialities and future viewers, determine the meaning and value of objects asserted to be art.[13] The corollary to this argument is, indeed, that art as such needs to be changed on the micro level (how it is made, how it structures spectatorship or engages

David Hammons, installation view of exhibition *David Hammons*, Hauser and Wirth, Los Angeles, 2019. © David Hammons. Courtesy the artist and Hauser and Wirth. Photo: Fredrik Nilsen Studio, Los Angeles

viewers, and for whom it is made are as important as questions of who makes it and what its perceived content is) as well as the macro (what are the institutions of art and how do they orchestrate social relations and hierarchies?).

Foundational to Enwezor's and my point is that these seemingly intimate and microcultural relationships that we see activated in art's exhibitionary and interpretive frameworks have everything to do with larger systems of power and value attached to the art world—including those of the sites in which art is made and exhibited such as Documenta. Interrogating how individual artists respond to these in relation to the institutions they work with and within is thus a key strategy to understand both what art is *doing* in relation to art institutions today and how these institutions maintain (or not) structures of power endemic to the colonial, imperial, and capitalist mindset of Westernism.

David Hammons and (Anti-)Westernism at Hauser and Wirth

In relation to this question of how artists work with institutional power, the museum-scale retrospective of David Hammons's work in the expansive galleries of Hauser and Wirth, Los Angeles, in 2019, is a revealing example, not the least because its shape and content and installation were determined by the artist himself, who was also nominally its curator. For those not familiar with Hammons's work, he was and remains a key figure in the US-based Black Arts Movement; starting his career in Los Angeles in the 1960s and 1970s, he now works and lives in New York City. Hammons's work and career are not so much attached to the explicit decolonial project outlined by Enwezor as to the broad-based, US-specific project of antiracist practice characteristic of the Black Arts Movement. Here, the legacy is slavery, one of the most violent and overtly

Aerial view of installation of *Care Not Cages*, Crenshaw Dairy Mart, Inglewood, CA, 2020. Photo: Mike Dennis

capitalized forms of European colonial domination. I turn to this show as an example for several reasons—especially because Hammons had a key role in organizing it, and because of the tension between the scrappy antiracist rigor of his work and its presence at the commercial gallery of Hauser and Wirth, an institution that epitomizes the neo-liberalism and corporatism of the "global" art complex.

In examining the Hammons show, I would assert the importance of considering two elements of the collusion of the museum/gallery complex in late capitalism. The first is what I call the *reactionary liberalism* of the so-called global art world: the appearance of furthering progressive values in the art world while maximizing profits.[14] Hauser and Wirth, which has thirteen international branches from Hong Kong to Zurich to Los Angeles, has gone on record mounting the kind of ambitious exhibitions formerly thought of as "museum" shows—even as museums become more and more commercial and driven by their dependency on private funding mechanisms.[15] Second, the Hammons show could be seen as epitomizing the art world's ethnic

envy: the motivation among white-dominant institutions to show (or appropriate) the work of Black and other minority artists so as to "correct" previous exclusions, even as they simultaneously operate against the interests of so-called ethnic (presumptively nonwhite) communities in places such as Los Angeles. Did Hammons's work placed in this context function to mitigate the gallery's obvious ethnic envy and reactionary liberalism (ca. 2020 versions of Westernism)? My answer will be equivocal.

Hammons is a profoundly important artist, who has long been honored as such within the Southern Californian art community as well as in New York. In Los Angeles, where he lived from 1963 to around 1980, he produced a wealth of politically charged "body prints" and assemblages involving wire and African American hair as well as collaborated with friends and colleagues, including Senga Nengudi, Ulysses Jenkins, and Marin Hassinger, to produce multimedia performances in the streets of the city such as Nengudi's *Ceremony for Freeway Fets* (1978).[16] Hammons began spending time in New York in the mid-1970s and moved there in 1980.

Described recently as a "famously reclusive artist" who "distrusts" the art market, Hammons is legendary for refusing invitations to show his work in major museums.[17] By all accounts, he has in his late career become master of his own value—carefully removing himself from the obvious circuits of the art market while producing works that key collectors purchase for millions. Notably, Hammons requires galleries that wish to exhibit his work to purchase it first.[18] He noted in a rare interview of 1990, "[a]s an artist I am not aligned with the collectors or the dealers or the museums; I see them all as frauds."[19]

Why, then, would Hammons agree to produce a large-scale show at Hauser and Wirth in Los Angeles—for which he made the exception to his rule that dealers had to buy the work, maintaining ownership of all but three major pieces?[20] It helps to know that he told Hauser and Wirth's New York-based partner that he felt ties to Los Angeles as an "important part of my life"—and he meticulously controlled the show, determining the entirety of its content and installing it himself, making maverick decisions such as eschewing wall labels (except in the case of a few works by other artists and his dedication to Ornette Coleman, as well as a few enigmatic textual phrases—all of which were written directly on the wall). It is also crucial to stress again that, essentially, Hammons was both the curator (with on-site assistance) and the artist whose work was installed. In this sense, the stunning and nuanced show was itself a giant installation work orchestrated by the artist. Hammons *took over* the commercial space of the gallery just as he has effectively managed the market system of his career over the past decades. Part of that effort at Hauser and Wirth involved countering what he identified as the overtly commercial energy of the gallery shop along the gallery's courtyard by providing "medicine" for gallerygoers in the form of a healer brought in to "cleanse" the gallery.[21]

Also striking, and to my mind confusing, was the installation of a number of tents stamped with the phrase "this could be u" in the outdoor courtyard—in the worst case, installed beneath Martin Creed's neon piece reading "Everything is going to be alright." These stood, it must be noted, a few hundred yards away from the lived-in tents on Los Angeles's unfortunately burgeoning skid row. Accompanying

the tents, which Hammons insisted be donated to homeless organizations after the show was over, was a large stone into which the words "Black Lives Matter" was carved and which formed the center of an impromptu shrine with burning candles. All of these elements were placed adjacent to the gallery store and its trendy and expensive restaurant.

As a local visitor, I found it impossible to get my head around this arrangement and to forget that Los Angeles's skid row, with its disproportionate numbers of Black Angelenos, who labor to survive every day on the street, is just around the corner from the gallery. There could be no more direct and horrifying evidence than these tent cities burgeoning across US cities of the collateral damage of late capitalist greed and individualism—or "racial capitalism"—as it rips apart the fabric of Westernism with its lingering, if bankrupt, Enlightenment fantasies of progress and equality.[22]

My long-standing respect for Hammons's work and knowledge of his legacy, however, colored my experience of this highly commodified space. I recognized the need to spend time with the nuances of the large-scale project: including Hammons's dedication of the exhibition to Ornette Coleman, his relentlessly politicized imagery and strategies, and his subtle but persistent interventions in both curatorial norms and the very relationship between the artist and spectator. I began to see the tents as a deliberate and direct—even embarrassing (for visitors, for the gallery)—engagement of the reactionary liberalism and ethnic envy of the museum/gallery complex. Local critic Anuradha Vikram has perceptively argued about the show, in relation to Hammons's career, that Hammons and Black artist Adrian Piper have a "staying power [in the art world that] lies in their unwillingness to be standard-bearers for a racial, gendered, or otherwise identity-based politics that, in art, often functions as a kind of low-budget symbolic 'reparations,' while money connected to board members at arts institutions continues to flow into new and more terrifying atrocities."[23] Vikram's point—persuasive criticism being, I would argue, one of the nodes of interface that Enwezor touches on with his attention to spectatorship—crystallized my own view on the show, and these complexities shifted my viewpoint toward a fuller understanding of how this moment of perceived crisis for white

liberals might feel to *Hammons*. Perhaps, I found myself musing, he does not share my relationship to Hauser and Wirth—underlaid by a disgust relating to my own white class privilege in the "global" art complex.

New Strategies for Combatting Westernisms

This attention to Hammons's show reveals, if anything, the continually shifting politics in relation to the "global" art world—and this show, even, was before the COVID-19 crisis. In closing, I present the ongoing work of a newly formed Los Angeles-based arts collective called Crenshaw Dairy Mart (CDM), cofounded by Alexandre Dorriz, noé olivas, and Patrisse Cullors—all three of whom, for transparency's sake, I will note were students of mine in the University of Southern California Roski School of Art and Design Master of Fine Arts program. Cullors, as well, is internationally known for having cofounded Black Lives Matter (with Alicia Garza and Opal Tometi) in 2013 after the brutal vigilante murder of Trayvon Martin and the acquittal of his murderer in Florida. Crenshaw Dairy Mart's mission, as stated on their website, is utopian and pragmatic at the same time:

> . . . shifting the trauma-induced conditions of poverty and economic injustice, bridging cultural work and advocacy, and investigating ancestries through the lens of Inglewood and its community. . . . [imagining] new collective memory through programming, events, and arts installations which cultivate and nurture communal arts and education. The Crenshaw Dairy Mart emerges from an investment in abolition.[24]

Speaking directly to the current moment (wracked by a pandemic and social protests over violence against Black bodies), the collective asserts its primary concern with healing and care on its opening web page, as well as through its most visible public project to date, Care Not Cages, which, drawing on Cullors's years-long work fighting against the mass incarceration and egregious mistreatment of African Americans, aims "through our work [to] generate less contact with police, less incarceration, less caging, less trauma and more healing."[25] This project is driven, in their words, by their denunciation of "racial capitalism and our government's addiction to greed, punishment, and man-made disaster," and an acknowledgement that "black, poor, disabled, trans and queer [communities] and communities at the margins will be impacted the most" by COVID-19.[26] The group fundraised in order to run a competition among incarcerated people to produce artworks on this theme of "care not cages," awarding three artists the top prizes and an additional eight smaller awards (see James Metters image, opposite). All awards included funds either paid to the artist or his family. More recently, CDM launched Black August, a series of events during August 2020, including an exhibition (online, due to COVID-19 restrictions) curated by Damon Davis; an artist takeover of the CDM Instagram account; and the re-release of Davis's public television documentary *Whose Streets?*, on the Ferguson (Missouri) uprisings after the police murder of Michael Brown in 2014.[27]

Beginning early in 2020 as a real-time, real-space south Los Angeles initiative, shifting nimbly to virtual formats with the lockdowns due to the COVID-19 pandemic, Crenshaw Dairy Mart functions on both registers as a specific and situated (but also networked) answer to Enwezor's critique of Westernism. These particular Care Not Cages and Black August initiatives seek to empower those local and national citizens oppressed by incarceration specifically by valuing and encouraging their creative work and making available a range of art and film work relating directly to the rise of Black Lives Matter. CDM exemplifies a political, artistic, and social initiative that merges activism quite directly with community work and visual arts production: it insists on art institutions as politically situated not only within a particular locale (Los Angeles), but within a specific matrix of political concerns (community well being and defunding police and prisons). It uses the concept and structures of art—including curation as a form of care—broadly as tools to nurture hope, agency, and even joy within communities continually beleaguered by the violence of Westernism. Notably, the roof of CDM lies under a major Los Angeles Police Department helicopter flight path, and olivos spearheaded the painting of "Care Not Cages" in huge letters for the police to see on their noisy trajectories across the city.[28] But all is not critique: CDM Instagram posts show the exhilaration and empowerment of bringing together community, whether in real time and

James Metters, *Care Not Cages*, 2020. Color pencils, Bic ink pens, chalk pastels, and ink pastels on paper, 8 ½ x 12 in. Courtesy and © the artist

space or on virtual platforms. Careful community building through creative initiatives can solidify political agency. Even parties and other forms of socializing can be crucial elements of this community empowerment: as visible on video clips on CDM's Instagram account, pre-COVID opening parties show CDM founders and a crowd of others dancing joyously to a live band, leaping ecstatically in the fresh air of their chosen free space for creativity and pleasure.[29]

Via Instagram and their website, their networked versions of locality, the Crenshaw Dairy Mart members disseminate initiatives, projects, public discussions, and social initiatives—curatorially disseminating the merged energies of community, creativity, and politics, as these urgently come together in the early twenty-first century to make change in the art world and beyond. Refusing Westernism's privileging of, in Ashon Crawley's words, "critical distance, abstraction, rationality,"

CDM participants revel in the "density that Black sociality . . . provides," fleshy and joyous chosen communities of creative people celebrating, what?, life's potential.[30] On a completely different scale from Enwezor's global initiatives, the collective here, vulnerable and supportive, labors on a local level to make art *work*—and to make it work against the grain of Westernism and racial capitalism.

In contrast to the reactionary liberalism and ethnic envy of the tick-box or multiculturalist approaches of the "global" art complex, which feed rather than undermine Westernism and racial capitalism, this strategy of infiltration and recreation (through which Crenshaw Dairy Mart produces a new art, a new art complex) asserts voices that demand *structural change*. In order to hear these voices and incorporate them, institutions must change on micro and macro levels, as Enwezor understood. This means defining art differently, perhaps even dropping the idea of art as it has existed to date in the

still Euro-American, Anglophone, and white dominant structures of the not-so-global art complex, still structurally racist and tainted by Westernism. The most impactful art can, after all, be dancing on a rooftop and cheerfully messaging the Los Angeles Police Department helicopters flying above.

Amelia Jones is the Robert A. Day Professor and Vice Dean of Academics and Research in the Roski School of Art and Design, University of Southern California, Los Angeles.

Notes

1 See "documenta11, 8 June–15 September 2002, Platform 5: Exhibition," documenta, documenta.de/en/retrospective/documenta11 (accessed August 10, 2020).

2 See, for example, Terry Smith, *Contemporary Art: World Currents* (New York: Pearson, 2011).

3 Carol Duncan argued in 1975, "More and better criticism within established modes—old art history with women added—these are not real solutions. The value of established art thinking and how it functions as ideology must be critically analyzed, not promoted anew." Duncan, "When Greatness Is a Box of Wheaties," *Artforum* (1975), artforum.com/print/197508/when-greatness-is-a-box-of-wheaties-36066 (accessed August 10, 2020).

4 Frantz Fanon, *Wretched of the Earth* (New York: Grove, 1963), 35–36.

5 Okwui Enwezor, "The Black Box," in *Documenta11_Platform 5: Exhibition* (exhibition catalogue) (Kassel, Germany: Documenta; Ostfildern-Ruit, Germany: Hatje Cantz, 2002), 45–46.

6 Enwezor, "The Black Box," 48

7 Giorgio Agamben, *State of Exception*, trans. Kevin Attell (Chicago: University of Chicago Press, 2003).

8 David Hammons, quoted in Calvin Tomkins, "David Hammons Follows His Own Rules," *New Yorker*, December 2, 2019, newyorker.com/magazine/2019/12/09/david-hammons-follows-his-own-rules.

9 See Macarena Gómez-Barris, *The Extractive Zone: Social Ecologies and Decolonial Perspectives* (Durham, NC: Duke University Press, 2017).

10 Enwezor, "The Black Box," 46.

11 Enwezor's team was comprised of Carlos Basualdo, Ute Meta Bauer, Susanne Ghez, Sarat Maharaj, Mark Nash, and Octavio Zaya. "Art is the production of knowledge" is noted as a key premise of the show on the Documenta11 website, documenta.de/en/retrospective/documenta11 (accessed August 10, 2020).

12 Enwezor, "The Black Box," 54, my emphasis. He is citing Giorgio Agamben on "forms-of-life": Agamben, *Means without End: Notes on Politics*, trans. Vincenzo Binetti and Cesare Casarino (Minneapolis: University of Minnesota Press, 2000), 3–4.

13 See the exhibition I curated, *Material Traces: Time and the Gesture in Contemporary Art,* Leonard and Bina Ellen Art Gallery, Concordia University, Montreal, 2013, and my summation of the theoretical goals there in "Material Traces: Performativity, Artistic 'Work,' and New Concepts of Agency," *TDR: The Drama Review* 59, no. 4 (2015): 18–35; and "Encountering: The Conceptual Body, or a Theory of When, Where, and How Art 'Means,'" *TDR: The Drama Review* 62 no. 3 (2018): 12–34.

14 My use of the term *reactionary liberalism* is very different from Gene Veith's analysis, which I became aware of after writing the initial draft of this article. See Veith, "Reactionary Liberalism," Cranach: The Blog of Veith, October 23, 2013, patheos.com/blogs/geneveith/2012/10/reactionary-liberalism-2.

15 See Hauser and Wirth, hauserwirth.com/locations (accessed August 10, 2020).

16 See Apsara DiQuinzio, "David Hammons: Printing the Political, Black Body," Wattis Institute, wattis.org/view?id=382 (accessed February 1, 2020). See also Kellie Jones, "Black Art West: Thoughts on Art in Los Angeles," in *L.A. Object and David Hammons Body Prints*, ed. Lindsay Charlwood and Connie Rogers Tilton (New York: Tilton Gallery, 2011), 18–61.

17 See Tomkins, "David Hammons Follows His Own Rules." This was not always the case. I saw an important Hammons early retrospective around 1990 called *Rousing the Rubble: 1969–1990*; originally organized by MoMA PS1 in New York, it traveled to the La Jolla Museum of Contemporary Art.

18 See Tomkins, "David Hammons Follows His Own Rules."

19 Cited with no attribution in Tomkins, "David Hammons Follows His Own Rules."

20 Tomkins, "David Hammons Follows His Own Rules."

21 Tomkins, "David Hammons Follows His Own Rules." In this extended profile on Hammons, Tomkins cites Stacen Berg, the Hauser and Wirth, Los Angeles, director, describing Hammons as he contemplated how to install the work: "'He sat on a bench in the gallery's garden for hours one afternoon, watching people walk by,' she recalled. 'When I asked what he was doing, he said, "I want to know what kind of medicine they need."' Soon after that, Hammons told [the New York owners] that the gallery shop, which sold ceramics, jewelry, and other craftwork, was 'a problem.' What was needed in that space was a 'healer.' Berg interviewed several spiritual healers . . . and brought in a psychic worker to 'cleanse' the gallery."

22 Some reviewers interpreted this part of the exhibition at face value as an ironic critique; see Geena Brown, "David Hammons," in *Artillery* (July 2, 2019), artillerymag.com/david-hammons. On *racial capitalism*, a term developed by Cedric J. Robinson indicating the intertwining of capitalism and the subordination of racialized bodies, see Robin D. G. Kelley, "What Is Racial Capitalism and Why Does It Matter?," Katz Distinguished Lecture in the Humanities, University of Washington, November 7, 2017, You Tube, youtube.com/watch?v=REo_gHIpvJc.

23 Anuradha Vikram, "Black Mirrors: Hammons, Wilson, and Julien on Capital in the Art Market," *X–Tra* 22, no. 3 (2020): 28.

24 See Crenshaw Dairy Mart, crenshawdairymart.com/about-us (accessed August 10, 2020).

25 Crenshaw Dairy Mart, crenshawdairymart.com/about-us (accessed August 10, 2020).

26 Crenshaw Dairy Mart, crenshawdairymart.com/about-us (accessed August 10, 2020).

27 See Carolina A. Miranda, "'Whose Streets?' Director Damon Davis Curates 'Black August' Resistance Art at L.A. Upstart," *Los Angeles Times*, August 6, 2020, latimes.com/entertainment-arts/story/2020-08-06/new-art-space-crenshaw-dairy-mart-black-resistance-black-august-show.

28 See the Instagram post of the painted rooftop at Instagram, instagram.com/p/CAhCfS6gDUx (accessed August 10, 2020).

29 See the video clip at Instagram, instagram.com/p/B9mSJwul-P4 (accessed August 10, 2020).

30 Ashon T. Crawley, *The Lonely Letters* (Durham, NC: Duke University Press, 2020), 10.

CHERRY RIVER

Where the Rivers Mix

Mary Ellen Strom
and Shane Doyle

Fox Family Fiddlers. Photo: Ben Lloyd

T he multimedia exhibition *Cherry River, Where the Rivers Mix* was presented to audiences of three hundred people over consecutive evenings on August 23 and 24, 2018, at the Missouri Headwaters State Park in Three Forks, Montana.[1] Long before the European invasion across the Atlantic, the headwaters, or the confluence of three forks of the Missouri River, was a crossroads, a hunting and meeting area for Northern Plains Indians, including the Hidatsa, Blackfeet, Shoshone, Crow, Nez Perce, Kootenai, and Salish. The eastern fork of the Gallatin River, the East Gallatin River, had originally been named the Cherry River by Indigenous Crow people. It was renamed in 1805 after Albert Gallatin, who was appointed Secretary of the Treasury in 1801 by President Thomas Jefferson and

 Journal of Contemporary African Art · 48 · May 2021
DOI 10.1215/10757163-8971342 © 2021 by Nka Publications

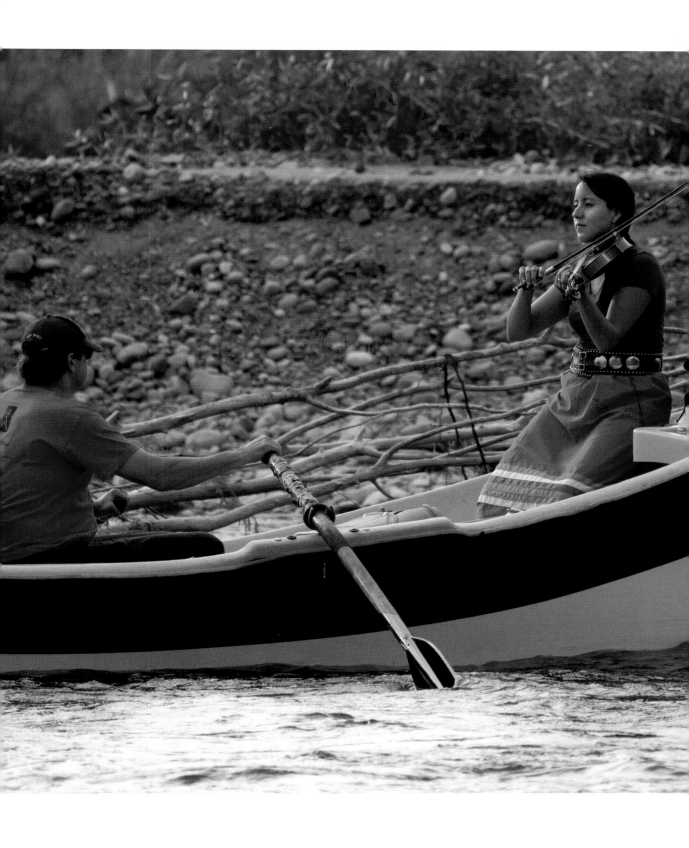

became a central figure in the design and implementation of Jefferson's plan for westward expansion.[2]

The place-based project *Cherry River*, created by artist Mary Ellen Strom and Native American researcher Shane Doyle, addressed the question, What does it take to change the name of a river? The event was produced by Mountain Time Arts, a collaborative arts and culture organization in southwestern Montana. In an effort to analyze the site, Mountain Time Arts convened a diverse group of participants, including Indigenous scholars, a geologist, local politicians, lawyers, ranchers, and an archeologist.[3] After six months of research, the project centered on the act of changing the name of the East Gallatin River back to the Indigenous Crow name Cherry River—or, in Crow, Baáchuuaashe. The name Cherry River honors and describes the numerous chokecherry trees growing on the river's banks that provide sustenance for bees, birds, small mammals, and bears and venerates Indigenous history, the ecology of running water, and riparian systems in the Northwest.

The Cherry River site presented a rich location rife with historic narratives and environmental lessons. For centuries, the European imaginary mistakenly believed that an all-water route across the North American continent existed, and the Missouri River was one of the main routes for westward expansion in the United States during the nineteenth century. In 1804, a year after the United States completed the Louisiana Purchase, which included Montana, Jefferson established the US Army unit, Corps of Discovery, and put Meriwether Lewis and William Clark in charge of finding a water route to the Pacific Ocean—specifically, "the most direct and practicable water communication across this continent for the purposes of commerce." It was at the headwaters in Montana that the Lewis and Clark expedition "discovered" that the Missouri River did not connect to the Pacific Ocean.

While archaeological evidence supports the presence of humans in Montana thousands of years ago and Plains Indians since the seventeenth century, Native American lands in the Missouri watershed were taken over by settlers beginning in the 1840s, leading to some of the most longstanding and violent wars against Indigenous peoples. During the twentieth century, the Missouri River basin was extensively developed for irrigation, flood control, and hydroelectric power. About one-fourth of agricultural land in the United States is currently located in the Missouri River watershed. Fifteen dams exist on the main stem of the river, with hundreds more on tributaries. Heavy development has taken its toll on wildlife, fish populations, and water quality. The river's stream flow has changed significantly over the last fifty years, leading to serious water shortages in southwestern Montana. During the last ten years, climate-related trends have included earlier snow melt in the spring. As a result, the region suffers water shortages by mid-summer.

As such, water flow is intrinsic to the narrative structure of the *Cherry River* project. Countering Jefferson's political hubris and desire to find a Northwest passage, the project's narrative structure highlighted the ways the Missouri River flows east and south. By featuring musicians playing on the Jefferson River, following the flows of the river, the return to the Cherry River was commemorated with a diversity of music from the Fox Family Fiddlers, a Métis group from the Fort Belknap Reservation, Montana, on the Madison River; a brass band from Bozeman, Montana, on the Jefferson River; and the Northern Cree Singers from Alberta, Canada, on the Cherry River.[4]

Despite the human and environmental tolls, the name Gallatin retains a distinct hold on this region. The county is named Gallatin. Along with the Gallatin River, there is the Gallatin National Forrest, the Gallatin Mountains, the Gallatin High School, the Gallatin Canyon, the Gallatin Mall, Gallatin Home Brew, and on and on. Place names of colonists have a significant psychological impact on the identity of a region, reinstating the land grab and reinscribing the trauma that followed. The Cherry River project voiced the desire to change the place names of geological sites that have been named by invaders and return those identities to the Indigenous names that honor a site, thereby promoting a healing of both the land and its inhabitants. ∎

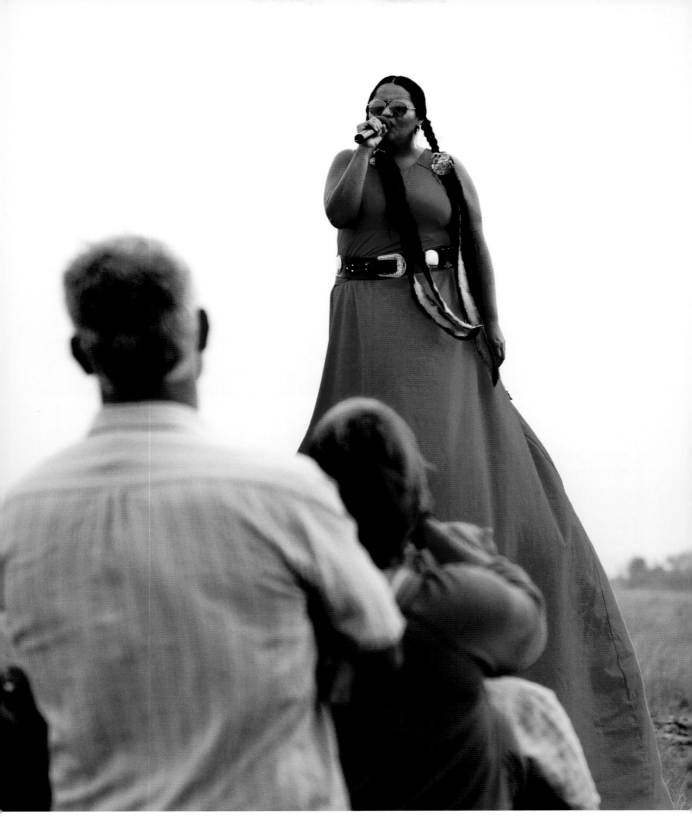

Shakira Glenn. Photo: Ben Lloyd

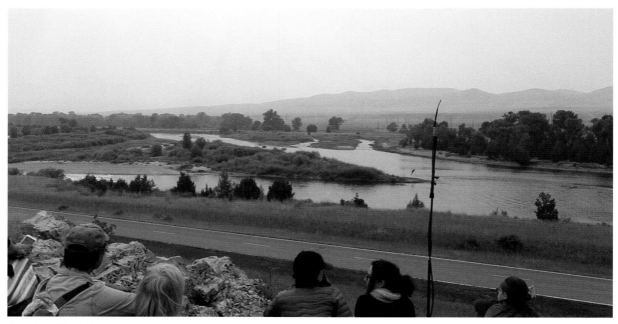

Photo: Jane Chin Davidson

Waiting is the participatory engagement of Cherry River. From the ridge of Fort Rock, looking down on the rivers below, the audience can barely see the four drift boats that carry the Fox Family Fiddlers, who play in the Métis tradition. As they move up the Madison, their music is being projected from the boats at a far distance. Four other boats arrive upstream on the Jefferson, transporting a brass band (with trumpeter and tuba player from the School of Music at Montana State University) along with four boats carrying the choir of orchestral singers to the bank where the three rivers converge. Now, fully in view, Jamie Fox stands up in the anchored boat against the surging wind and plays the song "Sitting Bull."

Singer Shakira Glenn, a member of the Apsáalooke Crow tribe, stands above the audience in a twelve-foot tall chokecherry-colored installation designed by artist Jim Madden, Mary Ellen Strom, and Alayna Rasile. Glenn captivates the viewers with song at the same time that the sound of violins begins to waft from the small speakers placed along the ridge of Fort Rock. Glenn's voice echoes the violin's phrases, resulting in a hauntingly beautiful melody that emerges powerfully from both the instrument on the water and Glenn's voice high on the hill.

This experience in Native singing and Métis violin was incredibly moving and augmented by nature, the scene of water and mountains. When Glenn finished the set by singing "It's Been Days," a Native round dance cover about longing, audience members did not know whether to clap or end the moment in silent reverence.

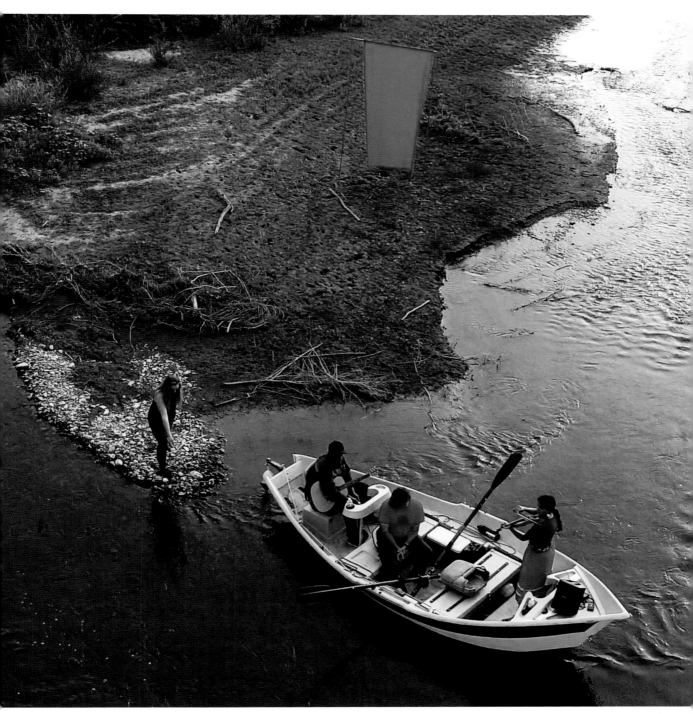

Photo: Ben Lloyd

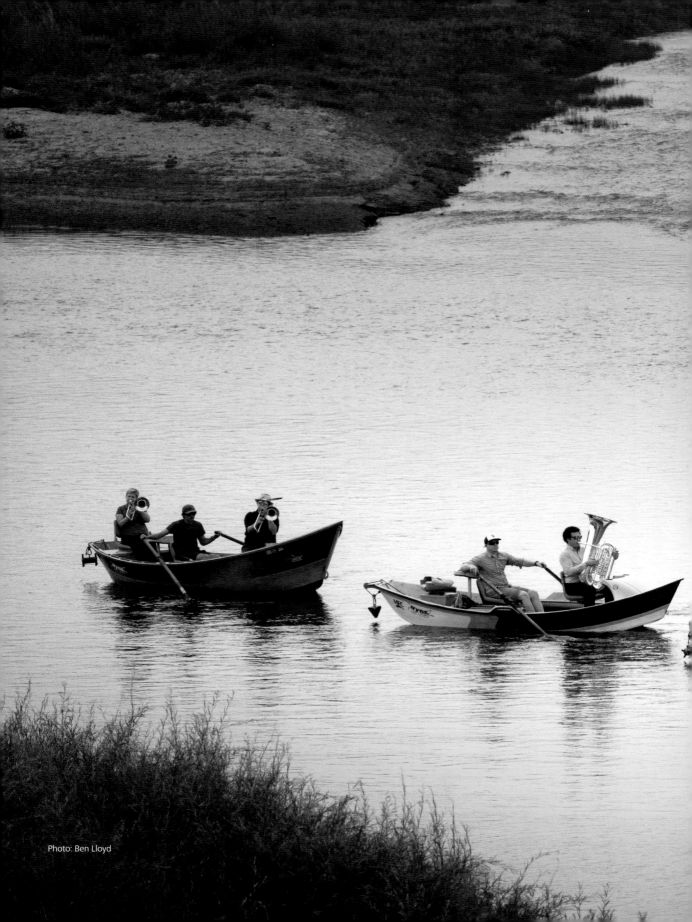

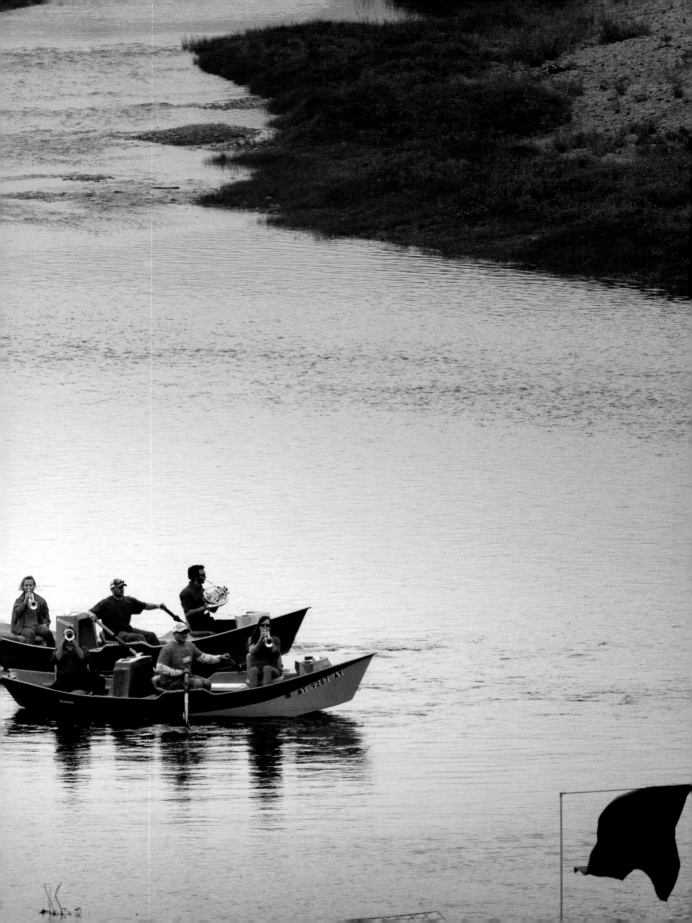

Cherry River and the Colonial Names of Montana

Shane Doyle

I am a member of the Crow Tribe from the small town of Crow Agency, Montana, along the banks of the Little Big Horn River in southeastern Montana, about one mile north of the site of the famous Battle of the Little Bighorn. Growing up in the 1970s and 1980s, it was known as the Custer Battlefield, and in high school I worked at the Custer Battlefield Trading Post and Café. Early in the 1990s, an Act of Congress changed the name to honor the Native people who also participated in the battle on June 25, 1876, and were merely protecting themselves and their loved ones. Yet, Custer's name is far from forgotten, as it marks Custer County, Montana; the Custer-Gallatin National Forest, also in Montana; and numerous towns with the name throughout the Northern Plains. The names of colonial legends such as Custer, Nelson Miles, John Bozeman, Nelson Story, Lewis and Clark, Albert Gallatin, and even Christopher Columbus have been immortalized throughout the region, their names assigned to hundreds of places, businesses, and institutions. I grew up in a reservation community that sits like a red island in a sea of white, postcolonial culture, and although I saw the world from a uniquely Native perspective, I nevertheless still consumed the food, music, movies, books, news media, science, and history of John Wayne's America. I became familiar with the sense of looking at the world from behind a two-way mirror; I could see out, far and wide, but nobody was looking back. My life as an outsider in my own homeland.

For all practical purposes, Native people and their astonishing thirteen-thousand-year-old history have been erased from Montana's place-name landscape. Were it not for the seven reservations, there would be no relevant site on the map to indicate that a diverse Indigenous population thrived there since time immemorial, maintaining the purity of the waters, respecting the spirit of the wildlife, and achieving a sustainably balanced way of life with the natural world. Our ancient Indigenous place names are nowhere to be found on official geographic information system registries or Google Earth, except for the few, slim references that survived the official name-making mapping process. These few places, whose names have withstood the fierce storm of colonialism, are now detached from the cultural traditions that once thrived all around them; we know their names but not where they come from, what they mean, or why they are important. Like an amnesiac who awakes with no memory of its point of origin, our contemporary American culture cannot mature beyond adolescence, because we operate with such little reverence to the ancient wisdom of the people of this land. Our intellectual and spiritual growth as a nation has been stunted and upended because we have not reconciled our rights with our responsibilities.

What do we call ourselves and our places, and what type of power do those names possess, both in our society and within our individual imaginations? Surely, our place-names are nothing less than the cornerstones of our mutually shared identities, reflecting our beliefs, values, sensibilities, hopes, and affirmations. Native culture has always held that names come with inherent power, forces of nature that are elemental and sacred; therefore, naming landscapes after men was not part of its cultural practice. The spirits, temperament, unique features, and qualities of the landscapes are what Native people recognize as the natural points of reference when place-names are acknowledged. In other words, places name themselves if you pay attention and allow them.

Colonial naming of "discovered" lands is rooted in a point of view that is hundreds of years old and is inextricably linked to slavery, genocide, and environmental devastation. Until we fully realize that the only path forward is one that traces back to our origins and takes progressive action through law and education can we begin a new circle in our American story. This new story will be informed and enlightened because it will be based on the ideals of reverence and respect, reflection and reciprocity, renewal and reinvention. America's greatest gift as a nation is its diversity and the vitality that accompanies it. We have the ability to provide a touchstone for future generations if we confront our sins of the past, sooner rather than later, and live up to our

Shane Doyle. Photo: Elly Stormer Vadseth

potential as renaissance people living in a modern age. Tearing down the old vestiges of our shamefully violent and cruel history as a nation is a maturation process that is as natural as the sun coming up, regardless of the ferocity of the storm. Justice is a real force of nature and cannot be stopped, only delayed. Say their names. Eventually all our colonial legacies weave into one braid of pain, dishonor, and brokenness. It is up to us to change the direction of this stream of consciousness by putting the words into our mouths and onto our maps that give us the first step in fixing what is no longer working.

Give us the names of the places so we can know where we are and why we know ourselves as natives of this land, no matter what the color of our skin or the heritage of our parents. We can all celebrate our indigeneity together, as native Americans, if not Native Americans. This land is your land, this land is my land; let us recognize the names it came with, the ones we inherited but neglected. Now is our time. Our legacy is calling us to act. ▪

Language carries and erases culture.
The words we speak.
The ways we hear.
The languages we read.
Influence our thoughts and ideas.

Words have the power to change the way we think or even how we remember.

Words convey symbolic ideas beyond their meaning.

The stories we tell and the ways we describe and name our environment are reflections of our attitudes and beliefs.

—Mary Ellen Strom

Mary Ellen Strom, center, and Shane Doyle, second from left, timing the boats on the river. Photo: Elly Stormer Vadseth

A Map for White Settler Awakening

Mary Ellen Strom

I am from Butte, Montana, a hard-rock mining town in the Rocky Mountain West, a town that pulled more than a billion tons of copper out of the ground in the nineteenth and twentieth centuries. The copper mine in Butte is called the Berkeley Pit. The Berkeley Pit is the focus of the United States' largest Superfund site. The cavernous pit is now a 900-foot-deep poisonous lake, with vast networks of contaminated subterranean tunnels. That is over ten thousand miles of tunnels filled with toxic water under the city of Butte. These staggering numbers explain the scale of extraction that happened in this town and the story of the environmental catastrophe that followed.

Butte, Montana, has one of the highest crime rates in the United States, compared to communities of all sizes. Poverty, violence, and cancer define this town. The copper brought tens of thousands of immigrants from around the world to work in this place, known for significant danger. At its peak, ten thousand men worked a shift in the mines.

There were three shifts a day in an industry operating 24/7. At the start of a shift, workers were transported thousands of feet below the Earth's surface to send up the copper. This dangerous work guaranteed accidents. Growing up in this community, I learned to read the workers' bodies: missing hands were from dynamite explosions; a crushed leg meant a fall down a vertical shaft; scarred faces were from underground fires; life in a wheelchair was the result of a cable snap that plummeted an elevator cage down thousands of feet. After the introduction of the machine drill, generations of workers with respiratory disease carried oxygen tanks in public. My grandfather, Mike O'Rourke, died of silicosis. My uncle, Mickey O'Rourke, the elevator operator at the Kelly Mine (who was mean as all get out) was permanently bent over at the waist, like a sideways "L."

In the early twentieth century, Butte supplied more than half the copper wire that electrified the United States. This new technology transformed workplaces and domestic spaces. Electricity altered

human relationships to time, labor, and sleep. World War I brought on new pressures of production in Butte's mines, which were already running at capacity. The companies ramped up output by digging deeper and enlisting larger work crews. Danger was omnipresent.

Labor unrest raged in this town that banked their hope on socialist ideologies and the possibility of unionization. Sabotage threats resulted in federal troops, state militia, and Pinkerton guards stationed in Butte from 1914 until 1921. I grew up with stories of soldiers with guns marching striking workers into the mines to pull out the copper.

In the late nineteenth century, at the same time that Butte's extraction industry was ramping up, the violent, militarized genocide of Indigenous people was taking place throughout the arid territory west of the 100th meridian. Racist legal and systemic structures began to regulate settler ethics. Hostile visions of a blank slate, presumptions of limitless growth, property ownership, and an endless drive for resource extraction was the capitalist ambition that remains in place today.

Following the genocide and displacement of Indigenous people who had inhabited the region for thirteen thousand years, white institutions were rapidly formed, including government and juridical systems, schools, businesses, religious organizations, and law enforcement and prison systems. These institutions enforced social control, maintained order, and ensured class conformity. These same white institutions privileged and protected white settlers.

Today, these intact systems and structures of white settler colonialism in the Western region of the United States continue to reward citizens of European extraction, who occupy and prosper on stolen lands. These same systems created a pattern of white generational poverty in many farming and mining communities that were designed to benefit the white elite. We have a white settler problem in the Rocky Mountain West. We also have an environmental crisis that was designed and has been maintained by white settler industries for the last two hundred fifty years. When I say "we," I mean white settlers.

The climate emergency is accelerating at a much higher speed than white settlers' awareness about racial injustice and white settlers' empathy. A knotted social and environmental disaster is fueled by present day white settler ethics and colonialism. The genocide of Indigenous people and the white settler industries that rapidly transformed the land continue to be an intact system that "we" continue to perform and reproduce. Today, economic inequality persists to produce unequal vulnerabilities to environmental injustices.

The myth of the Western region of the United States is a place of endless sublime landscapes. In *Race and Nature from Transcendentalism to the Harlem Renaissance*, Paul Outka notes that "'wilderness' functions in almost definitionally ideological terms. It marks a dehistoricized space in which the erasure of the histories of human habitation, ecological alteration, and native genocide that preceded its 'wild' valorization is, literally, naturalized."[5] That is the myth that has been held in place by two hundred fifty years of white environmentalism, two hundred fifty years of climate change denialism, a nationalistic optimism that ensures excessive growth, and, currently, green capitalism.

The Western region does indeed feature sublime geographic sites, but the land has been ravaged by extraction. Extreme alteration of the landscape through extraction was built into the very legislation that governed the westward expansion. Over fifty percent of the Intermountain West is owned by the federal government, which leases land to large mining companies for energy exploration. Rapid agricultural growth, clear-cutting forests, and mining transformed the region, creating critical environmental disasters. In 2020, almost all the mineral and fossil-fuel extraction that takes place in the United States is produced west of the 100th meridian—in the arid West. The fossil fuel industries that include fracking and mining for oil, natural gas, and coal remain highly incentivized and liberally regulated. As fossil fuels become scarcer and demand grows, a huge percentage of land is being transformed by new mining operations.

The fracking industry that uses hydraulic fracturing to extract oil and gas from the earth has boomed and keeps rising in North Dakota's Bakken shale. Fracking annually consumes trillions of gallons of fresh water in this arid region susceptible to drought, spills have contaminated the soil and

groundwater, and gas is continually flared or vented and being released directly into the atmosphere. Men from all over the world have streamed into this region to cash in on high-paying fracking and pipeline jobs. The encroachment of the Dakota Access Pipeline on the Standing Rock reservation in this area and other Indigenous communities has caused enormous social and environmental threats, including the rape, disappearance, and murder of Indigenous women and girls, especially in the vicinity of the Bakken oil fields and the Dakota Access Pipeline. Moreover, the pipeline has leaked crude oil that affects water supplies, emits high percentages of greenhouse gasses in the region, has disturbed sacred sites, and has brought significant new crime to the area.

The white, capitalist, settler, colonial ethic that was established in the Western United States during the eighteen and nineteenth centuries continues to be responsible for present-day crimes against Indigenous people and their land. The social, educational, medical, legal, and economic privilege for which white settler colonists laid the groundwork continues to be enacted and reenacted in the twenty-first century. Current white settlers need to acknowledge, interrogate, and reform their identities in order to take action toward restitution. White sellers have caused and continue to cause great suffering to Indigenous communities in the western United States. Like all whiteness, the category is perfectly masked, and in the Intermountain West, white settler identity is further complicated by extremes of white wealth and white poverty.

The colonial legacy persists into the present in the form of socioeconomic inequality, racism, discrimination, and political marginalization of Indigenous communities. Indigenous nations are still losing their land base and facing infringement from resource extraction and mining companies, property developers, and the pressures of urbanization. The arid West accounts for the increasing droughts, floods, and fires that have devasted vast areas of US land, but the activity that altered the landscape most profoundly was mining.

In the twenty-first century, this region remains dominated by predominantly white institutions. Yet, white settlers live in communities that are separate from Indigenous communities. White settlers are insulated from the racial, economic, and environmental struggles of Indigenous people. White settlers are also cut off from the deep environmental knowledge of Indigenous people.

Indigenous and new immigrant communities are the most vulnerable to the impacts of white colonial environmental wreckage of stolen land that was formerly sustained and flourished for thousands of years by Indigenous stewardship. We, the white settlers, must dismantle the white power structures in our core institutions. We must unlearn a white-centered worldview that has caused generational mental and physical trauma to Indigenous people. We must own the environmental crisis caused by white colonial industries built on stolen land and work toward restoration. We must abdicate our political offices and positions of power to Indigenous peoples and recognize their leadership. We must relinquish the economic privilege that our white skin, white educations, and white legal protections have afforded us. We must acknowledge that these privileges have existed at the expense and great suffering of Indigenous people. We must learn from Indigenous people what reparations are required and do the work of legislation and policy change. The reparations are big and deep and can never come close to undoing the damage done and the damage that persists. They include:

- Restore land and water rights
- Enforce criminal justice and reduce incarceration of Indigenous people
- Return place names of geographic sites to their Indigenous names
- Change school curricula to accurately depict the Western region's genocidal legacy
- Recognize intergenerational trauma impact on mental and physical health
- Organize efforts to locate missing girls and women and prosecute perpetrators
- Repatriate remains and cultural artifacts and ensure conservation of those objects
- Recognize and eliminate bias in state and federal law enforcement

We are the heirs to whatever is right or wrong. We did not erect the uneven pillars or joists, but they are ours to deal with now. ∎

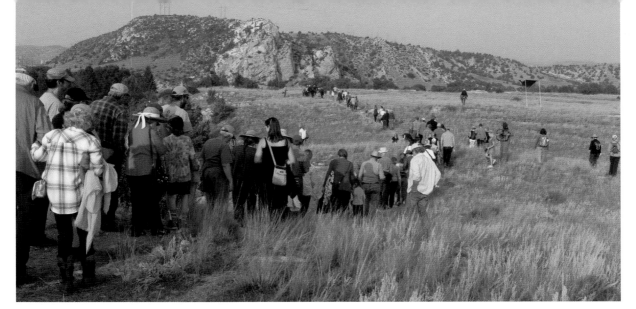

Photo: Jane Chin Davidson

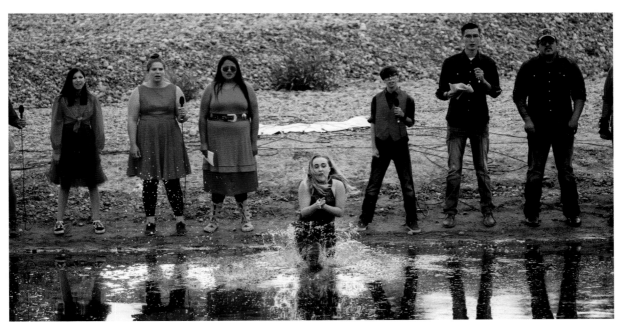

Photo: Ben Lloyd

Viewers are led to the bank across from the location where the rivers mix, for the second set. The brass band, the Fox Family Fiddlers, and the choir perform together. The combination of scores and styles arranged by musical director Ruby Fulton integrates music, the visual arts, and dance. The success of the performance mixing comes partly from the sound of water running cohesively through every scene.

The movement of three dancers—Melissa Dawn, Michael O'Reilly, and Elly Stormer-Vadseth— are reflected in the water, reinforcing the idea that humanity is not separate from nature and embracing life lived in harmony with the natural world. The second act ends in an uplifting crescendo as all the musicians play together, while the dancers dive into the water as a baptismal disruption to the river.

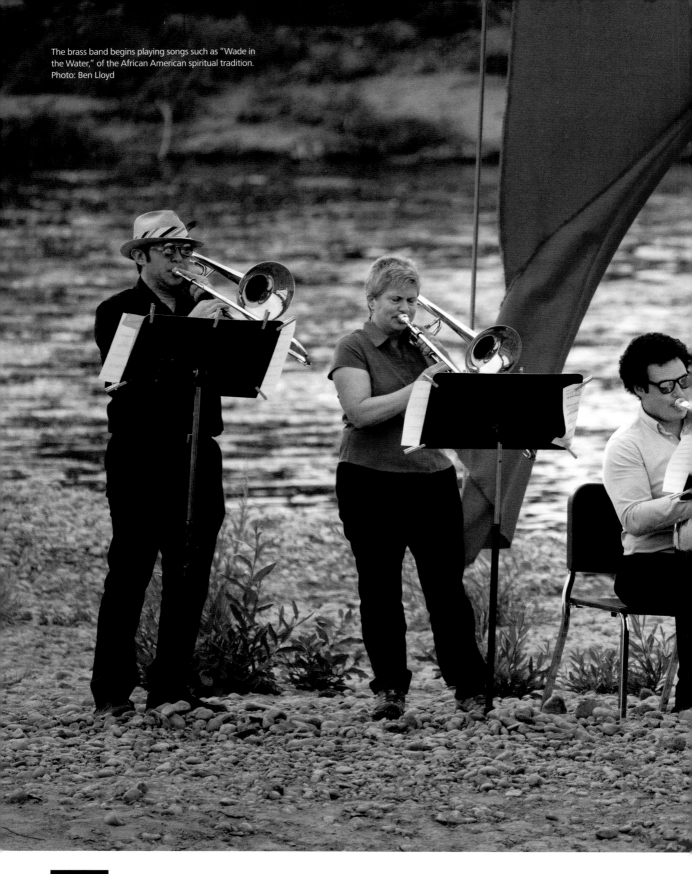

The brass band begins playing songs such as "Wade in the Water," of the African American spiritual tradition.
Photo: Ben Lloyd

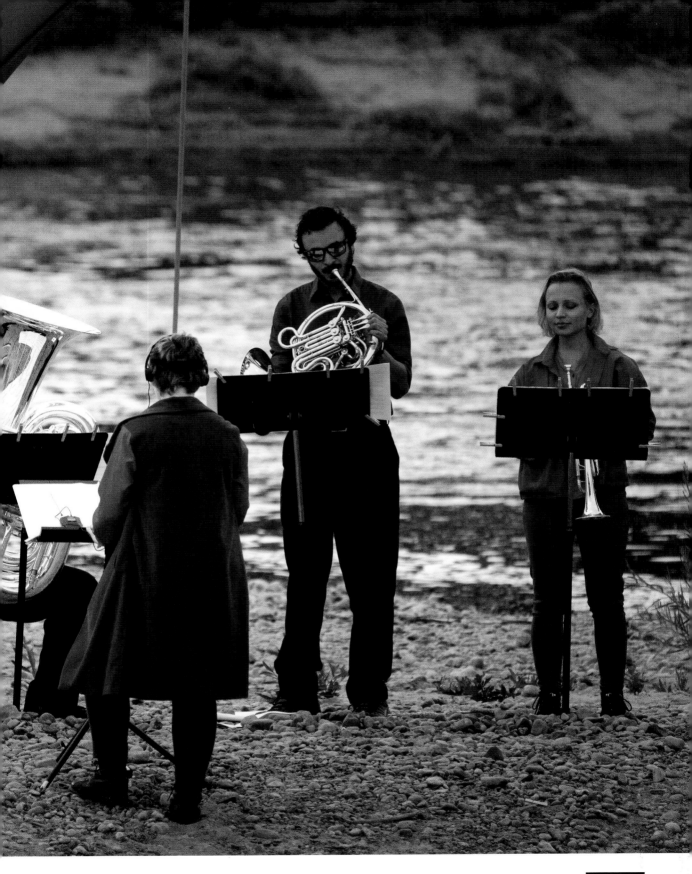

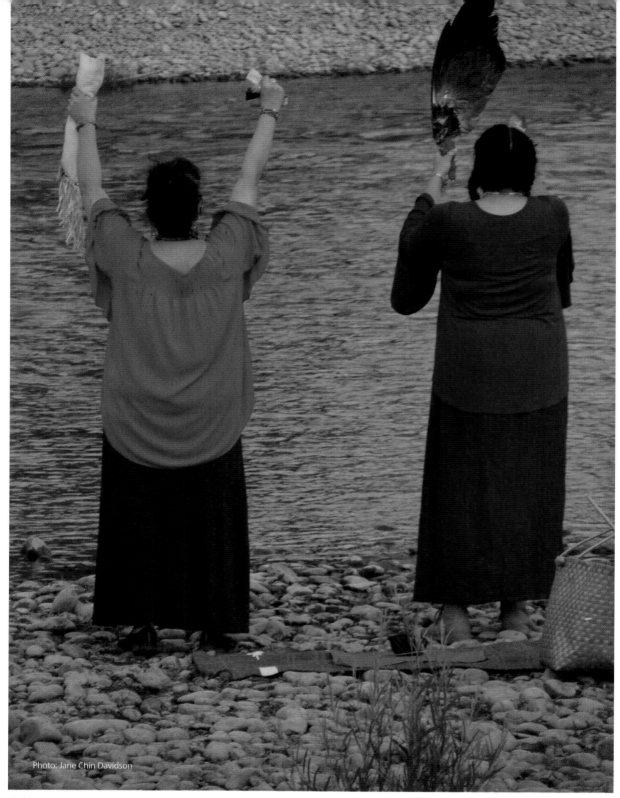

Photo: Jane Chin Davidson

Blackfoot representatives Grace King and Jaya King dedicate a prayer at the river to the four sacred directions of the earth and to the creator, offering berries to the water and sacred tobacco to the land.

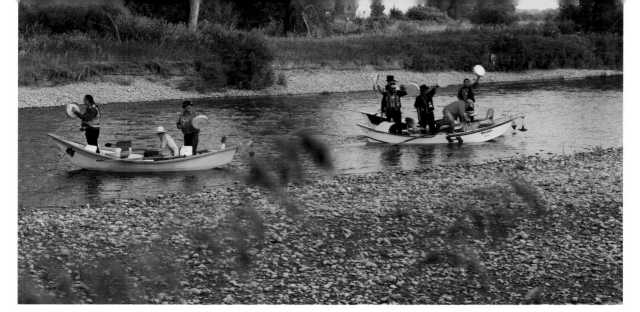

Photo: Mary Ellen Strom

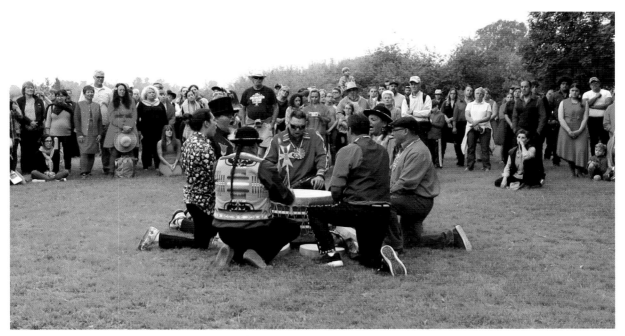

Photo: Jane Chin Davidson

The final act brings the audience to the star of the show, the Cherry River. The powerful ending, like the start of the performance, is marked by the assertion of women in seminal roles.

Viewers are guided to the other side of the Headwaters Park to face the river. Once there, they hear the Northern Cree Singers drumming and singing as they come up the river on four drift boats. After disembarking, the singers perform their Cree "Cuttin' Song." By the time Chontay Mitchell Standing Rock completes his Chippewa Cree solo, the audience members (a mix of people but mostly the Bozeman area community) are dancing.

Mary Ellen Strom is an artist, curator, educator, and writer whose work focuses on social and environmental justice. Shane Doyle is a member of the Crow Tribe and an Indigenous scholar and musician.

Notes

1 Editors' Note: We include this assemblage of images, poetry, and first-person narratives by Mary Ellen Strom and Shane Doyle in this collection of articles as an example of the kind of practice we feel is directly in dialogue with the legacy of Okwui Enwezor's decolonial actions. The rise of interest in the rights of Indigenous people in North America aligns with many of Enwezor's groundbreaking initiatives around the world. In particular, the exhibitions that are examined by the contributors of this special issue of *Nka* acknowledge Enwezor's innovative use of curatorial strategies such as confronting postapartheid culture head-on with the 1997 Johannesburg Biennale; connecting the postcolonial conditions of diverse geographies through the various platforms of 2002 Documenta11; recognizing surrealist artists of color as a review of the "superiority of French culture" in the 2012 *Intense Proximité*, La Triennale, Paris; and addressing the refugee crisis at the 2015 Venice Biennale. Enwezor called the platforms devised for Documenta11 as "interlocking constellations of discursive domains, circuits of artistic and knowledge production, and research modules," which he implemented to confront the "complex predicaments of contemporary art in a time of profound historical change and global transformation." [Enwezor, "The Black Box," in *Documenta11_Platform 5* (exhibition catalogue) (Ostfildern-Ruit, Germany: Hatje Cantz, 2002), 42]. The use of "constellations" as a methodology is especially effective, and while Enwezor was not an explicit source of inspiration or invoked for the Cherry River project, the futures of Enwezor are palpable in this anticolonial project restoring the past to reimagine the present.—Jane Chin Davidson and Alpesh Kantilal Patel

2 As Jefferson's Secretary of the Treasury, Albert Gallatin (1761–1849) devised the financial plan for the Louisiana Purchase, then skillfully resolved the constitutional conflicts that complicated the business deal with France. In 1803, the Louisiana Purchase was by far the largest territorial gain in US history. However, France only controlled a small fraction of this 828,000 square-mile area, with most of the land inhabited by Indigenous people. What the United States bought was the "preemptive" right to obtain Indian lands by treaty or by conquest, to the exclusion of other colonial powers.

The Louisiana Purchase extended the United States across the Mississippi River, nearly doubling the size of the country. This land acquisition was negotiated between France and the United States, without consulting the numerous Indigenous tribes who lived on the land and who had not ceded the land to these colonial powers. The ten decades that followed the Louisiana Purchase was an era of court decisions removing tribes from their lands and violent genocide.

To help solidify the land acquisition of the Louisiana Purchase, Jefferson proposed the so-called Corps of Discovery, or the Lewis and Clark expedition. Gallatin supported Jefferson's project, viewing the westward trip in financial terms. He knew that land in the territory Lewis and Clark were "exploring" could eventually be sold. However, most of the region needed to be described, categorized, and mapped. These actions would articulate the resources for extraction and agriculture in the region and, therefore, raise the land's monetary value.

When reviewing Lewis and Clark's charge to find a Northwest Passage to the Pacific Ocean, Gallatin feared negative public opinion if the expedition failed. He wanted positive publicity, no matter what happened; therefore, he lobbied to reframe the trip as an expedition for scientific discovery. Lewis and Clark became "scientists" in search of species and unknown geological locations in the western region. They compulsively categorized and named animal and plant species and geological sites, including the Gallatin River. Lewis and Clark named the three rivers that form the Headwaters of the Missouri after Gallatin, Jefferson (standing President), and Madison (Secretary of State).

3 Cherry River is only one of Mountain Time Arts's (MTA) projects that have raised deep-seated questions about the European invasion that caused a cultural and ecological crisis in the Rocky Mountain West. With the understanding that collaboration is the way to generate new knowledges of this region's critical cultural and environmental issues, the community examines the role humans play on planet Earth and the ways in which we produce, reproduce, and consume our material environment. MTA's projects look at the capitalist imperative to own and control nature and recognize local problems, including draught, fire, floods, ice jams, and extreme weather, as the earth talking back. Fundamental questions focus on ideas and actions for renovating and changing human perspectives and, most important, regenerating the Earth. At this historic moment, diverse knowledges are required to work toward solutions. Creating Cherry River provided an interplay between diverse cultures and disciplines. This is both a nuts-and-bolts pursuit to move toward yet undiscovered conservation practices and a way to dialogue about our different behaviors toward the land and each other.

4 The Métis are an aboriginal people of Native-Celtic-French descent. Fiddle music is an intrinsic part of the lifestyle.

5 Paul Outka, "Introduction: The Sublime and the Traumatic," *Race and Nature: From Transcendentalism to the Harlem Renaissance* (New York: Palgrave Macmillan, 2008), 2.

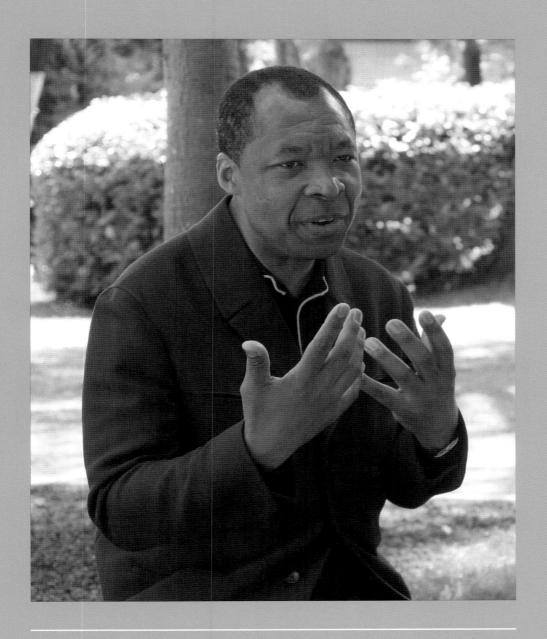

OKWUI ENWEZOR

(1963–2019)

TRIBUTES

Julie Mehretu

Julie Mehretu and Okwui Enwezor at the artist's temporary studio in Harlem, 2017. *HOWL eon (I, II)*, 2017, is in the background.
Photo: Julie Mehretu

A dear friend, intellectual revolutionary, and unparalleled force, whose vision, advocacy, and pivotal work created space for the radical imaginary. Okwui last visited my studio in Harlem in 2017, and, as ever, he conjured my material, process, and visual movements and spun the abstract into a profound concretization of everything at hand. He spoke to me with great passion and detail of the paintings as an interrogation and metabolization of violence and the colonial sublime. His passing is a profound loss to the infrastructure and possibilities of contemporary thought and aesthetics.

Julie Mehretu is an Ethiopian American artist.

DOI 10.1215/10757163-8971580 © 2021 by Nka Publications

Julie Mehretu, *Black Monolith, for Okwui Enwezor (Charlottesville)*, 2017–20. Photo: Tom Powel Imaging, New York

David Adjaye and Okwui Enwezor, 2015, Haus der Kunst lecture and seminar on architecture, Munich, Germany. Photo: © Marion Vogel

All the World's Futures

Sir David Adjaye OBE

In a series of essays published by Jacques Derrida called *The Politics of Friendship*, he spoke of the intimacy of friendship, which lies in recognizing oneself in the eyes of another and how we continue to know our friend, even when they are no longer present to look back at us.[1]

My friend, Okwui Enwezor, is no longer present, and yet he lived a life that forged so far into the future that we are forced to move in the direction of which he was looking. Okwui's legacy reverberated throughout the Earth—he was a force who continuously challenged the status quo through work fueled by his intention to create a better world for humanity as he saw it. There was a sense of urgency to his being, the type of urgency embodied in a person on a mission, whether it was addressing the colonial histories and inheritances of the global art world; questioning that very term *global*; surfacing the voices of the invisible within the African, Asian, or Indigenous context; interrogating the hegemony of

the art world as well as its most entrenched power relations; or forging ways to create new knowledge systems, it was always clear to me that Okwui's radicality was as signature as his neck ties.

In 2015, Okwui became the curator and first African director for the 56th Venice Biennale, which was the coming together of years of conversations, thoughts, and experiments into an interrogation of the exhibition space. It was one of the first moments in our friendship where we worked together on an exhibition called *All the World's Future*—an appointment that allowed him to interrupt and decentralize the historical trajectory of art through voices outside of the West. This moment placed Okwui on the map of being recognized as one of the world's most influential curators of the past quarter-century, a title I see as wholly Okwui's. It was a groundbreaking moment, one that was humorously seen by certain critics as Venice being overrun by a league of Black artists, and yet, Okwui held a vision of creating a

Journal of Contemporary African Art · 48 · May 2021
DOI 10.1215/10757163-8971356 © 2021 by Nka Publications

The tiered exterior detail of the facade of the Smithsonian National Museum of African American History and Culture, inspired by a Yoruban sculpture within the museum's collection, a seven-foot-tall depiction of a crowned figure carved by the late African artist Olowe of Ise. Photo: © Alan Karchmer

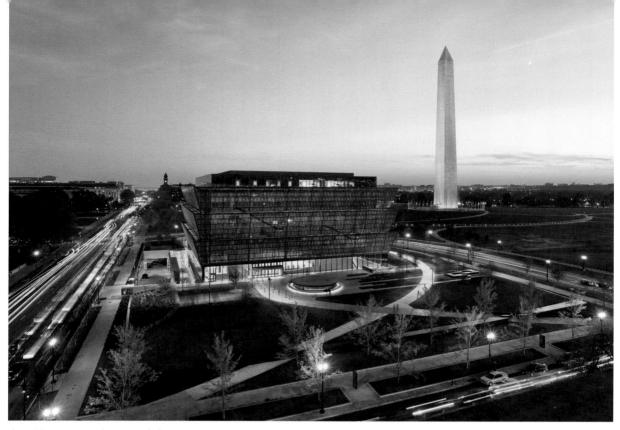

The Smithsonian National Museum of African American History and Culture, Washington, DC. © Alan Karchmer

space, a zone of criticality, in which art could reflect the unseens and the unheards of the world in which it was created—a place where art could act in a chamber of sound, releasing with it the voices that the world typically views as noise.

These were the voices that came to form an infrastructure driven by social conditions and repressed contexts. These were the voices beneath the surface that constitute our current reality through centuries of oppression, extraction, and historically violent interventions such as colonialism. These were the voices that offered perspective, a critique, or a shaking to the current topographical mapping of the global world, bringing with it the question of interrogating art's obsession with content, the object, and the efficacy of reckoning with context. The alignment Okwui and I shared in this thinking is one that informs my architectural practice, which asks: What are the conditions under which architectural meaning is or can be produced? What does it mean to move away from the building as an object, the building as merely form, into a realm in which form itself can be considered as an activation force

informed by its own history and surroundings? How can architecture, then, facilitate new perspectives in the same way that the exhibition expands worldviews, both becoming a social force of empowerment activated upon the public's encounter.

For Okwui, the possibility of reckoning with a context was the radical unmaking and destructive-constructive power of art to hold an unremitting potential, informed by history, that implores the viewer to reconsider one's own vision of reality—an invitation into our own personal authority, where the power of art as discourse could activate the public into *something else*. We've had many conversations on the public, the citizen, and the civic responsibility of the architect or the curator in shifting meanings of modalities. What Okwui called the "architectural ethic"—a means of enabling a multiplicity of voices and subjectivities to enter both time and space where the museum, for example, does not just become a space for the audience or a palace to fill with things but a civic site in which the idea of civilization allows us to forge a collective identity of being human on this planet. The construction of

spaces that allows for the expansion of worldviews are the lenses through which we push against marginalization to understand our creative potential as a species. The museum and exhibition space hold the possibility of collecting seemingly singular or disparate knowledges from various parts of the world that create new understandings of a connected, collective experience—how the *collective,* then, can become a *collection* of stories, histories, and cultural objects that inform and inspire the experience of a human identity.

In the last few conversations Okwui and I had together we spoke about the emergence of new institutions, how new institutions can perform as civic spaces, and how he saw this come together in the work of the Smithsonian National Museum of African American History and Culture (NMAAHC). We spoke of how the NMAAHC performs in service to the story behind its making—a four-hundred-year-old story of slavery to the two-hundred-year-old history of Washington—synonymous in the way that the American identity cannot be told without the African American story. The service of architecture in this sense became an understanding of how America, as a nation in its truest form, is a kind of hybridity—the movement of an African narrative immersed within a Southern American narrative that joins to create something different and expressive through the birthing of a new cultural emergence of the twentieth century. Expressions through art, music, literature, the booming of the Harlem Renaissance, the beginnings of the Black radical tradition, of spirit and struggle informed design in the same way that they inform time. The question of form became a dialogue about mutations and migrations to evolve with and contain different meanings throughout both time and space—how the contextual site, for example, could inform the structure by negotiating the tensions of the Washington Mall as a series of forms from the Washington Monument to the Statue of Lincoln, leading all the way up to Congress—each of which holds specific histories, violent or cohesive, that inform a larger story. The responsibility was to determine how such a form could converse with its past, *all of its past,* as well as with its future within a complex, layered site. We listened to the story of slavery as a movement and extraction from one side of the Earth to the other,

and how this new situatedness was not simply about the labor of picking cotton—an agrarian summary that is widely believed. It is also about an ancestral, transatlantic movement, the building of an economic system and literal construction of the "infrastructure of place" we know as America. The notion of bridge building, woodwork, and metal workings that physically connect the world, informed by the tools of an ancestral African past, are featured in the design as a reference to the ways in which the past creates the present. Through the activation of the viewer and architecture, citizen and institution, past and present, a future unfolds at that meeting space, a future predicated on the encounter with form and its flexibility with narrative.

Okwui once said that "an exhibition is something that happens within the world—and carries with it the noise, pollution, dust, and decay that comes from that world."[2] The architectural efficacy of this statement is that the happening is a type of construction, a construction that is messy in the way that a construction site bares the bones of dust and decay, architectural parts and materials, everything that is used to create it within the process. If we take for a moment both the construct and its scaffolding, we are able to read a dynamic—a dynamic that sees *form* supported by *surrounding,* a dynamic that re-engineers a center toward relationality, a dynamic that sees dust and decay as something generative, and a dynamic that sees institutions in a different light, where a space of learning becomes a space that is also learning. As I look back at my friend, I can see that he was looking in this direction, a visionary operating at an in-between, where the fragments of this world's past was also all the world's future.

***Sir David Adjaye OBE** is a Ghanaian British architect and founder of Adjaye Associates, which operates globally with offices in Accra, London, and New York, and has received renown for projects that include the National Museum of African American History and Culture in Washington, DC.*

Notes

1 Jacques Derrida, *The Politics of Friendship*, trans. George Collins (New York: Verso, 1997).
2 Okwui Enwezor, "Biennale Arte 2015 Creative Time Summit | Introduction: Okwui Enwezor," YouTube video, 5:03-5:15, September 2, 2015, www.youtube.com/watch?v=cC3BFzMBVdw.

For Okwui
A Gentle Smile from the Beyond

Octavio Zaya

1 —Some time ago, I wrote that life is struggle
between *perhaps* and *never more*,
that its paradise was made to be lost,
and that time is the ravishing agent.
As Blanchot, I always assumed that *contradiction*
and *leaving* were fundamental rights.
But I believe now that I should correct myself:
your departure has torn the only roots I had.
And with that, the absolute unresolved in words
cannot stand against death.

For you, *perhaps* and *never more* are the anxiety
and doom of the agnostic, and *contradiction* and *leaving*
are not rights, but the inevitable conditions of being.
So I'm not going to ask the world to stop all clocks.
I will not give the dog a juicy bone to prevent her from barking.
I'm not going to stop the music or muffle the drums.*
You are already buried, and I come again to conspire with you.

2 —If you go now, you also stay, because you are a part of us.
You said that so many times, so many times we read it:
We are also what we lost.
I only know that if I was once with you, you will remain
with me, until I'm gone. Nothing is the same though.
We will make up new words for the new story,
and it's a must we find them before too late.

3 —You did what you thought was your destiny:
You gave away your love, and left in silence,
without the time to understand who you really are.

—Cambridge, MA, 2020

* After W. H. Auden's *Funeral Blues*

Octavio Zaya *is an art critic and curator living in New York City who served as cocurator of Documenta11 with Okwui Enwezor, Carlos Basualdo, Ute Meta Bauer, Susanne Ghez, Sarat Maharaj, and Mark Nash.*

Journal of Contemporary African Art · 48 · May 2021
DOI 10.1215/10757163-8971426

Chris Ofili

Chris Ofili, *Cha Cha Cha (Triptych)*, 2004. Gouache, ink, charcoal, and gold leaf on paper. Three panels, each 198.5 x 130 cm. © Chris Ofili. Courtesy the artist, Victoria Miro, and David Zwirner

I recall Okwui's deep connection to the works from the *Within Reach* series, first exhibited in the British Pavilion at the 2003 Venice Biennale, designed in collaboration with architect David Adjaye. Okwui wrote extensively on these works in my 2009 monograph:

> The concept of totality, the fusion of painting and architecture, narrative and form, the secular and sacred, image and vision, myth and history, make *Within Reach* one of the most complete artistic projects ever undertaken in the history of the Venice Biennale.[1]

More recently, artist Isaac Julien curated a section of the 2020 *Summer Exhibition* at the Royal Academy of Arts, London, which paid homage to Okwui, and invited me to show a work: *Cha Cha Cha*, a triptych relating to the *Within Reach* series.

Chris Ofili was born in the United Kingdom and is based in Trinidad, West Indies.

Note

1 Okwui Enwezor, "Shattering the Mirror of Tradition: Chris Ofili's Triumph of Painting at the 50th Venice Biennale," in *Chris Ofili* (New York : Rizzoli, 2009), 156.

DOI 10.1215/10757163-8971440 © 2021 by Nka Publications

Curating at the Royal Academy *Summer Exhibition 2020*

Isaac Julien

My core artistic premise and point of departure to curate the first two galleries of the Royal Academy of Arts, London, *Summer Exhibition 2020* was to pay homage to my friend, the late, great curator, writer, and poet, Okwui Enwezor, whom both Mark Nash and I were fortunate enough to work with on nearly all of Okwui's exhibitions and projects, from Documenta11 (2002) to the 56th Venice Biennale (2015). Instead of a thesis or concept, I wanted to bring together artists for whom the interlocution with Okwui was decisive in various ways, to present distinct poetics from different generations and backgrounds, and to see what reflections would emerge from that.

Installation view of *Summer Exhibition 2020* (October 6, 2020–January 3, 2021) at the Royal Academy of Arts, London, showing **Isaac Julien**, *Lessons of the Hour, London 1983—Who Killed Colin Roach*, 2019. Photographic assemblage of 32 black-and-white Ilford FB Classic silver gelatin prints (each 45 x 64 cm.). Artwork: Courtesy the artist, Victoria Miro, London/Venice, and Metro Pictures, New York. Photo: © Royal Academy of Arts/David Parry

Journal of Contemporary African Art · 48 · May 2021
DOI 10.1215/10757163-8971454 © 2021 by Nka Publications

Needless to say, the global scenario was dramatically different when I was first invited to collaborate in this edition of the *Summer Exhibition*. Not that the social and political convulsion wasn't there; it has been piling up for decades and centuries. But, as if Trump and Brexit weren't enough to deal with, we seemed to have entered a watershed moment to debate racial inequality while reeling from a major global health crisis at the same time. The show was postponed, new dynamics had to be invented to work together; therefore, the *Summer Exhibition*, from my point of view, had to combine its traditional role of showcasing the present of art with the historic imperative to reflect critically.

Quite organically, I realized there were interesting connections with some of the themes addressed in the group show *Rock My Soul*, which I curated for Victoria Miro Gallery, London, in 2019, inspired by ideas by bell hooks and Okwui, among other authors. Put broadly, this selection of works questioned the cultural establishment in various ways, with a few of the poetics seen there specifically voicing Black self-esteem within contemporary art.

With the prominence (painstakingly) obtained by Black Lives Matter, the *Summer Exhibition* gained a kind of resonance that it probably wouldn't have had a year ago. Even as I look at my own work, such as the photography collage suite *Lessons of the Hour,*

Installation view of *Summer Exhibition 2020* (October 6, 2020–January 3, 2021) at the Royal Academy of Arts, London, showing **Yinka Shonibare**, *Air Kid (Girl)*. Fiberglass mannequin, Dutch wax printed cotton textile, globe, brass, steel baseplate, umbrella. Back right: **Oscar Murillo**, *Manifestation*, 2019. Oil, oil stick, cotton thread, and graphite on velvet, canvas, and linen. Back left: **Denzil Forrester**, *Echo Them*, 2020. Oil on canvas. Photo: © Royal Academy of Arts/ David Parry

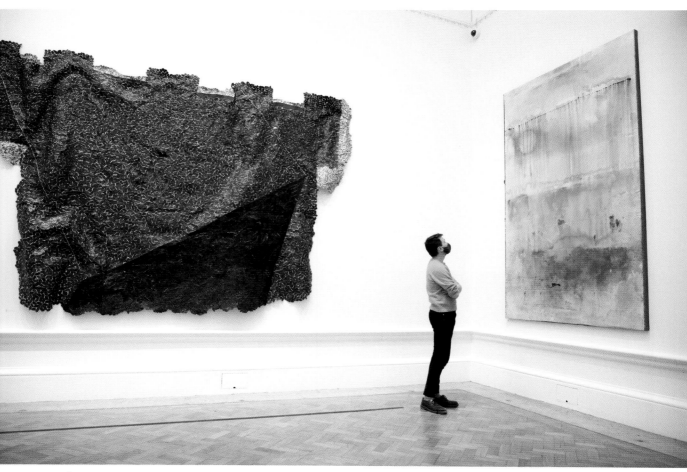

Installation view of the *Summer Exhibition 2020* (October 6, 2020–January 3, 2021) at the Royal Academy of Arts, London. Left: **El Anatsui**, *Castle in the Cloud*, 2020. Aluminum copper wire, 33.9 x 22.6 cm. Right: **Frank Bowling**, *Watermelon Bright*, 2020. Acrylic on canvas, 185.4 x 297.2 cm. Photo: © Royal Academy of Arts/David Parry

London 1983—Who Killed Colin Roach? (2019), I revisit history and our contemporary reality in new ways. That very piece, of course, is one that received a lot of attention from the outlets covering the show such as the *Guardian*, the *Art Newspaper*, and the *Evening Standard*, which clearly reaffirms how urgent it is to ask ourselves why have we have improved so little between the deaths of Colin Roach in 1983 in London and those of George Floyd, Breonna Taylor, Eric Garner, Tamir Rice, and so many others in 2020.

Further—and more timely—related reflections will certainly emerge from the exhibition *Grief and Grievance: Art and Mourning in America*, originally conceived by Okwui Enwezor for the New Museum in New York and on view from February 17–June 6, 2021, in which Black grief is addressed as the national emergency it is.

Each of the artists participating in the exhibition at the Royal Academy—El Anatsui, Frank Bowling, Sonia Boyce, Njideka Akunyili Crosby, Peter Doig, Denzil Forrester, Theaster Gates, Glenn Ligon,

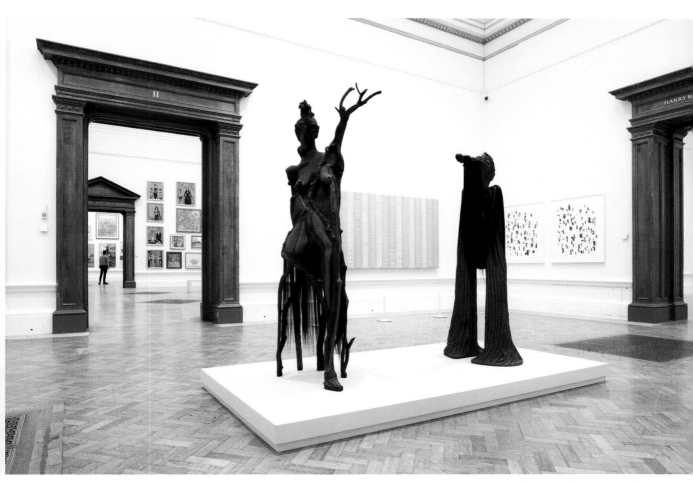

Installation view of *Summer Exhibition 2020* (October 6, 2020–January 3, 2021) at the Royal Academy of Arts, London. Center left: **Wangechi Mutu**, *Sentinel IV*, 2020. Paper pulp, wood glue, soil, emulsion paint, charcoal, ink, coconut, hair, and wood, 216.2 x 59.1 x 59.1 cm. Photo: © Royal Academy of Arts/David Parry

Zanele Muholi, Oscar Murillo, Wangechi Mutu, Chris Ofili, Frida Orupabo, and Yinka Shonibare—has given their unique and incredibly important contribution to contemporary art and the meditations on our demanding times. I'm profoundly grateful to their generosity and to all the many hardworking teams involved in this exhibition, especially under trying circumstances, with a great deal of remote work involved. I am especially indebted to the Royal Academy Head of Summer Exhibitions and Contemporary Curator Edith Devaney, to the

Victoria Miro Gallery and its Director of Exhibitions Erin Manns, and to Louise Neri, whose efforts were invaluable in helping me to make this memorial exhibition celebrating Okwui's curatorial legacy.

In memory of Okwui Enwezor (1963–2019).

Isaac Julien is an artist and filmmaker and currently a distinguished professor of the arts at the University of California, Santa Cruz.

Voice and Visibility

Wangechi Mutu

It was Audre Lorde who said, "My silences had not protected me. Your silence will not protect you."[1]

Okwui Enwezor was not a silent man. When he spoke, his voice was unmistakable because we could hear that he was speaking on behalf of African thought and African people. He spoke because he understood there was no other way to claim and hold the territory for those who love poetry, for those who love art, and for those who are proud of the long, vast and complex, potent Mother history of the great original African continent, whose sound has brought humanity to where it is today.

I always felt like Okwui was speaking as a guide and a leader who understood so clearly how truths had been twisted in the Eurocentric-dominated schools of thought and in our countries that had been left mangled and mad with the poison of plunder.

Okwui was the kind of person who could have succeeded in many fields; he was a natural leader. Everything we admired about him, all that I remember, was the embodiment of a proud and purpose-filled voice that was constantly blazing trails and reinforcing and revealing truths about African art, our shared histories, the power of our negritude, and the poetry and potency of human intellect that has been carried along through the sound of African knowledge production.

When I heard Okwui speak, he spoke upward; he enunciated, he pronounced our existence and represented our persistence as committed creators, thinkers, and predecessors who have been at the core of the evolution of humanity and the foundation of human intellect. His voice had urgency, his voice had clarity and depth, his voice wasn't one of excuses or fear or hesitation. He understood that to be silent is to disappear and to be inaudible is to be endangered. Okwui was a direct, deliberate, and courageous thinker, who created an arena that is now full of so many other raucous and roaring voices. This space is swollen with soulful strength, but for just a moment, only a moment, it feels a little quieter.

Wangechi Mutu, *Outstretched*, 2019. Paper pulp, wood glue, soil, charcoal, pigment, and feathers, 35 7/8 x 63 3/4 x 29 1/2 in. Courtesy the artist and Gladstone Gallery, New York and Brussels

DOI 10.1215/10757163-8971482 © 2021 by Nka Publications

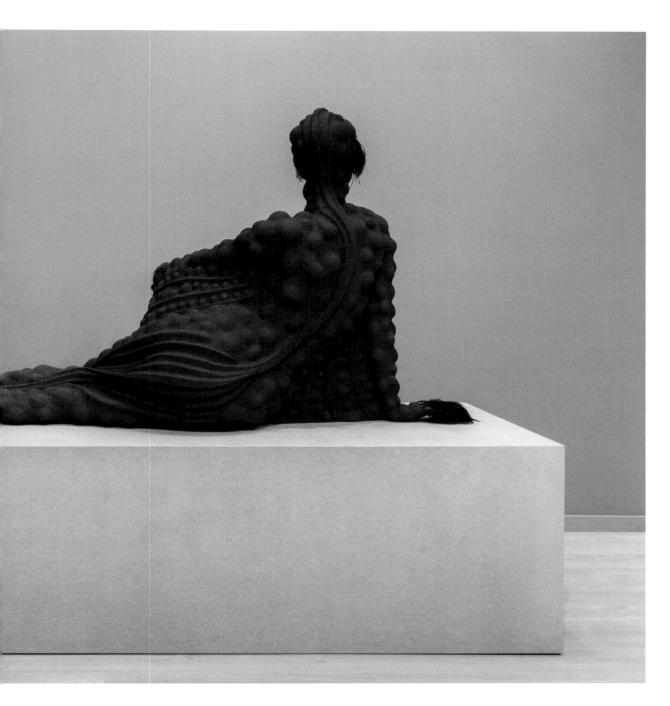

Wangechi Mutu is a Kenyan-American artist known for her work in sculpture, collage-painting, video, installation, and performance.

Note

1 Audre Lord, "The Transformation of Silence into Language and Action," in *Sister Outsider* (Berkeley, CA: Crossing Press, 1984), 41.

Dandies in Solidarity

Yinka Shonibare CBE

Yinka Shonibare CBE, *Diary of a Victorian Dandy: 11.00 hours*, 1998. Included in the exhibition *Mirror's Edge*, Bildmuseet, Umeå, Sweden, 1999–2000. Five C-type prints, dimensions 122 x 183 cm. unframed. Courtesy the artist and Stephen Friedman Gallery, London

Diary of a Victorian Dandy: 14.00 hours, 1998. Included in the exhibition *Mirror's Edge*, Bildmuseet, Umeå, Sweden, 1999–2000. Five C-type prints, dimensions 122 x 183 cm. unframed. Courtesy the artist and Stephen Friedman Gallery, London

I write this with a heavy heart precisely because of the gravity of this loss, not only professionally but personally. Some may remember what it was like to be an artist of African origin in the early eighties and early nineties. I saw around me a constant struggle for visibility among Black artists and curators, particularly in Britain through the efforts of Eddie Chambers, Rasheed Araeen, and many others at the time. I, along with many Black artists of my generation, were determined to inscribe ourselves into the mainstream visual arts discourse. My Nigerian upbringing had created a refusal in me to accept the colonial fallacy of Western thinking in relation to African artists. Then, something remarkable happened. In 1995, I attended a lecture at the School of Oriental and African Studies, London, and it was there I first met Okwui Enwezor.

Okwui was a dandy. He loved clothes; he was an aesthete. I, too, loved clothes—that is, the political aspect of dandyism, the aspect that challenges expectations, that aspect which says, "Say it loud, I'm Black and I'm proud," in the words of James Brown. Okwui, to put it in colloquial terms, had *swagger*. Then, behind that swagger was a deep thinker, and he was also from Nigeria, like me. I knew then, at that very first meeting, that this guy was special. I gravitated toward confident, Black men, and Okwui had *confidence*. I immediately loved his style and defiance. I subsequently learned about *Nka* journal, his writing, and the monumental and ferocious pace of his curatorial projects. His energy and transformative powers were evident even then; his significant contribution to the discourse on postcolonial art practice remains unparalleled today.

Journal of Contemporary African Art · 48 · May 2021
DOI 10.1215/10757163-8971468 © 2021 by Nka Publications

Diary of a Victorian Dandy: 17.00 hours, 1998. Included in the exhibition *Mirror's Edge*, Bildmuseet, Umeå, Sweden, 1999–2000. Five C-type prints, dimensions 122 x 183 cm. unframed. Courtesy the artist and Stephen Friedman Gallery, London

Diary of a Victorian Dandy: 19.00 hours, 1998. Included in the exhibition *Mirror's Edge*, Bildmuseet, Umeå, Sweden, 1999–2000. Five C-type prints, dimensions 122 x 183 cm. unframed. Courtesy the artist and Stephen Friedman Gallery, London

I had many conversations and many arguments with Okwui. He loved an argument, but they were always rigorous and never unfounded. As an artist, I admit to a contrary instinct, which he sometimes found frustrating. I often felt that as an artist I had to keep a sceptical distance from the theories of which he was most enamoured. Our most productive time was in the early period of both our careers. We worked on shows like *Trade Routes: History and Geography*, Second Johannesburg Biennale, South Africa, 1997; *Mirror's Edge*, Bildmuseet, Umeå, Sweden, 1999–2000; *The Short Century: Independence and Liberation Movements in Africa, 1945–1994*, Museum of Modern Art, New York, 2002; and then, of course, Documenta11, Kassel, Germany, 2002, a project that completely transformed the trajectory of my career.

In the current context of Black Lives Matter and the collective awareness and momentum driven by the zeitgeist, I think Okwui would be very proud of his contributions to social justice in the context of culture. In the words of Martin Luther King, "the arc of the universe is long, but it bends toward social justice." May I, as a visual artist, express my thoughts visually through some of the works of mine included in Okwui's curatorial projects over a number of years.

Yinka Shonibare CBE is a British-Nigerian artist based in London.

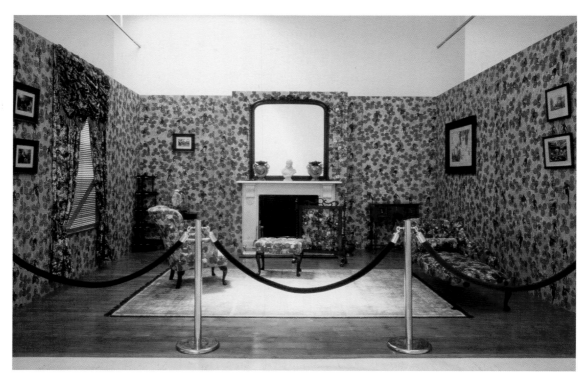

The Victorian Philanthropist's Parlour, 1996–97. Included in the Second Johannesburg Biennale, *Trade Routes: History and Geography*, South Africa 1997. Dutch wax printed cotton textiles, reproduction furniture, fire screen, carpet, props. Overall dimensions 259.1 x 487.7 x 530 cm. Courtesy the artist; Stephen Friedman Gallery, London; and James Cohan Gallery, New York. Photo: Jenni Carter, courtesy Museum of Contemporary Art Australia

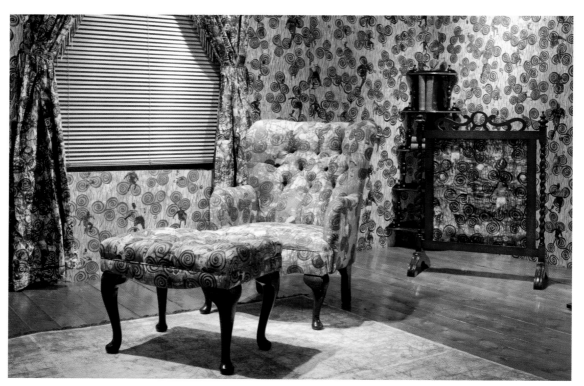

Detail, *The Victorian Philanthropist's Parlour*, 1996–97.

Gallantry and Criminal Conversation, 2002. Included in Documenta11, Kassel, Germany, 2002. Eleven life-size fiberglass mannequins, Dutch wax printed cotton textile, metal and wood cases, leather, wood, steel. Overall dimensions 200 x 260 x 470 cm. Courtesy the artist; Stephen Friedman Gallery, London; and James Cohan Gallery, New York

Detail, *Gallantry and Criminal Conversation*, 2002.

Notes in Reverie of Okwui Enwezor

Maria Magdalena Campos-Pons

Intended to be, as my father would have it, loving, brief, and clear

In my eyes, he was a rare, unparalleled, thinker on matters of cultural visuality during the transition from the twentieth to the twenty-first century.

The lasting vitality of his work, his impact, was not only in the clarity of his vision, which sharpened our perceptions, but also in the way he dismantled so many old models of curation and exhibitions to make room for new ones.

Okwui gave to my generation of marginalized Black and Brown people, from all creeds and orientations, a place in the venerable tomes of written art history and in the current immediacy of contemporary art. Thanks to him, a vanguard position was conquered with matchless authority. His thunderous and poetic pronouncements and the triumphal originality of his point of view identified horizons that the art world had ignored. That thunder and novelty shattered and shifted now outdated relations between African art and contemporality.

The gift of Okwui's attention to my work came as a blessing during my early quest for artistic interceptions from Africa the continent, Africa the sentiment, and Africa the heritage, a heritage heavy with burdens and also with ancestral pride. Okwui's inquiries guided me toward the concepts and the expansive meaning of *diaspora* that sustained the productive tension between debt and desire.

Cuba and the Havana Biennial model were the ideal platform for Enwezor. What the biennial proposed as aspirational and then managed to build gave him a concrete site for realizing his own dreams. Finally, he could see a place where the rich visual production of the Global South displayed all its flair, a site where the vitality and revelatory power of the arts created beyond dominant Western narratives emerged gloriously visible.

DOI 10.1215/10757163-8971370 © 2021 by Nka Publications

Invited to exhibit in the 1997 Johannesburg Biennial under Okwui's leadership, I benefited from the generous appreciation of Dr. Kellie Jones and from the company of artists who have staying power in twenty-first-century arts. Enwezor honored my work by using a piece as promotional material for the biennial press.

It is still hard for me think of Okwui Enwezor and not to imagine him in the company of Salah Hassan. They came together for me in a letter I received sometime in the mid-1990s, a request to use a piece I had just exhibited for the cover of *Nka*; a different piece made the cover a few years later. That invitation introduced me to a phenomenal group of young African artists and thinkers—Enwezor, Hassan, Olu Oguibe—all of whom became important interlocutors for me in conversations that have framed much of my work over the last three decades. Chika Okeke-Agulu and Odili Donald Odita were part of that group, too.

I still remember a long night of discussion in San Francisco, after the opening of the Museum of the African Diaspora in 2005, when Okwui and Salah debated about how to bring more attention to important figures of African art, whose important contributions were completely ignored in the West. Then there was the sharing of food in the house of a Senegalese painter during Dak'Art 2004. During the meal, Okwui convinced me to try the baobab tree fruit juice that was being passed around in a shared vessel. Delicious. I danced with him during that opening, and—oh, Lord—was he a good dancer!

In Venice 2001, while the African Pavilion launched with the exhibition *Authentic/Ex-centric*, we hung out with student assistants who were overwhelmed by Okwui's easy manner and his camara-derie. It was there on opening day that he invited me to Documenta11 in 2002. When I finally exhibited in Documenta14 in 2017, his memory and his inspiration were ever-present. Adam Szymczyk, the artistic director of Documenta14, still speaks of Okwui with profound gratitude and admiration.

By the time I managed to invite Okwui as guest speaker for the School of the Museum of Fine Arts Beckwitt Lecture at Tufts University, Boston, in 2007, as a gift of the university to the city of Boston, what struck me was his reaction when he arrived at GASP Gallery, the exhibition space in Brookline I had founded years before. He looked around and turned to ask me, "Magda who paid for this"? I answered just as directly: "My son's tuition." He smiled and hugged me and said. "You are a crazy sister!"

Okwui brought my work to the Second Seville Biennial in 2007. With Lisa Freiman, he authored the most exhaustive catalogue of my work to date. The text he wrote circa 2006 framed my practice in a historical and conceptual tableau of fundamental ideas about art in the twenty-first century, featuring the agency, narratives, and methodologies of diaspora artists. He redrew art's map into new geographies of the contemporary art world, and with it he bet on a future that continues to expand and to justify this generative vision. To his trust, his friendship, and the scope of his brilliance, I am forever indebted.

Love, gratitude, solidarity
Magda

Maria Magdalena Campos-Pons *is a professor of fine arts and the Cornelius Vanderbilt Endowned Chair of Fine Arts in the Department of Art, Vanderbilt University, Nashville, Tennessee.*

Adding Poetry to Politics

Kendell Geers, *Self-Portrait*, 1995. Courtesy and © Kendell Geers

Kendell Geers

Africa95 opened on October 4, 1995, at the Royal Academy of Arts in London, seven months and a few days after the First Johannesburg Biennale. The air was filled with great expectations as artists, curators, poets, musicians, art historians, academics, and philosophers gathered in the ancient colonial capital to experience the most ambitious festival of African arts and culture ever presented in Europe. I was lucky to have been invited by Linda Givon and Goodman Gallery to participate in two group exhibitions, one at Delfina Studios and the other at Bernard Jacobson Gallery on Cork Street. I received word that a young Nigerian artist had requested a meeting and was all the more curious because the artist, Olu Oguibe, had a reputation for being a troublemaker and rabble rouser. I suspected that his reputation might simply have been the consequence

Journal of Contemporary African Art · 48 · May 2021
DOI 10.1215/10757163-8971384 © 2021 by Nka Publications

of his sharp tongue and militant criticism of colonial politics, because I had carried too long my own curse of notoriety, unfairly dubbed the "bad boy" and "enfant terrible" of the South African art world. The many warnings against meeting Olu, probably by the same people who had told him to steer clear of me, made the forbidden fruit glisten all the more vividly with temptation.

I was not accustomed to the sharp, crisp London air and felt the cold cut its way through the skin of my shaved head. I wore a thick woolen beanie that made my South African scalp sweat and itch. The atmosphere of the East London café where we met was claustrophobic with overcrowded perspiration that had misted up all the windows, but it was not difficult to figure out who Olu was, because there was only one Black person in the room. I ripped the army surplus parka from my shoulders and stretched the beanie from my head with morbid pleasure as I slid into the chair in front of Olu. Next to him, an antiquated radiator was hissing, humming, and creaking very loudly. I was immediately taken off guard by a belly burst of mischievous laughter, as he found amusement in the incongruous comedy of my punk reputation being shattered by the desperate and comic attempt to accustom myself to the London cold. Olu called Okwui later that evening to say, "When Kendell took off his beanie, I did not see any horns," and that was all Okwui needed to hear from his most trusted friend to inspire his own curiosity.

Olu was presenting work on the *Seven Stories about Modern Art in Africa* at Whitechapel Gallery, so we met in the neighborhood. Already feeling entirely ill-suited and gauche, I made a joke right away about the fact that I had a cousin in East London. At first, he did not understand the humorous pun, so I explained that the East London I was talking about was not far from King William's Town in South Africa, 14,000 kilometers away.

I was, at the time, developing my theory of *terrorealism* and the ways harsh sociopolitical realities would influence aesthetics. I tried to convince Olu that the political values and social structures of colonialism were the very same as the aesthetics and principles of modernism, and both functioned according to proximity. The colonial strategy had been to copy/paste "Europe" as the standard by which so-called civilization was judged. The closer the copy to its European "original," the greater its civil respect and economic import, and I wanted to challenge that with an Afrocentric accent and argot. The best example was my recent *Self Portrait* sculpture, composed of nothing more, nor less, than a broken Heineken beer bottleneck, clinging on to its label, "IMPORTED from Holland—The Original Quality."

We spoke about art and politics and our common struggle to find respect as African artists. We shared an interest in conceptual art, but both of us insisted that the European system felt inadequate. We shared our thoughts and ideas about language and culture, about exile and protest, about how contemporary African art deserved a voice that was more than just another colonial fear dressed up with fancy. The conversation was as passionate as it was idealistic, two dreamers who believed that another world was possible in which African art could effectively challenge Eurocentric prejudice rather than merely embody patronizing fantasy. Olu insisted right away that I had to meet Okwui as soon as possible and gave me his fax number, and that was the beginning of our long friendship.

Okwui was living in New York, a poet with a passion for young militants trying to change the world with African art. Three years earlier, Documenta 9 director Jan Hoet had entirely dismissed African art. In *Jan Hoet: On the Way to Documenta IX*, he compares the art of the African continent with the art of children:

> How do you react to a kid's drawing? By saying how good it is, or beautiful, or maybe by saying that it could use a bit more colour, that we had better not hang it on the wall, all this from within your own information and experience, and from within your love for that child. But actually saying that the drawing is bad? We don't really know, because the child's world has no critical apparatus. Something similar happened to me in Africa. In my opinion, Africa is in a state of major transition. But that does not make the dialogue any easier, especially because there is no critical apparatus. Everything is still closely linked to ethnic-cultural backgrounds there, its people not striving for that universal capacity I need for Documenta. As a continent, it can still command a variety of things: sentimental, anthropological, sociological interest, etcetera. Fascinating, witty, crisp, narrative, moralizing, but I cannot handle that in Documenta.[1]

Hoet's conclusion about the art of a continent larger than the United States, Europe, and China together is the unapologetic question, "Do you appreciate now why I have come back empty-handed from Africa today?"[2] Stuart Morgan was one of few art critics at the time who called out the omission in his *Frieze* review of Documenta IX: "Enemies would call Hoet a formalist. They might also think him Euro-centric. After a month in Africa, he found nothing he thought worth including. In his own words, he met artists who operate in complete isolation."[3]

Hoet's Documenta successor, Catherine David, was not much more sympathetic and would declare that "it has become fashionable in the art world to invite artists from Africa and Asia. That is for the most part an alibi-gesture, in the best case conformism, and just simply colonialism. I won't be taken in by such exoticism."[4] The June–August 1997 edition of *Kunstforum* elaborated on the prejudice of her position, saying that "in her eyes, the fine arts in Africa and Asia do not necessarily play the most interesting role. She wants to avoid a showing of—according to Western standards—'mediocre' art just to fulfill a quota or satisfy a wish for folklore."[5]

Okwui's *Frieze* review of *Africa95* summed up the prejudice and struggle of the era in what might just be the most important text he ever wrote, because it laid the foundation and blueprint for his vision about a globalized art world. Curiously, no mention is made of his authorship in the *Frieze* online archive (suggesting that this early text might still be cause for some discontent). He expressed our collective frustrations:

> For many of us now, Africa is a memory, not a place. Each attempt at self-recognition is inexorably marred by the lack of freedom of self-narration, a state that Olu Oguibe has referred to as "the legislative code of speech". . . . It is within such a choiceless terrain, where the silenced narratives of those who have borne severely the sentence of history have suffered constant revisions, that the exhibitions and conferences making up the mega festival of African arts called africa95 opened in London. . . . While the obvious demand is for an involved and rigorous critical discourse, Westerners instead adopt a strategy of isolation that loses contemporary African culture in the peripheral discourses of power, eventually regarding it as inconsequential.[6]

At its most malignant, Okwui called out the collector Jean Pigozzi, whose collection was on show at the Serpentine in London and whose philosophy was that African artists should never study art in order to protect their "natural" talents. Pigozzi had amassed the largest collection of African art without ever having visited the continent and used the works "in an accelerated campaign through alliance with major institutions, publishers and write-ups in important publications to legitimise and valorise many questionable artists in his collection, pushing them to the world as the only 'authentic' artists from Africa."[7] Okwui objected "that work from one millionaire's collection represents the last word in what's interesting from Africa. To put it mildly, their decision to promote work which in the main encompasses one person's taste, is ill advised, inappropriate and offensive."[8]

The fax machines whined and screamed between Johannesburg and New York as Okwui and I shared ideas, contesting every proposition with another challenge. We eventually met in person for the first time on September 20, 1996, in Graz, Austria, for the opening of the exhibition *Inklusion/ Exklusion*.[9] I had invited Okwui to write a catalogue essay about my work and, with that as an excuse, convinced Peter Weibel to invite him to the opening.[10] Right away he asked if I agreed with Theodor Adorno that "to write poetry after Auschwitz is barbaric" and whether the same might be said about "poetry after apartheid"?[11] Okwui was a poet, so of course we did not agree, but his words fell upon my ears like manna from heaven, as he added poetry to my politics, and a decades-long conversation began.

Not long after that, Christopher Till and Bongi Dhlomo-Mautloa asked me to nominate someone for the position of director of the Second Johannesburg Biennale, and I argued the case for Okwui Enwezor on the basis of his as yet unpublished review of *Africa95*. Convincing the poet and critic who had until then never curated a single exhibition proved much more demanding, but he embraced my promise that he would not be alone, and that history would be on his side.

It was the tail end of the South African Rainbow Nation honeymoon period, and the Truth and Reconciliation Commission was in full swing, so Okwui leapt at the opportunity to move to

Johannesburg to witness firsthand the revolving doors of history being written. In his catalogue introduction, the winds of change were already blowing through his words:

> Today it is evident that the world is quickly changing. The question then is whether this unprecedented flurry of activities and events called globalisation—some of which disguise, mask, even obliterate the contentious nature with which certain epistemological concepts have been received within particular paradigms of the local—leads not to transformation but to displacement.[12]

The Second Johannesburg Biennale opened on October 10, 1997, and *Documenta11* opened on June 8, 2002. Since then, so much has changed, as the fax machine gave way to dial-up Internet, followed by email, then mobile phones, social media, and finally the scourge of fake news. With the archive, history, and global present now instantly available on every smart phone, the temptation exists to take the gratifying present for granted. So much has changed in the twenty-five years that have passed since *Africa95* launched at the Royal Academy that memory might smudge the opening ceremony of half-naked Zulu dancers dressed up in trophy skins of colonial fantasy. For a generation of Black Lives Matter and #MeToo protestors, the risk of the forever instant scrolling feed is that the brutal realities of the historical struggle get lost in the clouds of political amnesia.

Okwui was both gentle and passionate, equally militant and yet still diplomatic, an outspoken curator obsessed with setting the records straight, and so, out of respect, I have dwelled on the historical context from which he rose. The voice with which he enabled African artists, curators, poets, musicians, art historians, academics, and philosophers to stand tall as global equals was fought for against great odds, because that right to speak, either politically, culturally, historically, or economically, had been systematically structured to empower the brokers in London, Paris, Berlin, Lisbon, or Brussels. The best way to understand the enormous shift that has taken place might be to conclude with Okwui's own words written in 1995: "Dislocated to the West, like many African artists, writers, and intellectuals, and far from the fitful upheavals that tarnish the daily reality of Africans in the continent, I, too, feel perpetually suspended between reveries of unfulfilled desires made more vivid by the frustrations of Africa's misrepresentation in the western metropolis."[13]

Kendell Geers is a South African conceptual artist living and working in Brussels, Belgium.

Notes

1 Jan Hoet, *Jan Hoet: On the Way to Documenta IX*, ed. Alexander Farenholtz and Markus Hartman (Ostfildern, Germany: Time International, 1991), 48–49.
2 Hoet, *On the Way to Documenta IX*, 49.
3 "Documenta IX, Body Language," *Frieze* 6, September 4, 1992, frieze.com/article/documenta-ix-body-language. Stuart Morgan authored the review but is not identified online.
4 Catherine David, interview with Roberta Fleck and Axel Hecht, ART 4 (1997), 41.
5 Catherine David, quoted in Amine Haase, "Nich Namen, sondern Werke zählen" ("Not Names, but Works Count") *Kunstforum* 137 (1997): 435. English translation at "Documenta 10, 1997," Universes in Universe, universes.art/en/documenta/1997/statements-comments (accessed November 17, 2020).
6 "Occupied Territories," *Frieze* 26, September 1, 1996, frieze.com/article/occupied-territories. Enwezor is identified as the author in the print version in *Frieze* 26 (1996): 36–41, but is not credited online.
7 Enwezor, "Occupied Territories."
8 Enwezor, "Occupied Territories."
9 *Inclusion/Exclusion: Attempting a New Cartography of Art in the Age of Postcolonialism and Global Migration*, curated by Peter Weibel and Slavoj Žižek, 1996, Graz, Austria.
10 Enwezor, "Altered States: Die Kunst des Kendell Geers," in Peter Weibel, *Inklusion : Exklusion: Probleme des Postkolonialismus und der globalen Migration* (*Inclusion: Exclusion: Problems of Postcolonialism and Global Migration*) (Köln: Dumont, 1996), 203–05.
11 Theodor W. Adorno, "Cultural Criticism and Society," in *Prisms*, trans. Samuel Weber and Shierry Weber (1949; repr. Cambridge, MA: MIT Press, 1955), 34.
12 Enwezor, "Introduction: Travel Notes: Living, Working, and Travelling in a Restless World," *Trades Routes: History and Geography* (exhibition catalogue for the Second Johannesburg Biennale), ed. Matthew DeBord (The Hague: Greater Johannesburg Metropolitan Council and Prince Claus Fund, 1997), 8.
13 Enwezor, "Occupied Territories."

Okwui's Curating World

Abdellah Karroum

When I am asked what is the most important thing in life, I answer "luck," and the second most important is hard work. I was lucky to meet Okwui, and the hard work we did defined who I am today. Okwui's ability to perceive the world and to translate ideas into exhibitions and publications is simply unmatched in the world of art. His sense of alignment and solidarity with others is foundational for the success of his collaborations with artists, curators, and audiences.

Among the many places, experiences, and stories I can tell about Okwui, I want to mention five:

One: The first time I listened to his reading at a global art center was in 1996, when he gave a talk at the CAPC Museum of Contemporary Art of Bordeaux. Okwui showed works from Off centers by artists such as Yang Fudong of China and the Raqs Medial Collective of India. I was just starting to think about my research for a PhD at the University of Bordeaux, where Okwui had been invited by Michel Bourel and Jean-Louis Froment to give a lecture. Some ten years later, in 2005, I received a phone call in Rabat, Morocco: "Hi, Abdellah. This is Okwui. How are you. I am on L'appartement 22 balcony; the space is great"[1] Okwui was one of the first art professionals to look at my curatorial work in Morocco. The following year, I was cocurating the Dak'Art Biennale, one of the key experiences in my curatorial life. I loved hearing Wolof and realized how much the Amazigh culture that I am from is rooted beyond the vast Sahara.

Two: For the Gwangju Biennale, South Korea, in 2008, Okwui invited me to curate one of the Position Papers exhibitions. It was a moment of great awareness of the shared space, where the notion of transnational in the curating world was evident. There was no limit or border between the exhibition as an editorial space and the works of art as the expression of the artists' visions. We all shared the same belief and responsibility in the relationship between arts, technologies, and ecologies, leading to effective collective intelligence in addressing a political message.

Three: In 2011, Okwui, Claire Staebler, Émilie Renard, Melanie Bouteloup, and I traveled from Paris to Zaghreb, Belgrade, and Tangiers in preparation for our cocuration of La Triennale, which opened one year later at Palais de Tokyo, Paris. One of the most important memories for me of this project was the camaraderie that formed among us. In Belgrade, I was refused entrance to Serbia because of the visa. Although Okwui and my colleagues were allowed to enter Serbia, Okwui decided to not travel there if his entire team could not cross the border. This decision afforded us the opportunity to walk across the city of Vukovar, Croatia—ruined during the Balkan Wars of 1912 and 1913—to find the Serbian Consulate.

When Okwui often spoke about the injustice of the visa system and how it affected African artists and curators, it was neither a complaint nor a nationalist criticism. This issue reflects historical injustice, and his position was a leitmotif in the necessary decolonial discourse. His analysis of systemic racism helped establish the co-presences of Off centers in the art world's representations.

Of course, we had a lot of unforgettable moments during the research expeditions: the Morocco Palace night club in Tangiers, with Atlas Amazigh dancing music, was the best treat to relax after intensive studio visits.

Four: Doha 2013. Okwui was the first speaker I invited to Mathaf: Arab Museum of Modern Art in Doha for a talk on the Off center models of partnerships and institutional development, a theme that always made sense in consolidating relationships with curators and the institutions they work with in the Global South.

Five: Munich 2018. Okwui was imagining his last exhibition, dedicated to the work of El Anatsui. The monumental show took place at Mathaf and was delivered by his cocurator, Chika Okeke-Agulu.

My last meeting with Okwui was more silent, but important, followed by the trip to Akwuzu, Nigeria in 2019 to accompany him to the land of his ancestors. A year before, Okwui expressed the desire to show me his country. While I wish it had happened during his lifetime, this journey was still very much in commune with his spirit.

The transformative, unfinished project of Okwui Enwezor will remain active for many more decades. He reinvented curating strategies as a force where art is always at the center.

Abdellah Karroum is the director of Mathaf: Arab Museum of Modern Art, Qatar, since 2013.

Note

1 L'appartement 22 is an artist- and curator-run collective founded by Abdellah Karroum in Rabat, Morocco, in 2002.

Journal of Contemporary African Art · 48 · May 2021
DOI 10.1215/10757163-8971552 © 2021 by Nka Publications

Mikhael Subotzky and Gideon Mendel

Mikhael Subotzky and **Gideon Mendel**, *Three Portraits for Okwui (composited)*, 2013/2020. Ink on paper, 42.4 x 33.9 cm. each.
Courtesy and © the artists

Gideon Mendel is a South African photographer who worked with Okwui on The Rise
and Fall of Apartheid: Photography and the Bureaucracy of Everyday Life *(Prestel, 2013).
South African photographer **Mikhael Subotzky**, based in Johannesburg, showed work in*
Snap Judgments: New Positions in Contemporary African Photography *(Steidl, 2006) and
completed an installation for* All the World's Futures, 56th Venice Biennale *(2015).*

DOI 10.1215/10757163-8971412 © 2021 by Nka Publications

A Letter to Okwui

Naomi Beckwith

October 2020

Dear Okwui,

Remember that time when you were told you weren't *truly* African?

I remember being so excited to have been invited to present at a conference where you'd also be presenting. Indeed, it was a primary reason why I'd accepted the invitation—just to see you speak.

The day of, you'd just given an inspired talk on Wangechi Mutu's montage aesthetic, and I had hip-hop on the brain. Then a man gets up during the Q&A—African American, senior in age, all decked out in a kente crown and daishiki—and stated that he was surprised that "as an African brother" you did not relay the "true African spirit" in Mutu's work.

I mean, the whole thing was laughable. I'd long known the type: he was my uncles, my neighbors, my pastors, and the cats who used to play chess in the park near my house. He was among the brothers and elders who truly cared for their community and truly cared for the acquisition of knowledge, because *knowledge and truth are the only paths toward liberation* but who also thought truth and knowledge ultimately flowed through them. You were gracious enough not to laugh. Your answer was a nice, long, pregnant pause, followed by you listing the several canonical European and American works that *were part of your African education*; then you moved on to the next speaker.

What could a Black American man teach you about "true" Africanity? Why do I suspect it wasn't the first time you'd faced such criticism? I know that we in the West had a hard time marrying the ideas of "Africa" and "contemporaneity," but that moment made it perfectly clear that even many educated Black folks in America held on to some utopian, prelapsarian idea of an African Motherland—a place where everyone was royalty and where indigenous spirituality bound the community together in egalitarian serenity. After all, we needed a homeland *to go back to*. We still need an escape hatch.

You didn't stay for the conference's celebration dinner that evening.

There you were, African and contemporary, choosing as your calling to champion the work of contemporary African artists. You even focused on photography, for God's sake. It's a medium that is synonymous with technological prowess. Not ritual objects, not masks, not amulets—not that there is anything problematic with those things. It's just that a whole lot of folks failed to look at the breadth of what African artists had been doing in the twentieth century. You had a cohort of bad-ass Africans working the academic, funding, and museum institutions with you: Chika, Salah, Bisi . . . especially Bisi, whose equally premature death, so close to your own, I will always think of as a twin tragedy.[1]

But you also knew that the man who challenged your "Africaness" was also your potential ally. And why not? He got to this land now called the Americas because of the genocidal triangle trade, and your homeland was equally violated by that trade and colonial incursions. There was a chasm between your lives—years of history, years of knowledge, years of unknowing, and an entire ocean between—but he didn't want one. Even if he invented an imaginary Africa, he definitely wanted to counter the real effects of all that trauma. In the end, that's what you both wanted. You wanted anticolonial work to thrive all over the globe, not just across the African continent or just in the States. You saw the

Journal of Contemporary African Art · 48 · May 2021
DOI 10.1215/10757163-8971510 © 2021 by Nka Publications

global reach—even the global necessity—of the project, even if colonialism violated us in differing ways. You got me to check myself: to realize the moments when I—a spiritual child of pan-Africanism—start drifting into romantic notions of Black and Brown coalitions. How can I train myself to think holistically about Black cultural production around the world and simultaneously hold on to important cultural and historical distinctions? How can I first decolonize my mind?

As I am sitting here writing this letter, I am wondering what you would make of the recent calls for social justice in the States right now. And, what would you make of the revival (yet again) of some well-worn terms—*reparations, reconstruction, reckoning*? It seems to me that, for many people, the images they are now confronting are shattering their precious image of the United States as the gleaming city on a hill. And they are freaking out like kids who have just discovered there is no Santa Claus. Others are digging in their heels: dog-whistling about "true patriotism" and defending the land. It's gotten nasty. But you expected it, didn't you? You were writing lectures about it, after all. You even planned an exhibition about it.

How on earth did you see it coming?

I know you know the States and built a great deal of your career here. But maybe you always kept an outsider's distant eye on the place in a way I couldn't possibly do. The way a fish doesn't see the water it's swimming in. I suppose the clue is in the way you could tie Trump's bloviated election campaigning to the death of the Confederacy. You could always see the *longue durée* of history and its effects. We love to forget historical events here in the States—it keeps us fresh—but we spend an equal amount of time ignoring the symptoms of our collective trauma.

One of my favorite words in the English language is *disremember*. Funny, I'm not even sure it's a real word, but I read it once in a Mark Twain novel when I was a kid and remembered it. It's a perfect word, better than *forget*. Forgetting

implies passivity, like something escaped your mind because you accidentally left a cranial cat flap open. For instance, I disremember who said that Black Americans have found themselves on the wrong side of the Atlantic, when I really should have held on to that important bit of information. But I remember the feeling I had when reading it, because it perfectly shaped my sense of displacement—stranger in a strange land, and all that—but it also made me worry that everything I would put into the world would be just as far away from anything correct.

How, I thought to myself, can I situate my work, first and foremost, as an extension of a Western education that I've been blessed to receive but also somehow mobilize that sense of displacement? How can I honor the social and political urgencies of artists who share my sense of displacement and work and call out the serious inadequacies of the Western canon that I've inherited? How do I do all this within the criteria that are recognized in that canon? How do I argue hard enough for an artwork so that it is remembered, even if we love to forget the lessons of history?

You said to me the last time I saw you, your mind as sharp as ever, *Stop worrying about criteria.*

Thank you. I'm going to remember that.

Yours with gratitude, love, and forever in the struggle,

Naomi

***Naomi Beckwith** was recently appointed deputy director and the Jennifer and David Stockman Chief Curator of the Solomon R. Guggenheim Museum, New York.*

Note

1 References are to *Nka* cofounders Chika Okeke-Agulu and Salah M. Hassan, and independent curator Olabisi (Bisi) Obafunke Silva (1962–2019).

The Spoken Word

Steve McQueen OBE, CBE

This poem, "To Elsie," by William Carlos Williams (1883–1963) was the last e-mail I received from Okwui in early 2019. At that point, he was reading a lot of poetry out loud. I imagine that he needed to conjure up the idea that one could create art, and sustain life, from the spoken word. Okwui had one of the most beautiful voices, and he put his passion into every single word, as if it would be his last.

To Elsie
William Carlos Williams

The pure products of America
go crazy—
mountain folk from Kentucky

or the ribbed north end of
Jersey
with its isolate lakes and

valleys, its deaf-mutes, thieves
old names
and promiscuity between

devil-may-care men who have taken
to railroading
out of sheer lust of adventure—

and young slatterns, bathed
in filth
from Monday to Saturday

to be tricked out that night
with gauds
from imaginations which have no

peasant traditions to give them
character
but flutter and flaunt

sheer rags—succumbing without
emotion
save numbed terror

under some hedge of choke-cherry
or viburnum—
which they cannot express—

Unless it be that marriage
perhaps
with a dash of Indian blood

will throw up a girl so desolate
so hemmed round
with disease or murder

that she'll be rescued by an
agent—
reared by the state and

sent out at fifteen to work in
some hard-pressed
house in the suburbs—

some doctor's family, some Elsie—
voluptuous water
expressing with broken

brain the truth about us—
her great
ungainly hips and flopping breasts

addressed to cheap
jewelry
and rich young men with fine eyes

as if the earth under our feet
were
an excrement of some sky

and we degraded prisoners
destined
to hunger until we eat filth

while the imagination strains
after deer
going by fields of goldenrod in

the stifling heat of September
Somehow
it seems to destroy us

It is only in isolate flecks that
something
is given off

No one
to witness
and adjust, no one to drive the car

William Carlos Williams, "To Elsie,"
from *The Collected Poems of William
Carlos Williams, Volume I, 1909–1939*.
© 1938, New Directions Publishing
Corp. Reprinted with the permission of
New Directions Publishing Corporation.

Steve McQueen OBE, CBE, *is an artist, film director,
and screenwriter based in London and Amsterdam.*

Ibrahim Mahama, collage of Nkrumah Voli (one of the many silos built in the early 1960s by Kwame Nkrumah, first prime minister and president of Ghana, toward the economic independence project, abandoned after his coup in 1966), with an image of a sputnik and kids learning how to fly drones. Courtesy the artist

Out of Bounds

A Reflection on Okwui Enwezor's Contribution to the Art World

Ibrahim Mahama

Can the failures of the twentieth century lead us toward new degrees of freedom? What does freedom and artistic responsibility have in common? Can the concept of the gift economy, combined with the resurrection of failed revolutions, lead to a shift in the experience of art within this century and beyond? These are some of the most important questions I was introduced to in art school at the Kwame Nkrumah University of Science and Technology (KNUST) in Kumasi, Ghana. Like many art schools around the world, KNUST placed a strong emphasis on figurative forms, but that changed in the early 2000s, when a new generation of teachers started introducing experimental courses into the program. Suddenly, it was possible for students to think about introducing forms outside the history of art making

Journal of Contemporary African Art · 48 · May 2021
DOI 10.1215/10757163-8971524 © 2021 by Nka Publications

Ernest Sackitey, artist and staff member at SCCA, Red Clay, Tamale, Ghana, teaching kids in the community how to fly drones, using the cockpit of an old airplane. Photo: Ibrahim Mahama

or reexamining production systems through their work as a practice. Students were encouraged to work on independent exhibitions, using the city of Kumasi as a container of ideas and infinite forms.

BlaxTARLINES KUMASI, a collective consisting of teachers, students, and other comrades, uses the concept of the gift economy not only as a starting point to make art, but also to produce artists. The art world is a reflection of the failures of the world economy; it only consumes but fails to address the mechanism that produces artists: the art academy. Okwui and I once had a conversation about pedagogy and its potentials while trying to settle on a form my work was to take in his exhibition *All the World's Futures*, at the 56th Venice Biennale, 2015. He had come to the realization that probably rethinking the model of the art school could remold the art world into the varied forms of objects produced within it.

The idea of the container is promising, but politically, and as an aesthetic gesture, it inspired my practice and many others within my generation.

We were starting art with the artist as producer in a time of crisis but also acknowledging "crisis as a producer." My first conversation with Okwui was in Venice, when he invited me to participate in the international exhibition at *All the World's Futures*. Like many international curators, he was familiar with my work within the institutional context, so when I proposed producing *Out of Bounds* as my contribution, he made sure all the necessary permissions were granted to realize the work.[1] After all, the main subject within the exhibition that year addressed capital and its contradictions through various forms. How does the art world confront capital or produce other ways of living?

When I wrote Okwui later in 2015 about starting my PhD at KNUST, he was particularly excited that I had made the decision to continue the inquiry into art beyond the market. The Savannah Centre for Contemporary Art in Tamale, Ghana, and the adjacent Red Clay Studio, had already begun construction in early 2014 and 2015, respectively.[2] I had

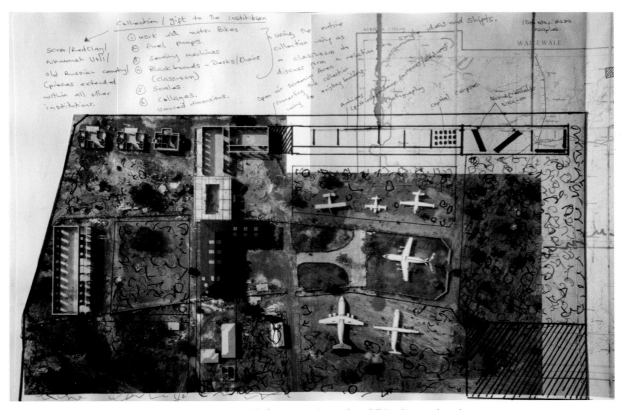

Ibrahim Mahama, drone image of Red Clay with notes on possible future expansions and possibilities. Courtesy the artist

made the choice to expand the forms within my practice to address the deficit in both the ideological and physical infrastructure in the region, using time and residues of history as a starting point to produce possible new futures. Can old spaces inspire us to build new forms, and can we use these new forms to go back in time to save those old spaces? In the post-independence era, particularly in the last four decades, infrastructural projects that were meant for pushing economic liberation programs on the continent have been abandoned. Can art promise new ways of reengaging these spaces?

Fundamentally, the point is to create spaces with conditions that inspire generations on multiple levels to think and act differently with their communities. Art can do more than just be an object to be moved around like any commodity. Saving archives from the post-independence era, collecting archives from the old railway workshops, collecting old airplanes and turning them into classrooms, building multiple library spaces, creating spaces for

the presentation and preservation of an artist's life work, creating cinema cultures across cities, acquiring old public spaces through private capital and turning them into public institutions for collective experience, building independent art schools, et cetera. Artistic responsibility can be the starting point to redefine art and its experiences, but maybe we can aim to produce better thinkers across fields for global transformations.

Ibrahim Mahama is an artist living and working in Tamale, Ghana.

Notes

1 Mahama's *Out of Bounds* (2014–15), a large-scale installation of sewn-together jute sacks and mixed media, was developed for the 2015 Venice Biennale and functioned as a corridor around the side of the Arsenale.

2 Mahama is the founder of the Savannah Centre for Contemporary Art and the nearby Red Clay Studio.

Conversations of a Lifetime

Penny Siopis

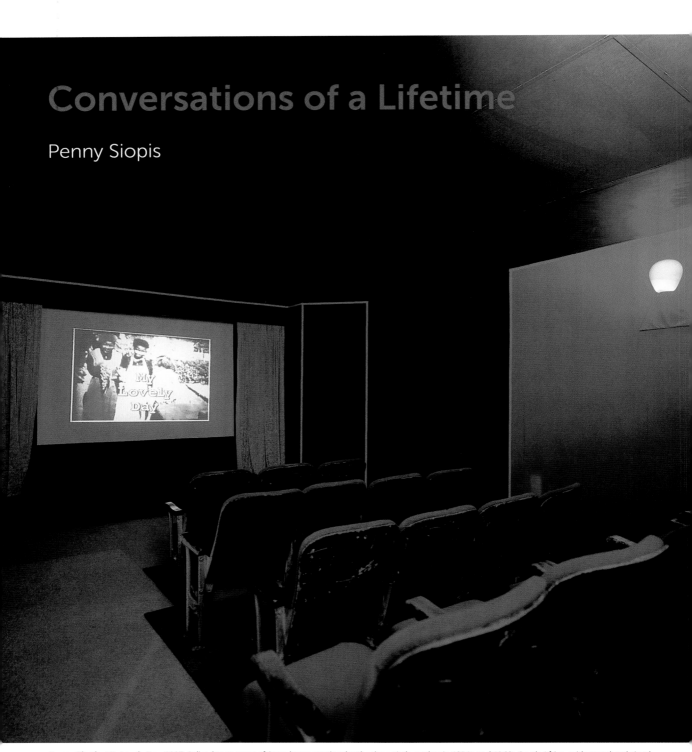

Penny Siopis, *My Lovely Day*, 1997. Spliced sequences of 8mm home movies shot by the artist's mother in 1950s and 1960s South Africa, with sound and visual text. Installation view at Second Johannesburg Biennale, *Trade Routes: History and Geography*, 1997. Courtesy and © Penny Siopis

 Journal of Contemporary African Art · 48 · May 2021
DOI 10.1215/10757163-8971538 © 2021 by Nka Publications

It was 1996, and Okwui had set up a temporary home in Johannesburg as the artistic director of the city's second biennale.

Two years had passed since the country's first democratic election. The Truth and Reconciliation Commission had begun. There could not have been a more extraordinary place to be than the "new" South Africa, now embraced by the continent and the world as never before.

On a visit to Cape Town, Okwui took a trip to Cape Point, later recalling:

> I was astonished by the experience of standing there, where the two oceans met. I knew at that very moment this would be my concept: the meeting of worlds. Like the deeply conflicted story of South Africa's historical origin, the exhibition was to be called *Trade Routes*. It was bubbling in my mind—I couldn't wait to get back to the hotel to write it down. I wanted to make an exhibition that took globalization as its point of departure, to argue that globalization actually started here, in South Africa.[1]

Back in Johannesburg, he wasted no time initiating conversations with the art community; he needed to know *everything*. He had been primed a little by reading the art criticism of my partner, Colin Richards, and called him up for a chat. Soon after, he invited Colin to be part of his curatorial team for the biennale.

Conversations with Okwui were always an event. Some events last a lifetime.

So it was for Colin, as it was for me. Around the same time, I was invited to be part of Okwui's exhibition *Alternating Currents,* which he curated with Octavio Zaya for the Second Johannesburg Biennale. We were all in this together.

If Colin were alive today he would be writing now, reflecting on Okwui's brilliance and how he changed the art world. He would be describing the nature of their conversations—intense and spirited, argumentative and agreeable. Inspired. Respectful. He would stress how these conversations continued long after the biennale, with Okwui inviting him to contribute to international conferences and publications and, so, join a like-minded circle across the globe: individuals who shared the commitment to challenge dominant narratives and the ways of the West. He would be recounting their shared ambition to make space for other voices and ways of making and being.

Colin would say that Okwui's extraordinary achievements were not bonded by his critical prowess alone or his aspirational ethos but by his capacity for friendship, his "African way," as some might say, or what Okwui articulated in philosophical terms as hospitality. He might mention Okwui's appreciation of his writing on "critical humanism," which Colin argued had a special life in Africa and was working to advance. Informed by Edward Said's reflections on humanism and democratic criticism, it connected African thinkers to the words of Steve Biko and those of local writers. A relooking at the philosophy of *ubuntu*—a person is a person through other people—the often maligned, clichéd, and readily corrupted notion considered central to the self-understanding of post-apartheid South Africa. An "age-old African term for humanness," as artist David Nthubu Koloane described it, *ubuntu* is an ethics "incorporating the values of caring, sharing and being in harmony with all creation."[2]

In December 2012, Colin died. Okwui wrote me a condolence letter, noting that Colin was "the rarest of intellectuals." He continued:

> We have all lost our brilliant intellectual shining star. Colin was not only important for South African letters, he was a true African scholar, engaged and committed. . . . Amongst the Igbos we will say that a mighty tree has fallen in the forest and the earth is shaking. Colin's recent writings on humanism have been particularly important to me. May Colin's memory never dim, may his legacy continue to burn bright.

His words could be ours about Okwui.

In January 2013, Stevenson was finalizing texts and images for the catalogue of their 2012 exhibition *Trade Routes Revisited* at the gallery's spaces in Cape Town and Johannesburg. Organized by Joost Bosland to mark fifteen years since the biennale, the publication presented myriad recollections by artists, art organizers, critics, and curators. Okwui's reflections opened the book, alongside a wonderful photo of him with Prince Charles, Christopher Till, and Johannesburg's then director of culture and mayor Isaac Mogase, standing beside the work of

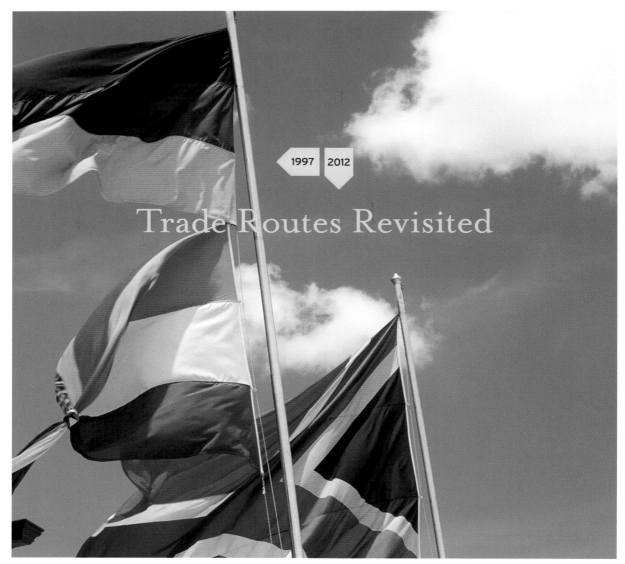

Cover of *Trade Routes Revisited 1997–2012* (Cape Town: Stevenson, 2012), featuring an installation view of **Hans Haacke**, *The Vindication of Dulcie September*, 1997. Photo: Werner Maschmann. Courtesy Stevenson, Cape Town and Johannesburg, South Africa

Chinese artist Wenda Gu, a huge curtain woven of hair collected from barber shops around the world.

But first, a dedication page: "In memory of Colin Richards," and a photo of Colin in front of an "installation" that graced our home in Melville, a bunch of marble angels from the local graveyard, which Okwui always commented on and joked about when he visited. This picture marked the end of the embodied conversation that so characterized the relationship between Colin and Okwui.

Okwui's reflections in the *Trade Routes Revisited* catalogue continue: "1997 was an incredible moment of hope, of excitement, and many of us didn't know what we were doing, but we had intuition and a sense of what the biennale needed to be. It needed to be about South Africa in the world, and Africa in the world—renouncing parochialism. The attempt to realise the event as a meeting of worlds meant we had to bring the best of the world."[3] Indeed. Here, at home, South Africans communed for the first time on this scale with other artists from Africa, the diaspora, and elsewhere. It was a special moment for me to reflect on my own diasporic identity as an African of Greek descent.

Later, in 2013, I met up with Okwui in Berne, Switzerland. We were both presenting at the Sommerakademie, at the Zentrum Paul Klee. He mentioned rereading a paper I had given in 1998 at a conference at the Bildmuseet in Sweden. We had shared a platform there, too, related to the show *Democracy's Images: Photography and Visual Art after Apartheid.* The film I made for Okwui's Johannesburg biennale, *My Lovely Day,* was included in the exhibition. Okwui said he missed the little cinema that I had constructed for its screening at the biennale, loosely modeled on my grandfather's Metro Theatre in 1930s Umtata in the Eastern Cape. He remembered how I had resisted the prospect of the customary black box to show the film, wanting something more embodied and historically specific, something akin to my earlier installation *Reconnaissance 1900–1997,* which Okwui had seen. It was composed of piles of found objects on a platform, gathered in front of a huge photograph of my grandfather's cinema, imagined now as a screen to project my new film. Some of the objects were 8mm reels, films my mother had taken of our family in the 1950s and 1960s, which became the material for the film. Okwui resisted the objects, that "debris of history," as he called them. I responded with curtains, chairs, lights, carpet, and screen, presented as a single inhabitable object in which to enjoy movies. He loved that.

Yet, more engagement followed. I had thought that, in the pile of film reels, there was also footage that my grandfather had taken in Greece in the 1920s in a politically charged moment. It might be troubling to see. "Open the canister," Okwui said. As it transpired, the footage was not there, and I used only my mother's films for *My Lovely Day.*

When I showed Okwui a draft of the work, he said, "It's incredible how you've used your grandfather's film"; he was referring to a burned-out scene of a street parade led by a boy sporting a flag. You couldn't really see what was going on. When I told him it was my mother's film, he was even more excited. He said something like: "You see, even when the archive is innocent, it also isn't." Okwui's ideas on the colonial archive at that time were contentious and enlightening, opening new critical ways to think about how imaginaries are formed through documents of everyday life.

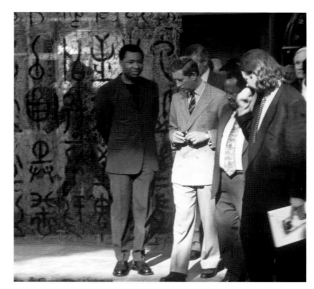

Okwui Enwezor (left) and Christopher Till (right) give Prince Charles a tour of the Electric Workshop at the Second Johannesburg Biennale, 1997. Former Johannesburg Mayor Isaac Morgase is second from right. Source: South African History Online, sahistory.org.za/article/2nd-johannesburg-biennale

Not long before Okwui passed, I saw a talk by him on YouTube. It was about a project he was doing at Haus der Kunst. He spoke of the archive as a living substance of historical reflection. I thought, that's exactly it.

Recently, someone asked me if I minded being labeled an African artist. I said, like being labeled a woman artist, when the power shifts I'll be happy to be an artist.

But actually, Okwui's story has changed this. It feels important to me to be an African artist.

Penny Siopis *is an artist and honorary professor at Michaelis School of Fine Art, University of Cape Town.*

Notes

1 Okwui Enwezor, *Trade Routes Revisited: A Project Marking the 15th Anniversary of the Second Johannesburg Biennale* (Cape Town and Johannesburg: Stevenson, 2012), 11, issuu.com/stevensonctandjhb/docs/trade_routes_book_issuu?fr=sYjdjMTE3ODk0Mg (accessed February 11, 2021).
2 David Nthubu Koloane, exhibition invitation, *Ubuntu,* Malaysia Art Museum, Kuala Lumpur, 2002, cited in Colin Richards, "Aftermath: Value and Violence in Contemporary South African Art," in *Antinomies of Art and Culture: Modernity, Postmodernity, Contemporaneity,* ed. Okwui Enwezor, Nancy Condee, and Terry Smith (Durham, NC: Duke University Press, 2009), 259–60[n54].
3 Enwezor, *Trade Routes Revisited,* 11–12.

Solidarity with Warmth

Zarina Bhimji

Zarina Bhimji, left to right: Professor Ruti Teitel, Okwui Enwezor, and Susanne Ghez, celebration lunch on the occasion of the exhibition *Fault Lines: Contemporary African Art and Shifting Landscapes*, curated by Gilane Tawadros, at the 50th International Art Exhibition, La Biennale di Venezia, *Dreams and Conflicts: The Dictatorship of the Viewer*, 2003. © Zarina Bhimji. All rights reserved, DACS 2021

I met Okwui Enwezor during the Second Johannesburg Biennale of 1996–97. Part of the biennale was in Cape Town, and I was exhibiting in the group show *Life's Little Necessities* at the Castle of Good Hope, curated by Kellie Jones.

When I arrived in Johannesburg, it was the first time I had entered Africa since leaving Uganda in 1974. That such an important event was happening on African soil was a landmark, but I felt anxious to be in South Africa, so recently under apartheid. It was around the time that Nelson Mandela was released from prison, and the conversion of Robin Island into a museum had just been completed.

When we visited, we could smell the paint on the buildings. I remember the color gray, the distant landscape, and the echoes of the wind.

The Johannesburg Biennale was a laboratory of activity. It accelerated the questions of crises and gave a new generation of thinkers, writers, and artists a platform to respond. So much was changing globally in economics, politics, and immigration. During this time of chaos, there were many ways to answer the questions posed by a changing Africa: by either being socially active or intimate, poetic. A new way of thinking had to be found, not unlike what you could see in writers such as Audre Lorde

Journal of Contemporary African Art · 48 · May 2021
DOI 10.1215/10757163-8971566 © 2021 by Nka Publications

Echo, 2007. Ilfochrome Ciba Classic print, 50 x 63 in. © Zarina Bhimji. All rights reserved, DACS 2021

and Franz Fanon, whose work is a reflection of the personal and political.

In South Africa, I also met Mahmood Mamdani. He introduced me to the late Jimmy Dean, a famous Ugandan rally driver. I felt safe to go to Uganda on a recce for my first film because of Jimmy; he was known to everyone, and he had adopted an African girl. This was during the war in Rwanda, and homeless Rwandese families were staying at the old Entebbe airport; I made a photograph called *Echo* (2007). Many Indian men had also escaped to Uganda from Kinshasa and were staying near Jimmy. In the evenings, they would get together after catching Tilapia to cook the fish on his barbecue and drink waragi.

The Johannesburg Biennale, as well as the later Documenta11, was an important support for me in trying to make sense of how to work visually and sonically—to listen with eyes, to listen to changes in tone. Toward the end of my film *Out of Blue*, you see blocks of color, like a Rothko painting, from the sun beating intensely. At the same time, you see swallows flying back to Africa and hear the sounds of mosquitoes: a metaphor for claustrophobia. This is not a personal indulgence; it is about making sense through the medium of aesthetics. Such a

Clockwise from top left: Zarina Bhimji; Okwui Enwezor; Duro Olowu, Nigerian-born British fashion designer; and US curator Christine Kim meet up by accident at Duro's shop, July 2015. All rights reserved, DACS 2021

Jimmy Dean's kitchen, Kampala, Uganda, during the *Out of Blue* recce, 1998. © Zarina Bhimji. All rights reserved, DACS 2021

combination of personal and public aspects holds a special resonance for me.

I have always been interested in working-class politics such as the miners' strikes, the Grunwick dispute, Jayaben Desai, the Southall Youth Movement, and the Southall Black Sisters.[1] But at the same time, politics hurts. When I met Okwui, it was possible to feel a different kind of temperature. I felt there was more possibility for international politics, form, space, and painting. Supported by an artist award from the Paul Hamlyn Foundation, I began to look at difficult subjects and to look outside of Britain. It was at this time that I moved my practice from the studio to the outdoors, becoming an open studio. During Documenta11, supported by Okwui and cocurator Sarat Maharaj, I began to make my first film, *Out of Blue.*

My conversations with Sarat and the other cocurators of Documenta11 gave me a sense of energy, urgency, and hope. I felt love from the curators. There was solidarity with warmth. We were together to make something. This allowed me to think creatively and take risks. There were big gatherings around food with conversation and laughter. During Documenta11, there was a big kitchen with food served for the artists. This was Okwui's amazing skill. With his loud laughter, he would say, "I don't want my artists starving, and I want us to be together."

Zarina Bhimji was born in Uganda and is a London-based artist.

Note

1 The Grunwick Dispute (1976–78) began with a workers' strike at the North London Grunwick film processing factory, led by Jayaben Desai, to improve working conditions and establish a trade union. It was supported at the national level by British trade unions. The Southall Youth Movement, established in 1976, was an antiracist and antifascist group of Asian and Black Britons from West London. Southall Black Sisters was established in 1979 as an antiracist group, increasingly focused on women's rights and empowering victims of domestic violence.

A Vision and a Conjuring

Lynette Yiadom-Boakye

Should the daft endeavor to doubt you
Should they claim crimson green and emerald white
Should they tie your tongue lest words take flight
Soft, hold your peace as a Visionary ought
As empty threats amount to nought

Should the mighty make merry and mock you
As the hyena goads the lion at rest
As only his patience and grace to test
Soft, and hold tight to the tranquil air
For a Visionary has the spleen to spare

Should the wide world take pains to court you
With sweets, sugar and songs from the farthest flung lands
The proverbial Greek with a horse in his hands
Soft, since flattery has no recourse to passion
And the Visionary ear holds such things at a fashion

Should Love see fit to lay her hands on you
Find fingers to quiver on rakish spine
Find hours to measure a mark divine
Soft, and let time take months into weeks and into days
For a Visionary sees love in all they survey

Should charlatans rise and take arms against you
Come heavy with metal in rifle-strong vanity
Come brash and insulting with leaden profanity
But soft, for such attacks will come, by and by
And a Visionary bird continues to fly

Should this world no longer be able to hold you
Know that nothing is lost nor fully unfurled
The mind and its magic live on in the world
And as the Visionary hearts of times gone past
This Visionary heart is ever to last.

Lynette Yiadom-Boakye *is a British painter and writer.*

DOI 10.1215/10757163-8971398 © 2021 by Nka Publications

JACOB LAWRENCE: THE AMERICAN STRUGGLE

METROPOLITAN MUSEUM OF ART, NEW YORK
AUGUST 29– NOVEMBER 1, 2020

Jacob Lawrence, *Massacre in Boston*, Panel 2, 1954–55, from *Struggle: From the History of the American People* series, 1954–56. Egg tempera on hardboard. Collection of Harvey and Harvey-Ann Ross. © The Jacob and Gwendolyn Knight Lawrence Foundation, Seattle/Artists Rights Society, New York. Photo: Bob Packert/PEM

Jacob Lawrence: The American Struggle, on tour through most of 2021, features known paintings comprising *Struggle: From the History of the American People* (1954–56), a sprawling, meandering series culminating three decades of muralism in miniature in the artist's oeuvre.[1] Its basic elements—nonfiction subject matter, Cubistic representational form, limited matte-finish palette distributed across a filmstrip format—were established notably early in his art career with his breakthrough *Migration Series* (1940–41). Sold shortly after its creation in a split between the Phillips Collection and the Museum of Modern Art, where it was exhibited in 1944, it has since accrued the status of a veritable national treasure, in terms of both American art of the era and pedagogical resources on the historical exodus of African Americans from the Jim Crow South between the world wars. Lawrence's analogic rough and tumble visual journey, punctuated by captions that steer the narrative, is also an indelible reference point in most any discussion of his art. Where the *Migration Series* arranges boldly flattened, geometricized bodies and reduced semiotic, or coded, settings into chunky rhythms, the spaces and forms of the *Struggle* series are further diced to effect Futurist-like motion, with the viewfinder zoomed out as well. Likewise, the complimentary color scheme of red and green, dominant in the former, is cooled with earth tones, blues, and white in the latter, punctuated with sporadically applied blood-red, apropos of the national roots theme and its violent underpinnings.

Looking back for another moment, which is always relevant with Lawrence, the *Migration Series* was preceded by three other series dedicated to, respectively, Toussaint Louverture, Harriet Tubman, and Frederick Douglass. Moving to a massive contemporary event that directly impacted his life and environment (his parents had moved north during WWI) did not preclude extensive research while formulating its pictorial program, an integral part of his art practice by then. In this vein, a headquarters and inspirational hotspot for Lawrence since his arrival in Harlem as a young teen was the formidable Schomburg branch of the New York Public Library (today, Schomburg Center for Research in Black Culture), which housed, from 1934, Aaron Douglas's four-part mural *Aspects of Negro Life*, somewhat more orthodox in Cubist style. At the time, the Black Mecca was hedging a second-wave renaissance invigorated by the Great Migration as well as New Deal work programs.[2] Under the mentoring of modernist painter Charles Alston, the Hans Hofmann of Harlem when it came to educating young artists, along with sculptor Augusta Savage, who got Lawrence involved with a Works Progress Administration branch program, he wedged a hard-edged urban regionalism into the melting pot of American figurative painting of the era—nearly full-fledged in the *Migration Series*. For the rest of his career, he built incrementally upon that

structural form and content, which he often referred to as explicitly continuous, a macro version of his predilection for serial compositions.

Fast forward a little more than a decade, when Lawrence, now a WWII veteran who had been drafted into a segregated army but ultimately served in its first integrated navy unit as an artist, embarked on the *Struggle* series. De jure segregation was still prevalent in the South and elsewhere, and in tandem, continuing African American south to north migration. Lawrence had been invited to the famously avant-garde Black Mountain College as a professor (kudos to facilitator Josef Albers) in a North Carolina that restricted his autonomy beyond campus. In the two years that the series came to fruition, the civil rights movement consolidated with catalysts like *Brown v. Board of Education*, Rosa Parks's bus protest, and the murder of Emmett Till. Lawrence, however, turned back to the beginning with a loosely conceived sixty-panel history of the United States of America, ca. 1775 to 1817, of which thirty panels were completed and ultimately dispersed. This exhibition brought together, at its outset, twenty-four known surviving panels, with one too fragile to travel and five unlocated scenes represented in reproductions,

where available, or empty frames with documented captions. This tactic was astute not only for scholarship and viewer engagement, but also for its unforeseen part in the recent recovery of one of the works, inserted into the exhibition for its final weeks at the Met and forthcoming legs of its tour.[3]

At the entrance to the Met installation were four bonus Lawrence works from the permanent collection depicting busy Harlem street scenes, which cast an apropos urban perspective on the ensuing fragmented, captioned saga. The first scene dives into the pressing, paradoxical dilemma of the sanctioned enslavement of Africans, accompanied by a 1775 Patrick Henry quote that compares the white colonist position to slavery, popular revolutionary rhetoric shared by other slave-owning patriots: . . . *is life so dear or peace so sweet as to be purchased at the prices of chains and slavery?* The depicted crowd of variously flesh-toned men with arms stretched upward into clenched fists recalls protest images by the Mexican muralists, whom Lawrence admired. The next scene, *Massacre in Boston*, memorializes a victim of the Boston Tea Party, presumably Crispus Attucks, one of few Persons of Color (African American and Native

American) noted as, ostensibly, patriots in their time. Lawrence's prostrate pyramidal figure gushes a sharp streak of vermilion, reiterated by bloody drips from a knife in the aftermath above that strategically spurt across the series. Lawrence also points out, in the third scene, a literal instance of the colonists subsuming the Other by masquerading as Indians in carrying out this raid (*Rally Mohawks! Bring out your axes and tell King George we'll pay no taxes on his foreign tea . . .—a song of 1773*). From there, Lawrence had me on his rhythmic roll through his offbeat narrative take, flecked with staccato details, which encouraged circling around while propelling me forward.

Another scene foregrounding Native American presence employed signifying shorthand with red silhouettes and zigzag patterns, captioned with the politically correct quote: *In all of your intercourse with the natives, treat them in the most friendly and conciliatory manner which their own conduct will admit . . . — Jefferson to Lewis & Clark, 1803*. The British recruitment of Native Americans comes up in a later scene on the War of 1812. Substantial slave defection to the British, based on promises of freedom, is not broached. In fact, with Lawrence's conveyed

Trappers, Panel 22, 1956, from *Struggle: From the History of the American People* series, 1954–56. Egg tempera on hardboard. Collection of Robert Gober and Donald Moffett. © The Jacob and Gwendolyn Knight Lawrence Foundation, Seattle/ Artists Rights Society, New York. Photo: Bob Packert/PEM

subjectivity and the unifying tricolor palette, Black patriotism emerges as an implied subtheme, harking back to several images in the Frederick Douglass series. Women combatants are also depicted.

The mythologized episode of the Christmas night Delaware River crossing of the Continental Army to the Battle of Trenton is represented with the caption, *We crossed the River at McKonkey's Ferry 9 miles above Trenton . . . the night was excessively severe . . . which the men bore without the least murmur . . .—Tench Tilghman, 27 December 1776*. Deconstructing the iconic Emanuel Leutze painting *Washington Crossing the Delaware* (The Met), which has triggered so many art-political riffs, Lawrence's version eliminates Washington altogether from his shivering, blood-flecked flotilla of blanketed armed men, the spiky vessels and peaking waves interlocked as in a Hiroshige print. Overwhelming, the scenes focus similarly on group efforts, decisions, and outcomes rather than individuals. Virtually, the only close-up framing two anonymous figures references infamous traitor Benedict Arnold, captioned *120.9.14.286.9.33-ton 290.9.27 be at*

We crossed the River at McKonkey's Ferry 9 miles above Trenton . . . the night was excessively severe . . . which the men bore without the least murmur . . . —Tench Tilghman, 27 December 1776, Panel 10, 1954, from *Struggle: From the History of the American People* series, 1954–56. Egg Tempera on hardboard. The Metropolitan Museum of Art, purchase, Lila Acheson Wallace Gift. © The Jacob and Gwendolyn Knight Lawrence Foundation, Seattle/Artists Rights Society, New York

153.9.28.110.8.17.255.9.29 evening 178.9.8 — an informer's coded message, is as psychologically chilling as Giotto's seminal *The Kiss of Judas* and triples as an allusion to McCarthyism, then peaking in Lawrence's own arts milieu.

In keeping focus on the layered implications of the title *Struggle*, internal violence is brought in with the Shays Rebellion (subject of the recently recovered work), essentially a failed commoner coup, and the Aaron Burr-Alexander Hamilton rivalry, attributable to wanton political behavior by both revolutionary veterans. In *Trappers*, a seeming non sequitur, Lawrence taps viewer empathy with the most pared of means in a metaphoric mise-en-scène of capture, murder, and, perhaps, survival. A related image of isolated human death, in the context of the high-percentage casualty War of 1812, portrays a bleeding solider trapped in razor-sharp ice floes—nonetheless captioned with the collective sentiment: . . . *if we fail, let us fail like men, and expire together in one common struggle* . . . —*Henry Clay, 1813*. Meanwhile, the rebirthing earth in a *Peace* panel is followed by one reminding of continuing slavery: . . . *for freedom we want and will have, for we have served this cruel land long enuff* . . . —*a Georgia slave, 1810*. The final scene (the piece that could not travel) introduces the fraught phenomenon of western expansion, capping the diverting interstices and ambiguities of Lawrence's trajectory: . . . *Old America seems to be breaking up and moving Westward* . . . — *An English Immigrant, 1817*. The dynamic visual energy of the series is inhered, precisely, in Lawrence's open-ended exploration of American identity, increasingly intimate and monumental in scope in equal measure, vis-à-vis what came before. For Lawrence, looking back was integral to the way forward. His ability to engage the viewer's perceptual, intellectual, and emotional facilities with the simplest of shapes and limited hues on tiny boards is always an amazing revelation.

Jody B. Cutler-Bittner is an art historian affiliated with St. John's University in New York City.

Notes

1 The exhibition was organized by the Peabody Essex Museum (Salem, Massachusetts) and is scheduled to travel to the Birmingham Museum of Art (Alabama), the Seattle Art Museum, and the Phillips Collection (Washington, DC) through fall 2021.

2 The sophisticated arts milieu that Lawrence fell into early was emphasized in a museum-sponsored exhibition video program; see "Jacob Lawrence: The American Struggle | Met Speaks," YouTube video, 47:15, September 16, 2020, youtube.com /watch?v=8naFij-PwfI.

3 The Met 150, "The Metropolitan Museum of Art Announces Discovery of Missing Painting by Iconic American Modernist Jacob Lawrence," press release, October 21, 2020, metmuseum.org/press/news/2020/jacob -lawrence-panel-16-discovery.

JACOB DLAMINI
THE TERRORIST ALBUM: APARTHEID'S INSURGENTS, COLLABORATORS, AND THE SECURITY POLICE

HARVARD UNIVERSITY PRESS, 2020

The instrumentalization and co-option of photographic headshots in the service of a cumbersome and often inefficient bureaucracy is the subject of Jacob Dlamini's important book *The Terrorist Album: Apartheid's Insurgents, Collaborators, and the Security Police*. Having come across a compendium of seven thousand black-and-white mug shots "capturing" political exiles once hunted by the South African Security Forces—one of the few salvaged volumes, known as the "Terrorist Album," that survived the decreed purge of documents and incriminatory evidence of National Party rule in South Africa between 1948 and 1994—Dlamini sets out in this book to understand how apartheid governance functioned at a granular, quotidian level. Beneath the grand narratives and ideological posturing, he argues, was a shabby, amateurish infrastructure metering out its cruel punishments through petty and crude systems of control. For Dlamini, the Terrorist Album is a symptom, as well as a cypher, of a state apparatus that, though violent and coercive, depended on very crude and time-bound techniques of co-option, conscription, and surveillance.

Created cumulatively from the 1960s to the early 1990s, the album was conceived in a megalomaniacal fantasy of control as a medium through which every exiled South African, branded as an enemy of the State, could be classified and "captured" in print. Using passport photos, ID documents, the notorious dompas, newspaper cuttings, and police records, seven thousand images were collected, pasted, reproduced, and "curated" according to standard racialized schema.[1] Accompanying them was an index that arranged its subjects into a simple system: S1 stood for "white," S2 for "Indian," S3 for "Coloured," S4 for "African": an invented and naturalized organizational structure that mirrored apartheid's reduction of humans into imposed categories and types. The images were meant to signify according to these delimited identities. It is part of Dlamini's project to demonstrate how this operated both as a conceptual/practical project and as a flawed system of representation and reference.

The photographs alone tell us little. Once used as prompts for interrogation and identification, most conform to the usual protocols used in police image banks. The faces appear devoid of life and liveliness, reduced to the tonal registering of shape, feature, and deadpan gaze, an accumulated register of resistance, both to the system that corralled these figures into its classificatory logic and to the mug shot's effectiveness as a technology of recognition and recall. The mug shots are singularly incapable of telling us

Courtesy Harvard University Press

DOI 10.1215/10757163-8971609 © 2021 by Nka Publications

1783

Mug shot of Odirile Meshack Maponya in the Terrorist Album. Courtesy National Archives and Records Service of South Africa

much about the material, physical, and emotional damage that the apartheid government's practice of identifying, torturing, and killing insurgents and political opponents entailed. Yet, the very existence of the album is revealing, despite its incapacity to relay the minutiae of individuated bravery or suffering, as well as its limitations as a reliable index of resemblance and record. In the pages of the album, faces are invariably reduced to schematic inscription and flattened conformity to type. It is often hard for people to recognize themselves and others in the shots that are said to represent them.

It is precisely the failure of the photographs to fulfill the mimetic promise of personalized portraiture (associated with the family album, the mantle-piece, or private scrapbook) that is instructive here, for this is a compendium of cutouts designed to signify and catalogue a surface identity that necessarily evacuates sentience, singularity, and depth. While ostensibly useful for identification purposes, where informers and collaborators, often complying under duress or torture, used the mug shots to name and define, it is what these people are seen to share that justifies their inclusion in the album. It is as figurations of the "terrorist" that their images were collected, classified,

and put to use. Ironically, therefore, a volume designed to identify and differentiate ends up homogenizing and flattening its occupants, reducing and misrepresenting the very people it set out to police.

In 1993, five hundred copies of the album existed, held in drawers and cabinets in Security Police offices across the country, but they were ordered to be destroyed, alongside piles of incriminating evidence, in the dying days of National Party rule. One of the great achievements of the Truth and Reconciliation Commission (TRC) was its success in salvaging some of the material remnants of the apartheid archive as well as supplementing these with new kinds of testimony from witness reports and records to oral history, personal accounts, and reconstructions. The ritualized hearings and staged encounters between victims, survivors, and perpetrators have entered collective memory and consciousness, providing the impetus for an extraordinary array of works (plays, novels, memoirs, videos, films) that both mediate its content and question its efficacy and forms of address.[2]

But what the TRC also unearthed, and this is where Dlamini hones in, are some uncomfortable truths and trajectories. A case in point is the Terrorist Album, for, thanks to the testimony offered to the TRC as well as interviews and private conversations that Dlamini undertook, we now understand how the pictorial compendium was used to turn one-time opponents of apartheid into collaborators and functionaries of the State. Slowly, painstakingly, relentlessly, Security Police would interrogate arrestees, getting them, wherever possible, to talk about the images, spill the beans on their former comrades, and become informers or spies.

Take, for example, the story of Gladstone Mose, a onetime African National Congress (ANC) comrade who received military training in the Ukraine but was arrested by the South African Police in 1972 and ended up betraying his former beliefs and buddies. Mose not only revealed some of the folks in the album to his bosses, he effectively "curated" it by adding to its collection, extracting images from ANC publications to supplement the list of the "wanted." Other examples include Joseph Maponya, who ended up on the Security

Police payroll as well as betraying his own son, Odirile, and Chris Giffard, an ex ANC intelligence officer who identified six individuals for the police.

Dlamini fleshes out the stories of such individuals, intent on complicating the dominant narrative of the antiapartheid struggle beyond the Manichean binaries of perpetrator and victim, hero and villain. Apartheid's tenacity, he argues, depended on the collaboration and collusion of many, whether active perpetrators or passive bystanders, and these came in many hues and complexions. This is not, for him, a history of goodies and baddies or simplistic racialized positions (mirroring those of apartheid-era nomenclature and determinism) that serve to confer universal heroism (or victimhood) on one group and unquestioned villainy and moral bankruptcy on another. History, Dlamini shows us, is much more complicated than that, and the Terrorist Album provides a material instance of its entangled and intricate operations. Not that he is in any way an apologist for the apartheid system and its violence, both overt and implicit, but he is an astute observer of the way it operated, managing to uncover its cracks and incoherence as well as its power to pervert.

The Terrorist Album is a brilliant object through which to uncover the myths and mythologies of apartheid's operational functionality. It is precisely the meanness of the "official" pictorial record that Dlamini exposes in order to illustrate the uses and misuses to which its contents were put. Through extensive interviews, conversations, reading, and research, Dlamini fills in the stories that the album repressed. In its compromised covers, there was little room

A copy of the Terrorist Album in the National Archives, Pretoria, South Africa. Courtesy Jacob Dlamini

Novelist Bessie Head. Courtesy Gallery MOMO, South Africa. Photo: George Hallett

for complexity or ambiguity to express itself. In fact, the very rigor of the grid, with its conformity of arrangement, placement, and pattern, as well as the simplistic schema of the index, was designed to impose coherence on a variegated world. (Who knew what a "terrorist" actually looked like?) True, there are the odd occasions when anomalies creep in: in the case of the novelist Bessie Head, for example, a portrait by George Hallet, once reproduced in the antiapartheid literary magazine *Staffrider*, was cropped and pasted into the album so that the subject is shown informally puffing on a cigarette, finger raised and brow furrowed in a contemplative and idiosyncratic pose. Head's inclusion in the volume is curious, but not only because of her lack of conformity to pictorial type. That she was designated a "terrorist" in the first place points to the looseness by which this term was applied—and the deadly effects of being so described.

Dlamini revels in the failure of the album to fulfill its own logic. Nowhere is this more apparent than in

the misidentification of Barry Gilder, labeled erroneously in the album as Rashid Patel, a Jew for an Indian, so scrambling the very idea of racial separation on which its structure was based. Whether classified as a S1 or S2, this mug shot did not know its place, confounding the certainties on which apartheid's pigmentocracy relied.

Dlamini's *The Terrorist Album* is full of such derailing and deflationary anecdotes. In it, photographs can only tell us so much. Subsumed as veridical documents in a classificatory system that relied on their capacity to denote, they so often failed to do so. As isolated images they were open to misrecognition and abuse. But as material components of a complex signifying structure (sandwiched on the page, between covers, in drawers and fingers and hands) and contextualized in this bizarre and unique set of albums, they tell us much more than they were intended to do. It is the achievement of this book to allow them an eloquence that they did not necessarily deserve. In the context of the testimony of the

TRC and the tyranny of apartheid-era typology, these purloined pictures become vehicles through which history and memory unfold.

***Tamar Garb** is the Durning Lawrence Professor in the History of Art, University College London, and a scholar of the art/visual histories of South Africa.*

Notes

1 The dompas was the passbook that Black South Africans were obliged to apply for and carry in areas designated for whites during the apartheid era.

2 See, for example, Mark J. Kaplan, *Between Joyce and Remembrance*, directed/produced by Mark J. Kaplan (Oley, PA: Bullfrog Films, 2004). In the last minutes of Kaplan's searing documentary, the filmmaker is seen paging through an album of black-and-white mug shots. Among the seven thousand or so photographs pasted in a grid in the Terrorist Album, Kaplan locates the photograph of Siphiwo Mtimkulu, a murdered African National Congress operative and student activist, whose bland effigy fixed him as a wanted enemy of the State. Kaplan's "handling" of this piece of material evidence comes at the end of a harrowing film that chronicles the efforts of the Mtimkulu family to find out what happened to their son, locate his bodily remains, and bury the few locks of his hair that survive. As part of the hearings of the Truth and Reconciliation Commission, Siphiwo's killers, including the notorious Gideon Niewoudt (who was also implicated in the killing of South African black consciousness leader Steve Biko), applied for and were granted amnesty. The family, to whom Niewoudt appealed for forgiveness, did not accept his feigned and disingenuous apology. According to Mark Kaplan, in an interview I had with him on February 1, 2021, "Siphiwo and his friend Topsy Madaka were killed by the Security Police, who maintained that they had fled to Lesotho. The appearance of both of them in the Terrorist Album was part of this cover-up—a deliberate smokescreen, a fiction, which also formed a base for the Security Police to continue harassing Siphiwo's family whenever they raised awkward questions about his whereabouts." The film not only tells Siphiwo's story, but also captures the dramatic moment when his son, Sikhumbuzo, only three months old when his father was murdered, erupts in uncontrollable anger and throws a heavy vase at Niewoudt's head at the moment that he is filmed asking his victim's parents for their pardon. The violence of the son's pain is palpable, its explosive energy cracking the skull of the killer at the same time as appearing to puncture the narratives of forgiveness and reconciliation privileged by the TRC. For this family, the film shows us, there is no resolution or closure to be had.